100% KID

ALLISON TYLER JONES

A PHOTOGRAPHER'S
GUIDE TO CAPTURING
KIDS IN A WHOLE
NEW LIGHT

Peachpit Press
www.peachpit.com

100% KID
A Photographer's Guide to Capturing Kids in a Whole New Light

Allison Tyler Jones

Peachpit Press
www.peachpit.com

To report errors, please send a note to errata@peachpit.com
Peachpit Press is a division of Pearson Education

Senior Editor: Susan Rimerman
Production Editor: Tracey Croom
Developmental/Copy Editor: Anne Marie Walker
Proofreader: Elaine Merrill
Indexer: Karin Arrigoni
Composition: Kim Scott/Bumpy Design
Cover and Interior Design: Charlene Charles Will
Cover Image: Allison Tyler Jones

ISBN-13: 978-0-321-95740-5
ISBN-10: 0-321-95740-7

9 8 7 6 5 4 3 2 1

Printed and bound in the United States of America

To my husband, Ivan, the kindest person I know,
with a sense of humor, who does laundry.
Best move I ever made.

Acknowledgments

Writing a book is not unlike having a baby. All the fun takes place at conception and once the final product is placed in your hands. Everything in between stinks.

The midwives, if you will, who soothed my furrowed brow and coached me through this laborious process consist of the crack team of editors and designers at Peachpit Press. Ted Waitt made writing another book sound like *such* a great idea. Susan Rimerman's expertise and no-nonsense advice talked me off the ledge on more than one occasion, and Anne Marie Walker's deft editing made me sound smarter than I really am. Production editor Tracey Croom and the graphic design team of Charlene Charles Will and Kim Scott understood my pathological need for negative space and created an end product that I'm proud to put my name on.

My studio manager and assistant, Jeff Starr, not only worked tirelessly to organize and prepare all the images for print but had to listen to my endless whining and moaning about deadlines. Thanks Sarge.

The real credit for this book goes to my mother, Karen Hathcock Tyler, who passed away on April 11, 2013. She gave me the gift of life, the love of learning, books, and words. She also gave me five younger siblings who are my best friends and constant supporters: Loren Tyler, Ann Tyler Smith, Caroline Tyler DeCesare, Doug Tyler, and Laurel Tyler.

None of this would be possible without my amazing clients who trust me to boss, tease, and manipulate their children during every shoot.

Lastly, credit goes to my own 100% kids: Bryson and Tierra Jones, Lauren Myers, Breckyn Jones, Keaton Myers, Jamyn Jones, Harrison Jones, and Hayden Jones. Without you I would have a clean house, no stretch marks, naturally blonde hair, and money in the bank. But who needs it? Life would be so boring without you. I love you all.

Contents

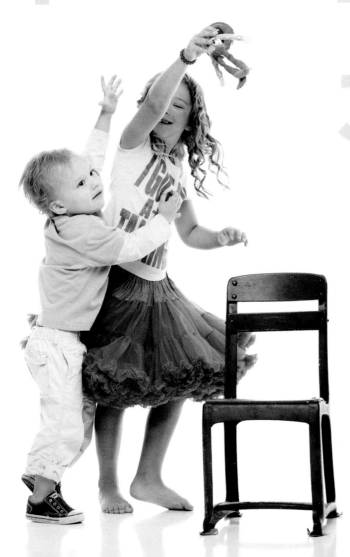

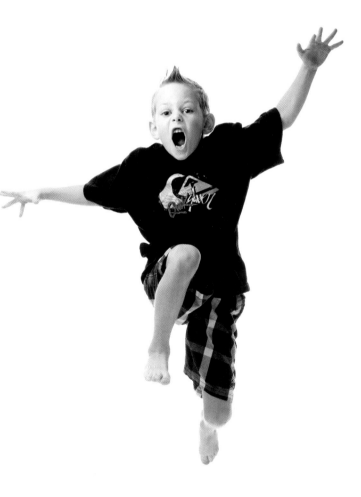

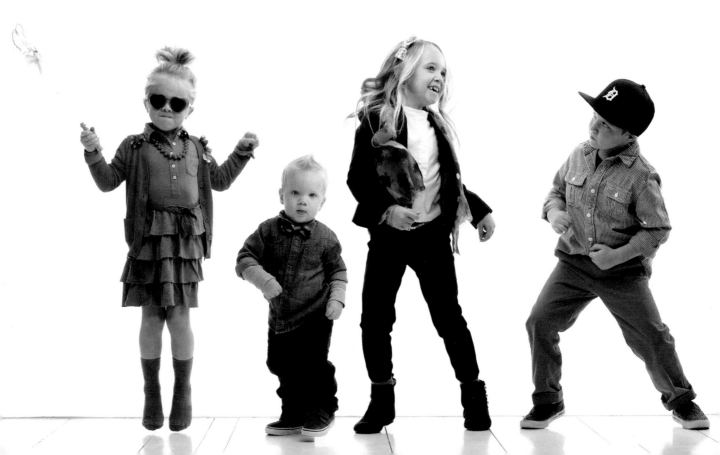

Introduction

A few years ago I stood in front of a group of incredibly talented photographers from all over the world. We were attending a workshop taught by two famous New York photographers whose work regularly appears in *Vanity Fair* and *Vogue*, and in the the windows of stores like The Gap. All the students were required to share ten of their favorite images with the group and instructors. In the middle of my presentation, Mr. *Vanity Fair* Photographer interrupted me and said, "Well, I have to hand it to you; I could *never* shoot kids."

Those of us who have chosen to specialize in photographing kids may be a little bit crazy. If you have kids of your own, it makes sense that you'd want to have some photos of them. But what about those of us who like to photograph children who are not our own? We've made a career out of making crazy faces, rolling on the floor, and snorting like a pig just to elicit some expression from a grumpy toddler. Isn't there an easier way to make a living?

Maybe we still haven't grown up and just like to be with "our people." Maybe it's the trend in your area to be a child photographer, and why not? All you have to do is buy a *good* camera and Photoshop, right? Or perhaps you appreciate how surprising and magical it can be to spend time making images of young subjects who haven't had a chance to develop their social mask yet—to capture the openness and wonder of being a kid.

ISO 100, 1/200 sec., f/11, 70–200 mm lens

This book is for those photographers who want to be better than they are right now. It's for photographers who have mastered the challenges of natural light and want to dip their toe into the scary world of studio lighting. It's also for photographers who were born curious and want to continually learn and improve their craft and how they relate to their subjects.

At last count there were roughly a zillion books on the market that explore the techniques of photography. Most of them illustrate those techniques with photos of leggy models, professional athletes, or grungy guitar players—all, presumably, well-behaved adults who can sit still and

take direction. I love those books and the techniques they share, but how am I supposed to light a toddler hyped up on sugar with a beauty dish? How the heck do you achieve a 3:1 lighting ratio when you can't even get the kid to stay in one place, let alone look at the camera? And it's not just the kids who present the challenge. I doubt that the leggy supermodel's mom is standing behind the photographer coaching her to "smile honey!"

So, rather than one more book full of general lighting tips and techniques, this book focuses specifically on lighting, photographing, and interacting with kids. The goal is to capture something real about that child.

You'll learn off-camera lighting techniques for both studio and location work, that you don't need a truck full of lights to create interesting portraits, and that much of the time just one light will do the trick.

You'll discover methods that will give you the confidence to deal with challenging kids *and* challenging parents—methods that I use every day in my photography studio to manage expectations and get the shot I want.

You'll learn my tried-and-true (and slightly weird) tricks for getting authentic expressions from my subjects, and you'll pick up practical tips on how to style, pose, and direct every shoot. Every technique and every tip in this book has been included with the sole purpose of arming you with the means to create beautifully lit, meaningful imagery of children.

What you won't find in this book are complicated diagrams and ratios. There's not a lot of math here. You'll also notice an astonishing lack of Photoshop instruction. Scott Kelby wrote the book(s) on Adobe Photoshop; go read them.

I wrote this book to encourage other brave souls who are on the path to the insanity and joy that is photographing children. I want to motivate you to channel the artist inside and re-envision how you approach the children you photograph. I want to inspire you to learn new techniques or refine those you already know. Push beyond the ordinary and the safe. In the process you'll make some big mistakes, but in the end you'll make your best images ever.

SECTION 1
VISION

Stranger: That's a beautiful child you have there.
Mother: That's nothing, you should see his
photograph. —Anonymous

Start with the Kid

IT MAKES SENSE THAT A BOOK about photographing children would "start with the kid," but how many photos of children have you seen that center around anything but the kid? Instead, many images center around a grungy environment, a couch in a field, or a tutu the size of Montana. All of these elements may be trendy and fun, but what do they have to do with the child you're photographing?

In this chapter, I want to challenge you to more carefully consider how you approach the children you photograph. I encourage you to take the time to go deeper in your thought processes and contemplate how you work and how your work could be more personal, more interesting, more thought provoking, more humorous, and more *real*.

ISO 200, 1/200 sec., f/8, 70–200 mm lens

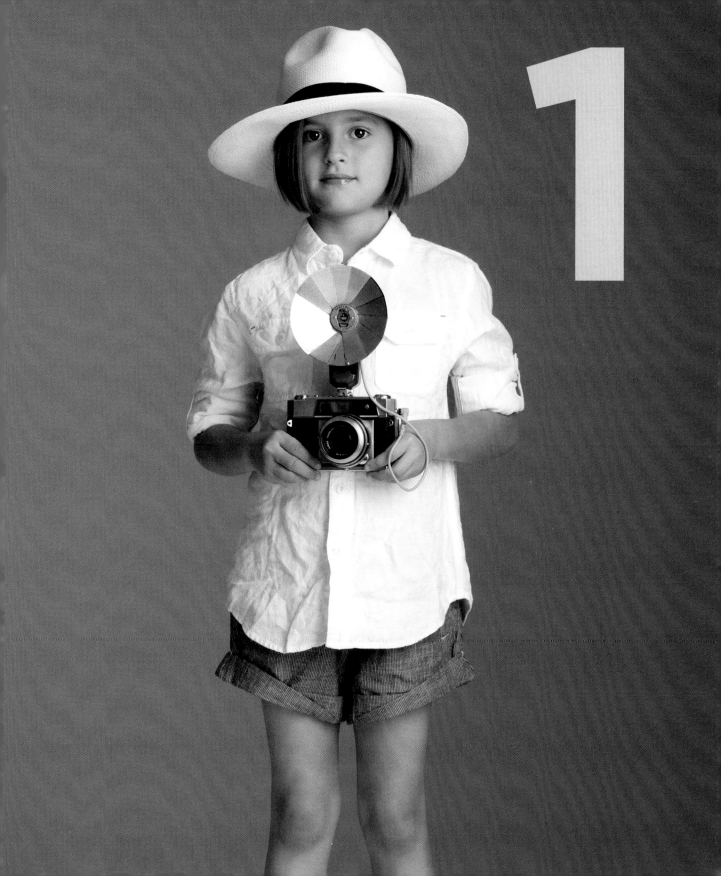

1

Snapshots vs. Portraits

It's not enough to just capture a faithful representation of a child. Any old snapshot can do that. A snapshot conveys the specifics of who, what, when, and where. A portrait, on the other hand, communicates something more universal about the subject. To illustrate this point, consider the photo in **FIGURE 1.1**, which shows a little girl with her parents on their front porch. For those who know this family, the image says, *the Giles family on their front porch*. The mom will love this photo, and Grandma will love this photo too. But although part of our job as photographers is to capture a straightforward shot of our clients, isn't there more to the art of photography than this? Instead of just snapping a shot of a specific child, could you *portray* the child in a way that would have meaning for or evoke emotion in someone who didn't know that child? It is that very quality that separates a snapshot from a portrait.

Evoking viewers' emotions calls for a more thoughtful approach than snapping the obvious shot. You have to start with the kid. Who is she? What do you know about her? How can you portray that information in the two-dimensional medium of photography? Once you've gathered that information, you can bring all your technical expertise to bear, marrying your photographic tools with your unique portrayal of the child.

The little girl in Figure 1.1 is an only child, and the family's life revolves around her. She is the cute yet benevolent dictator of her family. In **FIGURE 1.2** you see the same little girl, the same parents, and the same front porch, but instead of being a shot that only close family would respond to, this image speaks to a larger audience and explores more universal themes, such as the love between family and a little girl who is the center of her parents' world. The fact that the parents are looking at each other as though thinking, *oh hi, I recognize you!* represents a familiar feeling most parents share during the early years of high-intensity parenting. It's a portrait, not a snapshot.

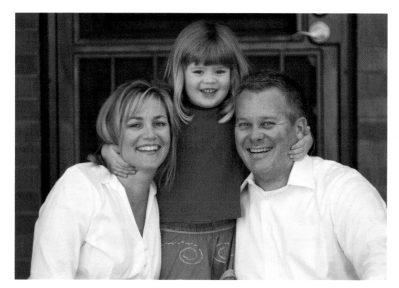

FIGURE 1.1 A snapshot of a girl and her parents—normal yet boring. You can do better than this (left).

ISO 400, 1/200 sec., f/2.8, 70–200mm lens

FIGURE 1.2 A portrait of the same little girl and her parents, but this image communicates more than the sum of its parts (below).

ISO 400, 1/200 sec., f/2.8, 70–200mm lens

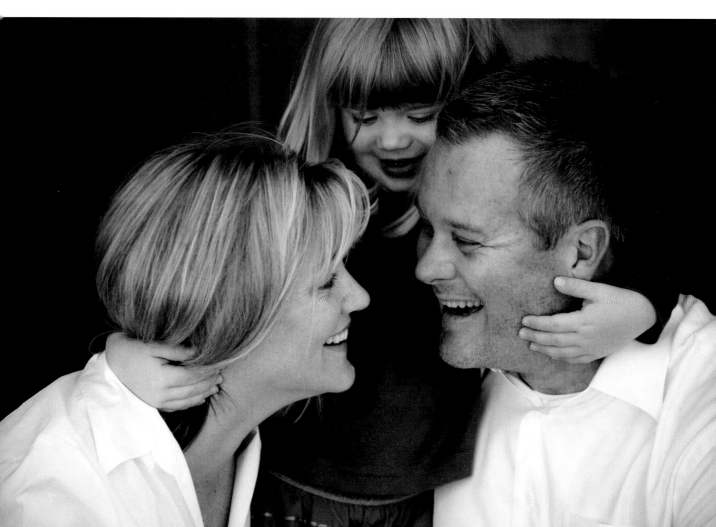

Evoke a feeling or emotion in the viewer.

Clarify Your Intention

As a photographer, you may find your job is different than you think. When asked, "What is your intention as a photographer?" the answers are as many and as different as the photographers: "To pursue my passion." "To make money." "To express myself." "To be famous." These may be the eventual results of the correct intention, which is to *evoke a feeling or emotion in the viewer*, whether the viewer knows the subject in the image or not. What creates that feeling or emotion is often the viewer responding to something universal about that image—a recognition of something *real* that feels tied to a common human experience.

The best way to explain it is that a poignant image calls up *themes* in your mind versus *specifics.* So, rather than just looking at a typical photo of Emily, Olivia, and Sarah at tennis lessons (**FIGURE 1.3**), you smile at **FIGURE 1.4** because more universal themes come to your mind, such as *friends*, *women-in-training*, *secrets*, and so on. There is more than one way to read this image.

FIGURE 1.3 Cute girls at a tennis lesson. This is the shot that mom or dad might line up and take (right).

ISO 100, 1/200 sec., f/13, 70–200mm lens

FIGURE 1.4 Challenging yourself to inject a storytelling element results in images that have a broader appeal and say something more than just who is in the shot (opposite page).

ISO 100, 1/200 sec., f/13, 70–200mm lens

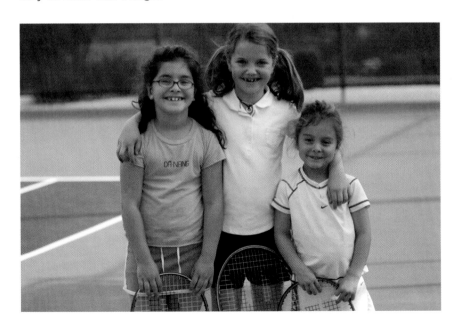

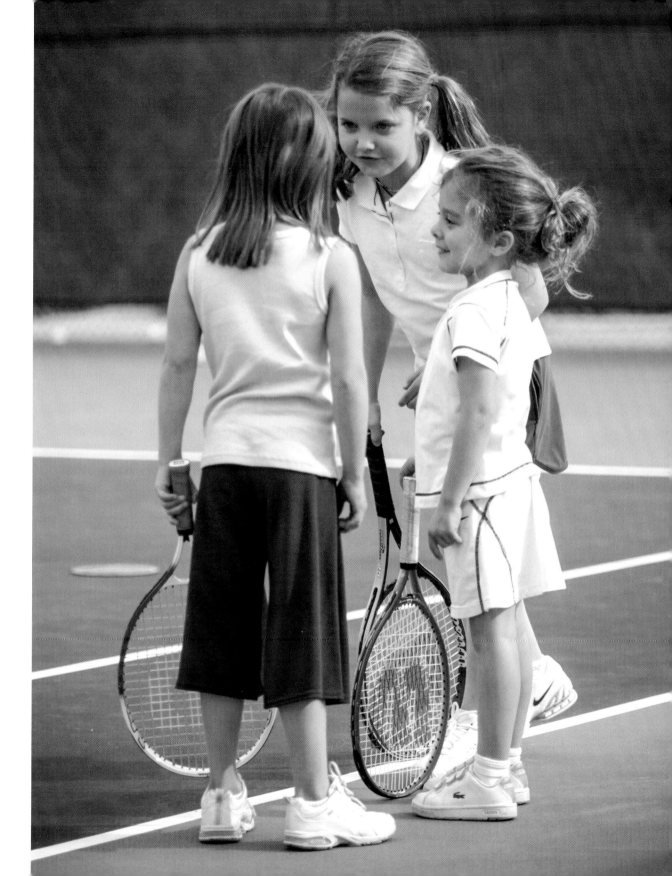

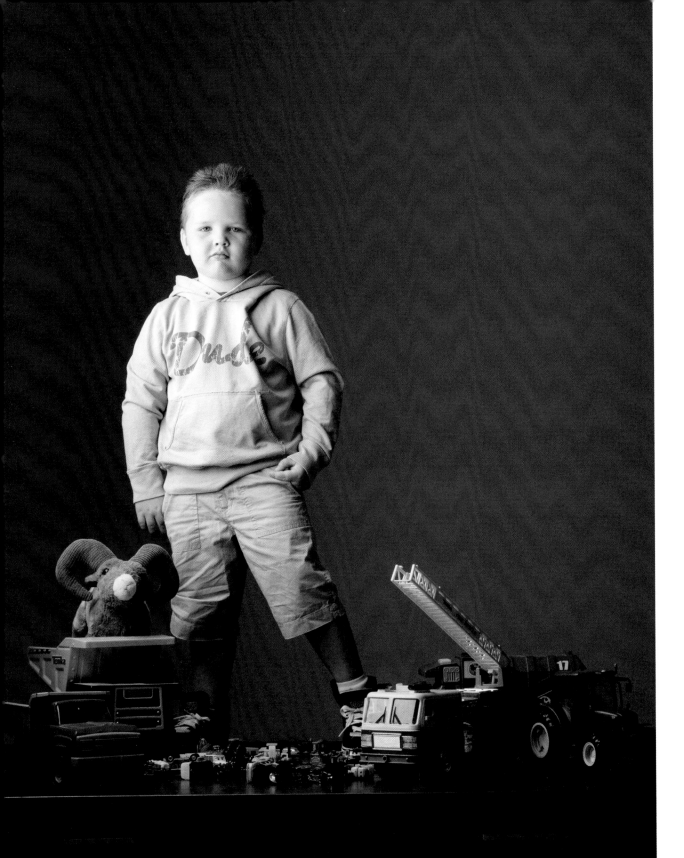

Beyond the Obvious

Is it possible to capture a straightforward image where the child is aware of the camera and have it read as more than a snapshot? Of course it is, and that's where the technical expertise comes into play in addition to your understanding of the child you are photographing. You select all the elements and *portray* the child in an authentic way. You decide on the lighting, your camera angle, the pose, and the direction you'll give. Then ask yourself what you want to convey about this child. Do you want to show off that sweet boy and his cherub face, or his obsession with his favorite toys of the moment (**FIGURE 1.5**)? It takes more time and more thought to carefully consider every child, but your images will show the care and contemplation you put into your process.

FIGURE 1.5 Allowing the child to bring his favorite things informs a more authentic portrait (opposite page).

ISO 100, 1/200 sec., f/11, 70–200mm lens

The Real Kid

Years ago I had a client named Debbie who hired me to photograph her two little girls. At the time, one was four years old and the other was six. Debbie shopped and shopped for the perfect clothes, and on photo-shoot day the girls arrived in immaculate white dresses with their hair pulled up in tight, perfectly coiffed pigtails and their faces scrubbed clean. Cute photos were captured, and everyone was happy.

A week later, Debbie arrived with her girls in tow to look at her proofs. The oldest girl was dressed in popsicle-stained overalls with a tutu on top, had iPod earbuds stuck in her ears, and was rocking her mom's sunglasses. The little sister had painted her own nails (and most of her fingers) that morning, and her ponytails were uneven and messy on her head. She clutched a collection of Barbies while trying to keep a sparkly purse that had seen better days from falling off her little shoulder. Debbie apologized for how messy they looked; she hadn't had time to get them ready that morning. I was devastated and whined, "Why didn't you bring them like *this* for the photo shoot?"

"You've got to be kidding!" Debbie said. "This is what they always look like unless I get them dressed up!"

I never put the camera away until my client has left the parking lot.

FIGURE 1.6 A sweet, but expected, portrait of a darling little girl.

ISO 100, 1/200 sec., f/8, 70–200mm lens

FIGURE 1.7 Keep your camera out and your eyes on the lookout, especially at the end of the shoot. Getting dressed to leave the shoot this little girl made up her own outfit and accessory combo that was 100% her (opposite page).

ISO 100, 1/200 sec., f/11, 70–200mm lens

I knew then what all mothers of older children know: Someday those girls would outgrow their Barbies and dress-ups, and they'd be demanding the car keys. On the wall of their home would be a nice, cute portrait of them together at four and six in little white dresses. Nice. Cute. Boring. This was not what I wanted to do. And that's when I realized that my true passion was photographing what was *real* about kids. Good, bad, or ugly, if it's true, then that's what I want to portray.

Consider the nice, sweet portrait of the little girl in **FIGURE 1.6**. Like the young girls in my preceding story, she is well dressed and ready to pose for me. Compare that image with **FIGURE 1.7**, the last photo from her photo shoot. This photo was taken after she had changed her clothes to go home. She put on two skirts (because one is just *not* enough) and her Ugg boots, and then grabbed her mom's old purse (now hers) and her personal Ray-Bans. At this point she had already drooled a little sucker juice onto her tank top and was ready to leave.

But I've learned a very important lesson; I never put the camera away until my client has left the parking lot. I brought her back on set for one or two more quick shots and turned on the fan. This image hangs as a 60-foot canvas in my office to remind me to challenge myself and never stop looking for the 100% kid.

Never work with children or animals. —W.C. Fields

Brace Yourself

IF YOU'LL BE SPENDING YOUR DAYS photographing kids, you'll need to be part circus clown and part shrink. Taking time to get inside each child's head to understand them as an individual will make your job easier and your images more authentic.

This chapter gives you a format for getting the lowdown on each kid, while preparing you for some personality types you may encounter. You'll also learn how the age and stage of development of a child can affect how that child performs during your session and what to do about it.

ISO 100, 1/250 sec., f/10, 70–200mm

Laying the Groundwork

There's a good reason I don't shoot landscapes or still lifes; I need a subject I can form a relationship with. For me, the very best part of any photo shoot is the time I spend connecting with the kids. By acquiring some pertinent information about a child before that child ever walks into my studio, I can significantly increase the speed of that connection.

The best way I know to gather information on my subjects is by consulting with their parents prior to the photo session.

The Client Consult

A client consult is critical to the success of any shoot; in fact, I don't schedule a session without doing a consult first. Whether on the phone or in person, the client consult is the time I spend with the mom or dad getting the nitty-gritty on each kid I'll be photographing. I want to know what the kids are into, what they hate, and what their personalities are like. Because most of my kid sessions involve more than one child in the same family, I'll ask the parents to give me the rundown on each child and then clue me in on the relationship dynamics between the siblings.

The client consult breaks the ice and allows us to get to know each other a bit. Mom and dad need to determine if they like me well enough to pay me to photograph their kids. And I need to make sure the clients understand my style, how I work, and what I'll need from them during the shoot, so there are no surprises when it's time for our session.

I've created a client consult form that I use with all my clients, which is included in Appendix A. Besides names and ages of each child, I like to ask for specific details, such as:

- What are they into these days? (any obsessions?)
- Who's the girlie-girl (or tomboy)? Who's the athlete or the bookworm?
- Who's the brat?
- Who's the pleaser?

Address them directly and don't talk down to them. Ever.

- What do they want to be when they grow up?
- What is unique about each child?
- Which sibling does she get along with best/worst?
- Any physical characteristics that are unique or that you'd like highlighted?
- Hair, eye, skin color
- Is it OK to give them candy/treats?
- Do they have a favorite toy/blankie/object that is near and dear to them?
- What problems do you anticipate I will run into when working with this child?
- What is this child's best quality?
- Any unique quirks? (thumb sucking? hair twirling? silly expressions?)

Respect Goes a Long Way

Make it a point to treat kids with the same respect and consideration that you would extend to their parents. Address them directly and don't talk down to them. Ever. When my clients walk in the door with their children, I welcome the kids first. If appropriate, I either bend or kneel, look them straight in the eye, hold out my hand for a handshake, and say, "Hi *<name of child>*, it's nice to meet you." Some kids don't know what to do with that and some might be a little shy, but you'd be surprised at the number who walk up and shake my hand: They are *mine* for the shoot.

Connecting with kids before I pick up the camera allows the parents to actually enjoy the shoot. Rather than having to spend time micromanaging or threatening their kids to behave, the parents can sit back and watch the "show," enjoying their kid's antics and personality.

Kid Psych 101

Although every child is unique, you'll run into some common personality traits again and again. The key to a successful session is to find out what makes the kids tick and then tailor your interaction to their individual personality traits.

The Slow Warm-Up

The Slow Warm-Up likes to size up a situation before he commits himself. Cautious by nature, he doesn't like to be rushed. If you have a gregarious personality and come on too strongly too early with this kid, he'll go into lockdown. I've learned (the hard way) to let the Slow Warm-Up come to me rather than to try to coax him out.

Try speaking to one of his siblings first and refer back to the Slow Warm-Up along the way, piquing his interest in the conversation. For example, if the Slow Warm-Up's name is Hayden, you might say to Hayden's older brother, "So, does Hayden like video games?" Most younger kids can't stand to have their older sibling speak for them so they'll pipe right up and answer you, which starts the conversation between the two of you. If there isn't another sibling around, you can try this trick with the parent.

The little 18-month-old boy in **FIGURE 2.1** was a very shy Slow Warm-Up. He didn't want anything to do with me, so I began by photographing his older sister. Once I had a few frames of her, I made a big deal of showing her the results on my camera's LCD. The Slow Warm-Up became interested and wanted to see what we were doing. Between me and his big sister, we convinced him to get in a few shots so he could see himself in my camera.

The resulting shots of her convincing him to cooperate highlight their relationship at this stage in their development.

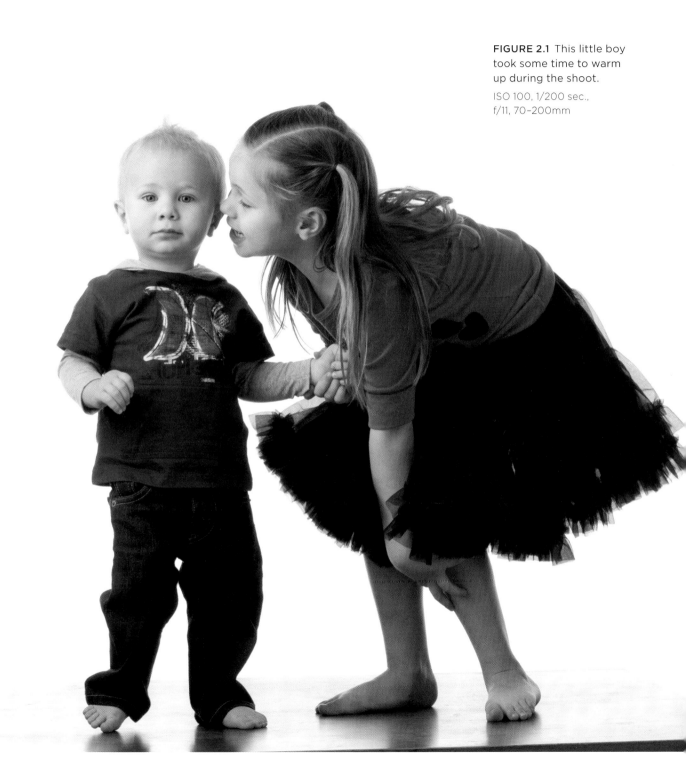

FIGURE 2.1 This little boy took some time to warm up during the shoot.

ISO 100, 1/200 sec., f/11, 70–200mm

The Sassy Pants

FIGURE 2.2 Putting the
Sassy Pants "in charge"
of her parents played
to her bossy nature
(opposite page).

ISO 100, 1/200 sec.,
f/11, 70–200mm

Also known as the Bossy Cow, the Sassy Pants has a personality that
is large and in charge. She's going tell you how to do it, and if you're
not careful, she'll be calling all the shots. This personality type can be
very bossy with younger siblings, and everyone else for that matter.
Although it seems as though she wants everything on her own terms,
what she really wants is for you to like and approve of her, thus the big
performance.

Get the Sassy Pants on your side early in the shoot. Pull her aside and,
confidentially, put her in charge of something. For example, you could
say something like, "I need your help; can you make sure that all the
shoes are lined up over there?" The phrase "I need your help" is crucial to
getting bossy kids on your side. It feeds into their need to be in charge of
something and their need to please the *actual* person in charge (you!).

The little girl in **FIGURE 2.2** was a very charming Sassy Pants. Super smart
and running rings around all of us, she had big plans. I put her in charge
of her parents during the shoot, which she loved. All I needed to say to
her was, "I need you to be in charge of your mom and dad. Don't let them
get off those chairs or they are going to be in trouble!" Her reaction to
being assigned as the disciplinarian brought new energy to the session.

The Difficult Child

When I'm consulting with clients and we're reviewing the list of the kids,
they sometimes pause and say something like, "And then there's Jack.
Jack is, well, a little high spirited," or some other euphemism that means
the kid is basically a nightmare to deal with (**FIGURE 2.3**). Many photogra-
phers develop ulcers at the thought of dealing with this type of child.

Difficult kids (even some babies) sense that you need something from
them, and they are determined *not* to give it to you. The Difficult Child
may run away from you, make crazy faces, or burst into tears at the
slightest provocation. You coax and cajole, and parents threaten, but still
it's a no-go with this type of kid.

The phrase 'I need your help' is crucial to getting bossy kids on your side.

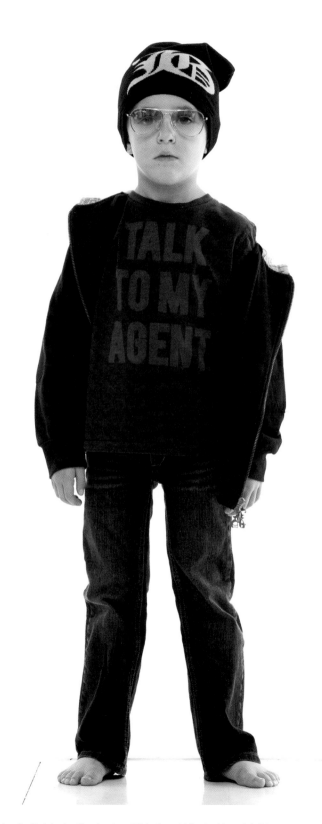

FIGURE 2.3 The shirt says it all. The Difficult Child is not interested in doing it your way.

ISO 100, 1/200 sec., f/11, 70-200mm

The dynamic turns into a tug-of-war. When you find yourself on one side of a tug-of-war, it's time to "put down the rope." Try these four magic words that will instantly slacken the rope and relieve the tension: "You don't have to."

Of course, this might seem crazy because although they may not *have* to cooperate, you *do* have to get the shot. Trust me; saying those four words will ease the pressure in the moment and give you some space to problem solve how you can best gain the child's cooperation.

The six-year-old girl in **FIGURE 2.4** was part of a larger group of grandkids being photographed with their grandparents. She was *not* happy about the whole situation, and as I was getting started, out of nowhere, she burst into tears.

Immediately, I put down the camera and asked, "What's wrong Avery?" She screamed (with tears and snot streaming down her reddened face), "I hate taking pictures!" Before Grandma and Mom could start coaxing her into complying, I said, "It's OK, you don't have to." Everyone looked at me like I was crazy. I "put down the rope" and let her sit with that thought for a second. Then I asked her to come over to me so I could tell her a secret, but I didn't want anyone else to hear it. Intrigued, yet wary, she approached. (The Difficult Kid can smell manipulation a mile away.) I whispered in her ear, "Wouldn't it be funny if after we're done taking pictures, I pretend to get a picture of Grandpa and you together? But when I say 'now,' you spank his bum and I'll snap a picture of him saying, 'Ouch!'" She started to giggle and agreed that would be a good idea. To confirm the arrangement, I whispered, "OK, so can we just take a few pictures and then we'll spank Grandpa? But it's our secret; don't tell anyone!" This gave us a secret pact that no one else knew about; she felt like the privileged insider and cooperated like a pro for the entire 90-minute shoot. Of course, she got her reward in the end—and so did Grandpa!

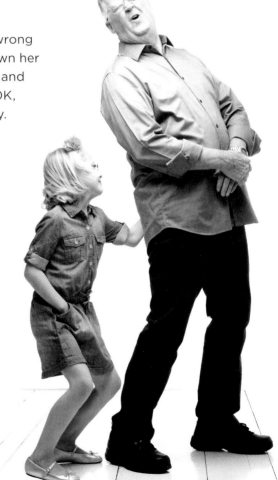

FIGURE 2.4 A potential meltdown was avoided by conspiring against Grandpa.

ISO 100, 1/200 sec., f/11, 70–200mm

Rather than trying to squelch The Poser, let her go for it and see what happens.

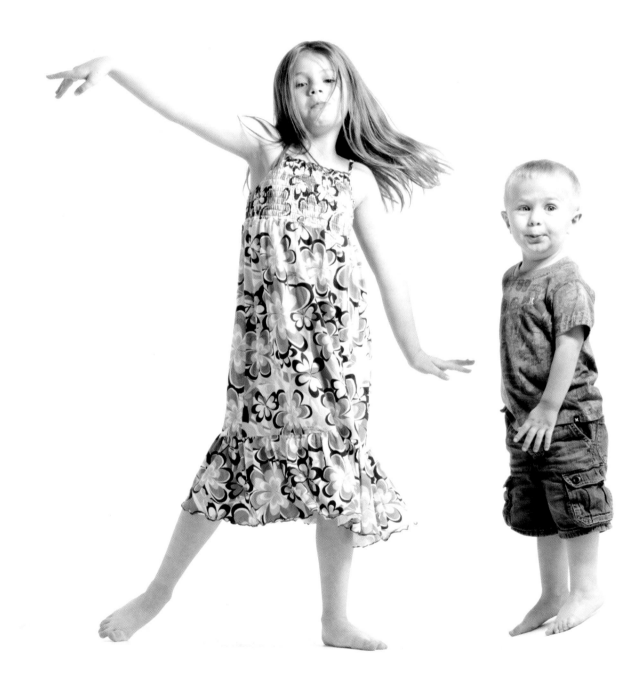

The Poser

The Poser is usually, but not always, a girl. She might be in dance classes and have been trained in all kinds of crazy poses by dance photographers. Rather than trying to squelch The Poser, let her go for it and see what happens. Tell her that every time the flash goes off she needs to come up with a new pose. This challenges her posing skills, and hilarity can result.

The older sister Poser in **FIGURE 2.5** was one of my more animated subjects. She was in a constant state of flow, but her little brother was not always on board. I let her do her thing to her heart's content, knowing that the results would be entertaining. The contrast between the two shows off their personalities and makes me laugh.

The Wild Card

The Wild Card never sits still. He's constantly making faces or torturing his siblings. Disruption is his game, and he doesn't know when to quit.

The Wild Card looks for attention, and he'll take it however he can get it. I love to photograph these types of kids because they introduce an unpredictable element that keeps the shoot from becoming too posed. That doesn't mean they can't be annoying. If you keep your higher purpose in mind, you can put up with almost anything to get a great shot.

The best approach for dealing with the Wild Cards of the world is to "dangle the carrot." Broker a deal that includes an end-of-the-shoot-jumping-karate fest or whatever they are dying to try in front of your camera, with the stipulation that they have to give you a few shots that you want first. Deal? If they can't wait until the end, get a couple of shots for you and then let them do their thing. Then switch back and forth between your idea and their action shots. The back-and-forth method works best for younger kids who can't delay gratification as easily as the older ones.

The little boy in **FIGURE 2.6** kept complaining that he was "girl trapped" between his sister and cousins. Allowing him to act like a lead singer while the girls played backup put his personality front and center.

FIGURE 2.5 This Poser was on an imaginary catwalk; little brother had other ideas (opposite page).
ISO 100, 1/200 sec., f/11, 70-200mm

The best approach for dealing Wild Cards is to 'dangle the carrot.'

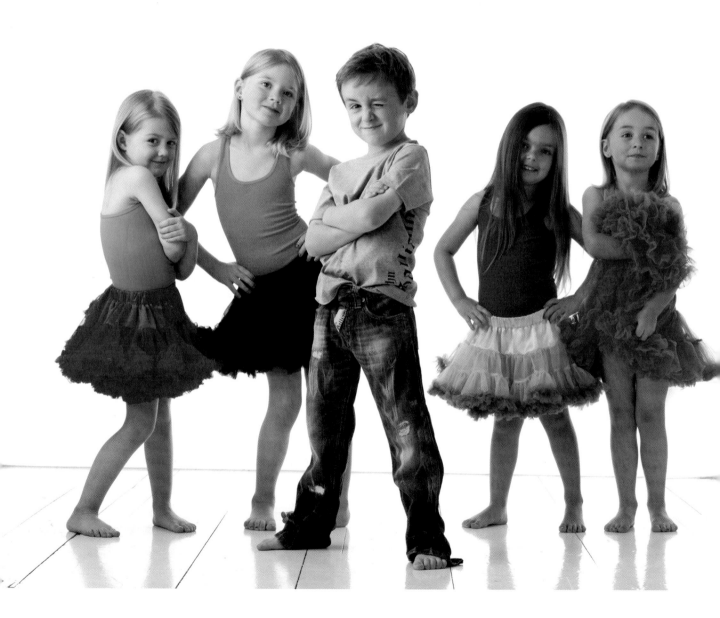

It's a Phase

Some kid quirks are developmental: Newborns are sleepy, three-year-olds are stubborn, and ten-year-olds are easy and sweet. Recognizing the developmental stage a child is in can arm you with understanding and patience, and help you maintain the upper hand during a shoot.

Newborns

Entire books have been dedicated to photographing newborns. This sub-specialty of photography is for the patient, sweet baby whisperers of the world—not really my thing. However, give me a cranky older sibling to photograph *with* that newborn, and I'm all yours. Capturing the fascination of older siblings with this new little alien that has upset their world is much more interesting to me than baby alone. Sometimes the older kids aren't really all that fascinated, so they need a little help.

FIGURE 2.6 Pulling this Wild Card from the background to act like the lead singer brought out his inner rock star (opposite page).

ISO 100, 1/200 sec., f/11, 70-200mm

Items to Have on Hand for Newborns

Newborn sessions require patience and some extra supplies:

- **Lightweight clothing for you.** You'll want to keep the room very warm for newborn babies, especially if you're photographing them without clothing, so dress accordingly.

- **Paper towels and Clorox Clean-Up.** Accidents *will* happen, so be prepared for sanitary clean up.

- **Plain white swaddling blankets.** These stretchy, textured blankets are perfect for making a baby burrito for an older sibling to hold.

- **Extra everything.** Let mom know to bring five times the diapers and wipes she thinks she'll need plus extra onesies, and formula if she's not breastfeeding.

- **Hand sanitizer.** Use this for you and your assistant or anyone else who touches the baby. Mom will appreciate this extra attention to detail.

- **Smarties candies or Cheerios.** Use these to hide on the baby's person for interested older-sibling shots.

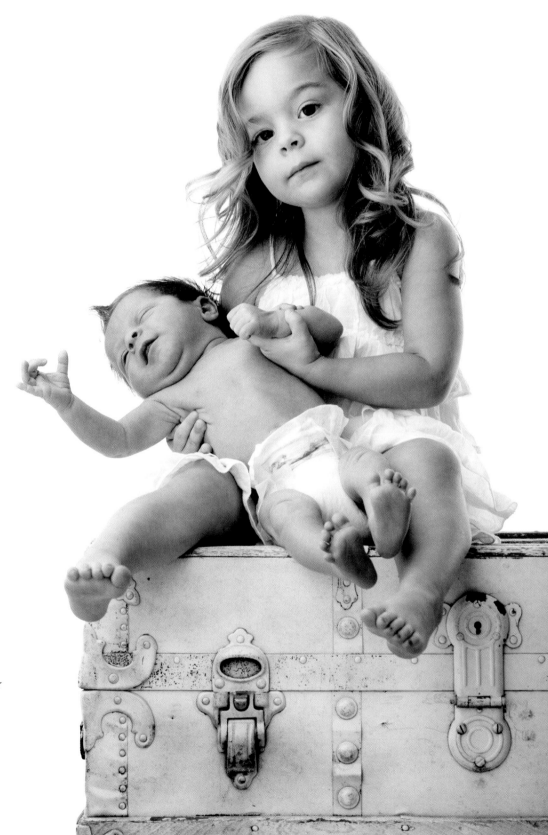

FIGURE 2.7 This older sister regards the camera with a "What am I supposed to do with this?" look.

ISO 100, 1/200 sec., f/11, 70–200mm

For a photo of older sister and baby brother we once tucked a Smarties candy behind the baby's ear and asked the sister to try to find it. The manhandled cranium is shades of things to come.

When I'm photographing an older sibling with a newborn, I like to get the older sibling on my side by highlighting the differences between how *big* the older brother/sister is and how the baby is just "little" and can't really do anything. I'll sometimes start out by asking, "Is that your baby? She's just little. She can't run or jump like you can she? You are so big. I'll bet you're a big helper." Comments of how big and responsible they are work well for older siblings in the three-to-four-year-old range (**FIGURE 2.7**).

Tip: A calm mother makes for a calm baby. Reassure new moms that the shoot will take at least two hours but not to worry; you'll be working around baby's schedule for changing and feeding.

Babies Six Months–One Year

At six to eight months, babies begin to sit by themselves. At this stage most babies reach maximum fatness. They have chubby little cheeks (top *and* bottom) and arms that look like the Michelin Man. Pure deliciousness. Most babies have a short window of happy baby time, so don't use up their good will by stressing them out with multiple clothing changes. Choose one outfit and transition into no outfit (nakie). When the baby's happy, everyone's happy!

Items to Have on Hand for Babies

A few essential items to have handy while shooting babies include:

- **The Bumbo.** This is great for babies who aren't quite sitting up yet. It's perfect for getting good facial expression shots and shots of baby discovering his toes.

- **Sturdy little chair.** For babies who are pulling up to stand before they are walking, have a sturdy (heavy) child-sized chair for them to pull up on and stand next to.

- **Snacks.** An extra bottle, sippy cup, and finger foods are ideal. Don't even think of photographing a kid who's hungry.

- **First birthday cakes.** I prefer a small-sized cake with white buttercream frosting (not fondant). The small size is a perfect scale for babies to get their hands on, and the buttercream frosting smears all over the place (in a good way), whereas the fondant pulls off in pieces and looks weird.

FIGURE 2.8 The Bumbo is a great posing tool for babies who aren't yet sitting on their own (right).
ISO 100, 1/200 sec., f/11, 70–200mm

FIGURE 2.9 Twin boys share their birthday cake with the first "child" of the family (opposite page).
ISO 100, 1/200 sec., f/11, 70–200mm

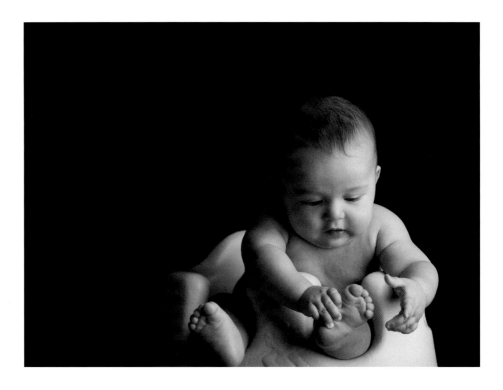

Tip: Don't let babies get to the point of no return: If the baby starts to get stressed out with a particular setup, stop and regroup before the child completely loses it. Mom will appreciate your sensitivity, and the shoot will go more smoothly if you take little breaks during the shoot.

If you've scheduled a shoot for a baby who isn't quite steady sitting on his own, a Bumbo is a wonderful tool to have (**FIGURE 2.8**). This baby "sitter" helps the baby to sit up without having to be held up and allows you to capture sweet slobbery smiles. And it may help your subject discover something new, like his toes.

A child's first birthday is a big milestone to document and, for many families, the last time they will be comfortable having their child photographed without clothes. Adding a cake smash at the end of the shoot is fun to do for the expressions you can capture and the experience. But remember to keep your camera up, because other family members may want in on the action (**FIGURE 2.9**).

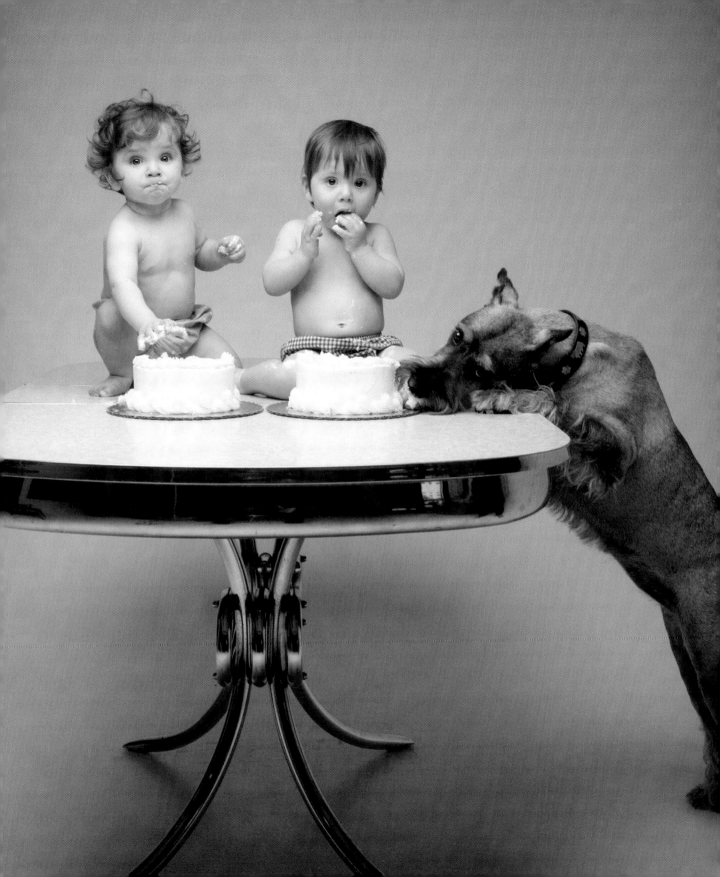

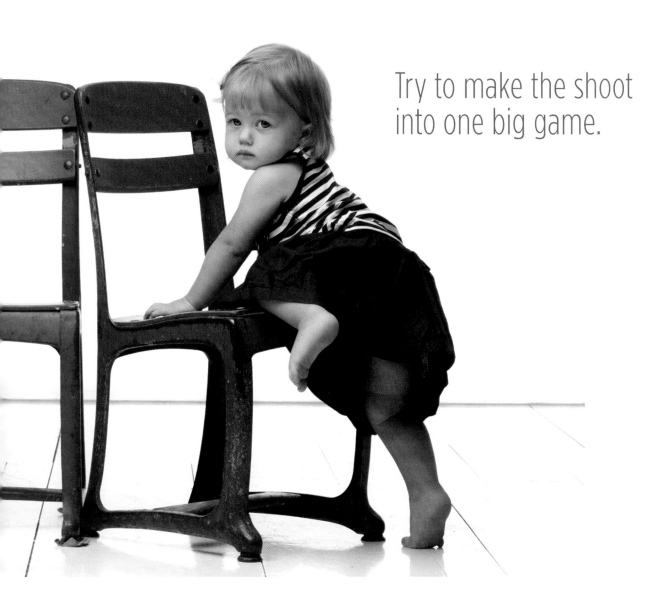

Try to make the shoot into one big game.

FIGURE 2.10 Toddlers will either try to climb on a chair or move it out of your shot (or both).

ISO 100, 1/200 sec., f/11, 70–200mm

Toddlers 18 Months–3 Years

Speed is the name of the toddler game. Forget about posing at this age; it's all run and gun. You'll need to be a master at distraction and redirection because the toddler requires the most tricks of any age group to get the shot you want. I never sweat more during a shoot than when there's a toddler to be photographed.

Getting toddlers up off the floor is your only hope in maintaining some control. A sturdy chair, trunk, or platform about 18 inches off the floor will give most toddlers pause before they try to climb off it. It will also give you a few seconds to get a shot.

Little chairs can be used as well, but keep in mind that toddlers love to pick up and move chairs; still, this gives you some time to get an image or two before they take off (**FIGURE 2.10**).

Try to make the shoot into one big game, and don't be afraid to make a complete fool out of yourself. Enlist mom or dad's help to blow bubbles, throw balls, and stand behind the camera making funny faces—whatever it takes to get the shot.

Tip: I encourage my clients to avoid getting hung up on "outfits" for babies or toddlers. There is nothing cuter in this world than the bare skin and chub of a baby, so I keep the clothing to a minimum (or none at all).

Tip: You may want to ask parents to carry their toddlers into the shoot and not put them down. Once their feet hit the floor, they'll be gone.

Items to Have on Hand for Toddlers

Toddlers require every trick in the book to get their cooperation. Here are a few essential items you should have at the ready:

- **Bubbles.** I haven't met a baby or toddler yet who didn't *love* bubbles. I always have two bubble guns on hand, in case one breaks, and a full gallon of refill bubbles.

- **Clean snacks.** Cheerios are the best, cleanest snack to give toddlers. They don't take long to eat, they don't have coloring that will show in the child's mouth or on clothes, and they aren't very messy. Ration them out one at a time as needed.

- **Stickers.** Buy a sheet of those little stickers that teachers use for charts in their classrooms. They are very small and perfect to put on a toddler's tummy or somewhere you'd like them to look and investigate for a cute shot of their profile.

- **Parental guidance.** Enlist the parents to help get the child's attention. Have them pop up from directly behind you or from behind your light, depending on where you want the child to look. If both parents are at the shoot, they can send the toddler running from one to the other for some great action shots.

Preschoolers
Three–Four Years

If you think two-year-olds are hard to handle, just spend time trying to photograph a three-year-old. The saving grace is that using reverse psychology almost always works with kids this age. Throw out a statement like, "Oh, I forgot; you're too little to sit up in the chair for me," and then watch them jump up on the chair. Or, you can say, "Oh ya, your mom said you didn't like candy." Of course, they will violently disagree and state that they do, in fact, *love* candy, at which point you can negotiate the terms of how they can obtain said candy. When kids are close to turning four, they are much easier to deal with, and reason can prevail.

Preschoolers want to be *big*, especially if they have older siblings. Let them make some of the decisions during the shoot. Do they want to sit in the chair first or would they rather stand on the box? It might seem like a small thing but feeling that they have some options helps them to stay engaged longer.

During the client consult, I often recommend that moms let their preschoolers bring in a favorite toy/blankie/object (**FIGURE 2.11**) that represents where they are at this stage in their life. It gives them something familiar to interact with and has integrity as a prop in the final image.

I'm not above a little bribery, so I keep a well-stocked candy jar and what I call the *treasure suitcase* filled with mini cans of Play-Doh, bouncy balls, bracelets, parachute guys, and other interesting toys. I'll mention the treasure chest when I catch the kids doing something good and say, "Wow, you are doing such a great job; you might get to pick two prizes from the treasure suitcase!"

Items to Have on Hand for Preschoolers

It's never too early to begin bribing children. Here are a few items I find essential for gaining cooperation:

- **Child's favorite toy, blankie, or object of affection.** Finding a way to incorporate one of these best-loved objects into the shoot gives the child something to do and something to share with you, increasing your opportunities to connect.

- **Smarties candy or Cheerios.** Use clean treats and snacks to bribe and reward preschoolers when necessary.

- **The treasure suitcase.** I use a small vintage suitcase stocked with small party-favor-sized toys. Sometimes I'll tell the kids before the shoot starts that if I get the photos I want, they'll get to pick a toy (or two or three). The number of toys they can pick is negotiable depending on how they are cooperating.

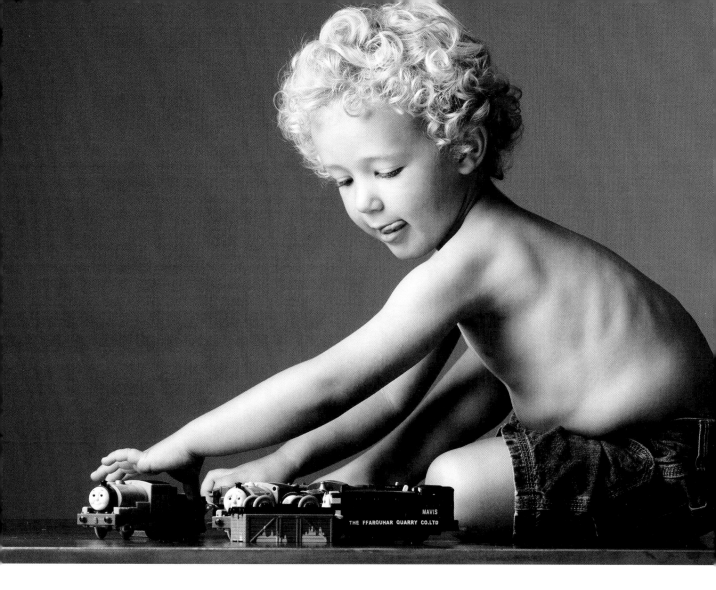

School-Age Kids Five–Ten Years

School-age kids are at the easiest stage to photograph because they are used to taking orders from adults who aren't their parents. You can be more creative and take more chances with your lighting, posing, and concepts with children of this age. You can worry less about getting *any* shot and take more time to pursue *the* shot.

This is the age at which I engage in direct connection with the kids before the day of the shoot. Once I've booked the session with the mom and I know a child in the house is old enough to read, I mail the kids of

FIGURE 2.11 This three-year-old boy was all about his Thomas the Tank trains.

ISO 100, 1/200 sec., f/8, 70–200mm

the family a secret word puzzle. I use one of those blank puzzles that you can write on and jot down a secret word on it. Then I break it into an envelope and add a note telling the kids to put the puzzle together to discover the secret word. When they come in for their photo shoot, they can tell me the word and they'll get to choose a prize from the treasure suitcase when the shoot is done. Kids I've never met will burst in the door just dying to tell me the secret word, and parents love that I've taken the time to motivate the kids about the shoot.

Kids at these ages are old enough to include in the creative process. I suggest to the moms to get their children's input on what they'd like to bring to the shoot. Most common are sports uniforms and balls (**FIGURE 2.12**), favorite books for the bookworms, favorite outfits and shoes, or whatever the kids are obsessed with that can give them some input into what we are creating together.

During this phase, many children will go through certain religious rites of passage, such as baptisms or First Communion (**FIGURE 2.13**). Don't let these important events go by undocumented.

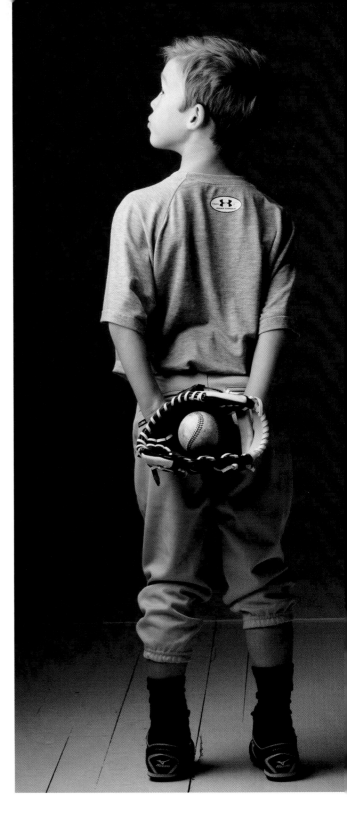

FIGURE 2.12 Dreaming of the day when he goes pro (right).

ISO 100, 1/200 sec., f/8, 70–200mm

FIGURE 2.13 Pretty and sweet for First Communion, but you still see the sly little smile of the sassy girl (opposite page, far right).

ISO 100, 1/200 sec., f/8, 70–200mm

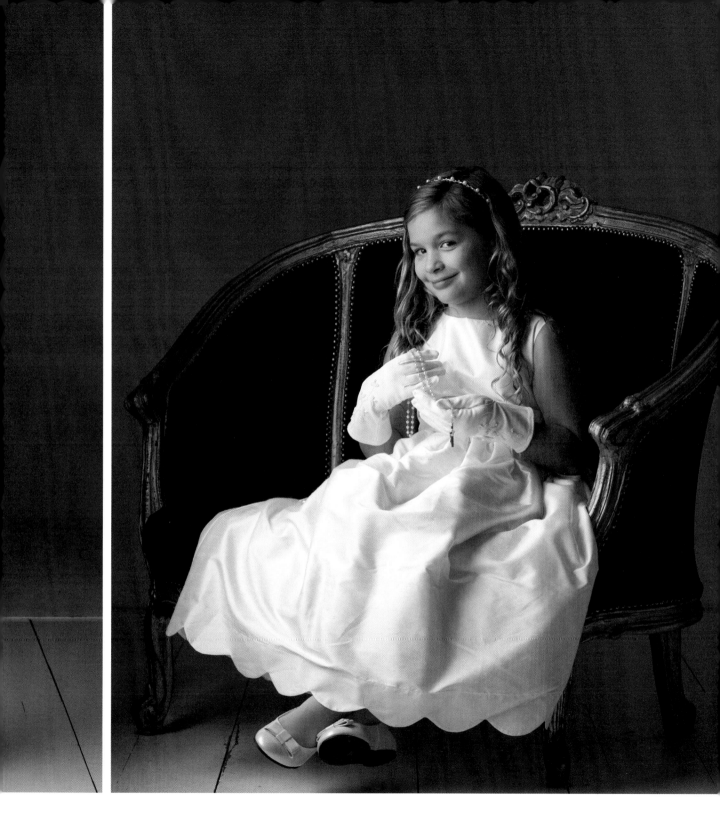

School-age kids are the easiest age to photograph, but they aren't necessarily hygienic. Here are a few grooming essentials I stock for this age:

- **Hair accessories.** Make sure you have a brush, comb, and some hair spray and gel for the inevitable occasions when mom forgets.

- **Hand/body lotion.** Kids of this age aren't usually into moisturizing, but girls in dresses or shorts look much better if their legs have lotion on them.

- **Single-use toothbrushes.** Moms have enough going on to get their kids dressed and in the car. It's a good idea to have these toothbrushes on hand to avoid any grungy teeth. It's pretty difficult to retouch yellow, yucky teeth in postproduction.

- **The bubblegum jar.** I have a huge jar of extra-large gumballs in my studio, and everyone, including older kids (and their parents), loves them. I definitely wait until the end of the shoot to offer these goodies because they will color the kids' mouths. Note that gumballs can be a choking hazard for younger kids, so always ask mom before handing out treats.

Tweens 11–13 Years

Tip: Girls between 11 and 13 want to look older and more sophisticated than they are, but remember, mom will love the photos that show the little kid still inside.

The tween years aren't called the awkward phase for nothing. A combination of feet and hands that are too big for their bodies, braces on their teeth, and the puppy fat that can be a precursor to puberty can turn the tween years into a self-conscious ordeal. Perhaps that's the reason this phase of childhood is the most neglected photographically. But it's too bad because tweens are so much fun to photograph. They are excited at the prospect of getting their picture taken, and they haven't entered the "I'm so bored with it all" phase of the middle teens.

Have tweens bring as much stuff as they want to the shoot and then work with them to decide how they'd like to be photographed. A great photo shoot experience at this stage can give girls new confidence in themselves (**FIGURE 2.14**).

Boys are usually less enthusiastic to begin with, but give them a skateboard or something physical to do and they'll turn up the energy (**FIGURE 2.15**).

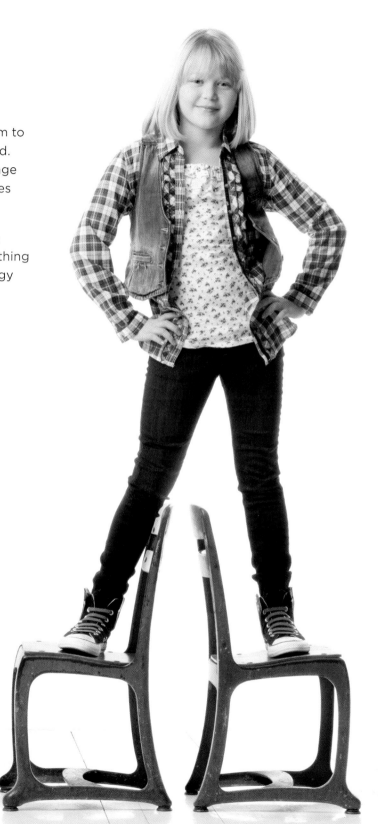

FIGURE 2.14 This tween-age girl rocks her new outfit with confidence.

ISO 100, 1/200 sec., f/11, 70-200mm

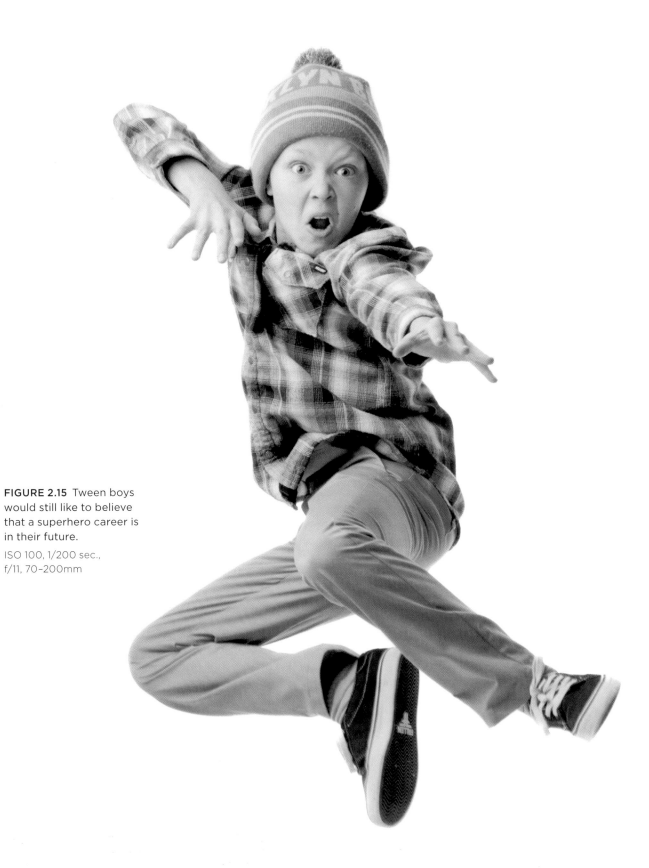

FIGURE 2.15 Tween boys would still like to believe that a superhero career is in their future.

ISO 100, 1/200 sec., f/11, 70–200mm

Boys

Boys see themselves as part explorer, part superhero. They love their bodies and are pretty sure they could be pro athletes at any time. The most important detail to know about photographing boys is that they don't want to look like girls. They want to look cool, manly, and tough (**FIGURE 2.16**).

Action shots are big with boys, but once they've started jumping around it's difficult to settle them back down, so start with Dirty Harry (strong, silent, and masculine) and end with Jackie Chan (jumping through the air like a maniac).

FIGURE 2.16 Ever enamored of their gorgeous bods, these boys didn't take much convincing to give us a "gun show."

ISO 100, 1/200 sec., f/8, 70–200mm

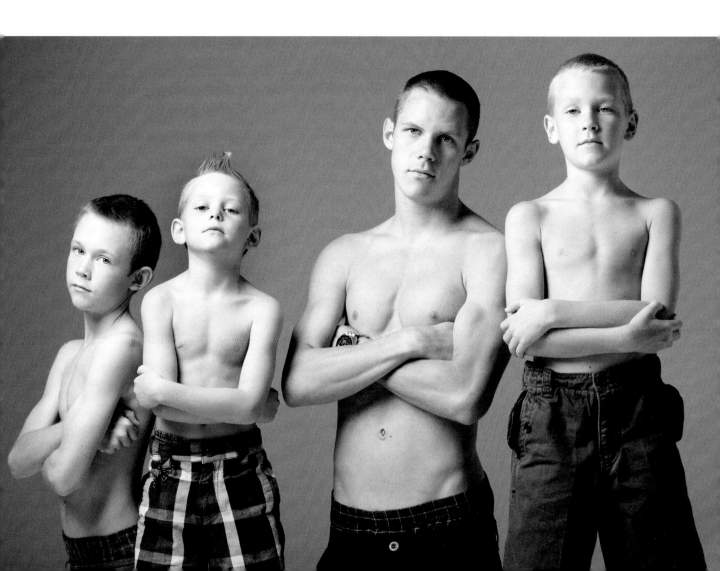

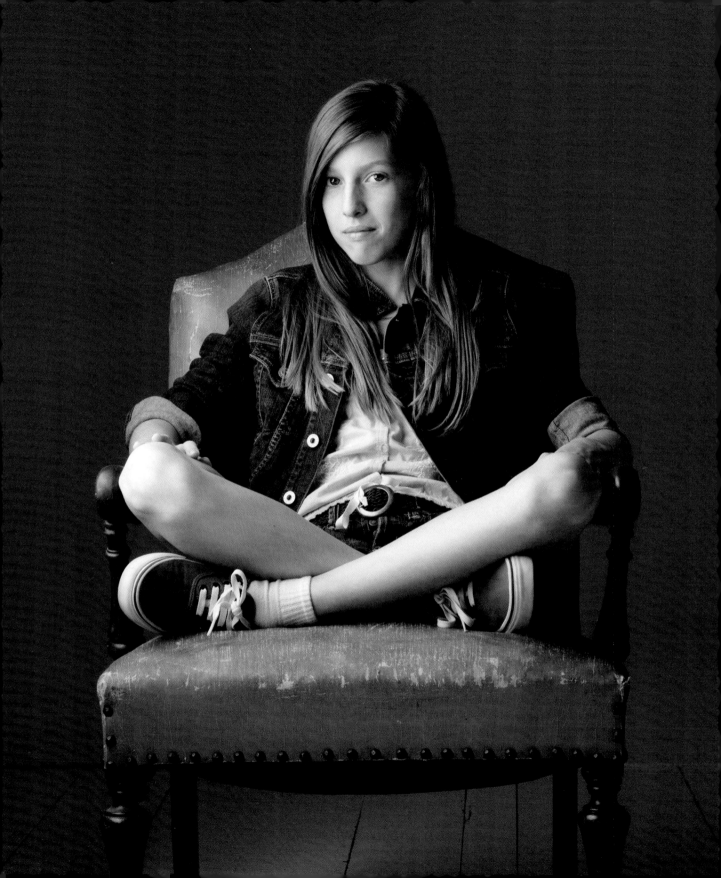

Girls

No matter how old they are, most girls are all about a photo shoot. They love the entire process of dressing up and selecting outfits and poses; it's dress-up on a larger scale.

As a photographer, you can have a profound influence on building the self-esteem of the girls you photograph. Take the time to notice the details of their clothing, hair, nails, and so on. Compliment them as you notice them doing something great, whether it's a cute look or pose. Girls want to be seen as pretty, even the tomboys (**FIGURE 2.17**). Your encouragement during the shoot will give them the experience of feeling like a supermodel.

Tip: Sometimes even little girls will bust out some pretty sexy moves, so try to redirect them into something more age appropriate. Mom and Dad will be grateful.

Siblings—The Pecking Order

Photographing one kid at a time is relatively easy; it's when you have a whole pack of siblings together that you really have to put on your psychologist's hat and determine which family dynamics will make or break your shot (**FIGURE 2.18**). Birth order plays a large role in how siblings interact with each other, and although they might seem like oversimplifications, I've successfully used the tactics described in the following sections time and again when photographing siblings together.

The Oldest Child: CEO of the Family

Oldest kids are the CEOs of the sibling pack. They are used to delegating to the younger kids and prefer to be the top dog at all times.

Benefits. Oldest kids are usually obedient and ready to comply with whatever is asked of them. They consider themselves adults and are motivated by adult approval.

Challenges. Oldest kids are the most worried about how they look; their need to be seen as competent can cause them to appear nervous and stiff in photos. Your main job with oldest children will be getting them to have fun and loosen up (and quit bossing their younger siblings around).

FIGURE 2.17 Not a girlie-girl, this young lady exudes a quiet confidence (opposite page).

ISO 100, 1/200 sec., f/11, 70–200mm

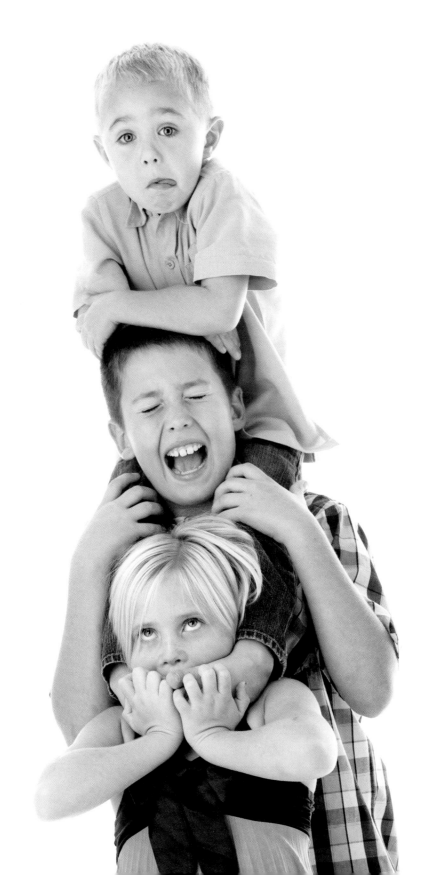

You really have to put on your psychologist's hat.

Don't make the mistake of putting the oldest children in charge of their younger siblings. This scenario plays out every day in their real lives, so replaying it in the shoot usually backfires because the younger kids are sick of being manhandled by big sister.

The most common problem when you're photographing siblings at younger ages is the older kid trying to control the younger, which starts a negative chain reaction of coercion and rebellion. Nip it in the bud early by giving specific directions. Rather than saying, "Give your brother a hug." I'll ask them to, "Put your hand behind your brother and lean on your hand." This gets them close enough to each other without too much contact.

The Middle Child: The Attorney

Middle kids can be easygoing and mellow or the catalyst for all kinds of misbehavior. It's a crapshoot. I've found that if the oldest child is dialed in and obedient, number two children are typically naughty, especially if they are the same sex. Knowing this information ahead of time will help you plot your approach.

Benefits. Middle kids are usually more confident than their older siblings. They tend to be more comfortable in their own skin and don't care as much about what others think. They aren't the oldest or the baby, so they aren't under any illusions that it's all about them.

Challenges. Middle kids have a finely tuned sense of injustice. "It's not fair!" is most often heard coming from a middle child's mouth, so beware of any favors or treats promised. You'll have to keep them equal for everyone or the attorney-in-training middle kid will let you know. Middle

FIGURE 2.18 Sibling dynamics can create great energy during a shoot (opposite page).

ISO 100, 1/200 sec., f/8, 70–200mm

kids can also be major attention seekers; either negative or positive attention will do. If acting up and stirring the pot will put them in the spotlight for a minute, they'll go for it (**FIGURE 2.19**).

When it comes time to pose the siblings together, I'll make a big deal about bringing the middle child in first and then the oldest, leaving the youngest to be popped in at the last possible second before we shoot. Posing kids in this order makes the middle kid feel special. Middle children *never* get to go first. They are used to either the oldest dominating or the baby being catered to in every situation. Giving middle children a little love will make major points and gain their cooperation quickly.

The Youngest Child: The Baby

The pet of the family, the youngest child, may be the silly comedian or the overindulged baby. Sometimes, the youngest children are a combination of both.

Benefits. The youngest children are used to performing all their tricks to an approving audience, so they can be ideal subjects. Youngest kids look to their older siblings for cues and will usually follow along with whatever the group is doing.

FIGURE 2.19 Middle kid's antics can bring an element of the unexpected to a shoot.

ISO 100, 1/200 sec., f/16, 70–200mm

The key to successful parent interaction is to manage expectations.

Tip: When you're photographing each kid individually, photograph in reverse age order. Let the youngest kid go first for two reasons: The child feels special, and you're done with the youngest, least mature kid first.

Tip: For more information on the psychology of birth order, check out the classic, *The Birth Order Book*, by Dr. Kevin Lehman (Revell, 1985).

FIGURE 2.20 The baby of the family is used to getting her way (opposite page).

ISO 100, 1/200 sec., f/8, 70-200mm

Challenges. Babies of the family are used to having their way, and they know that nothing proceeds until they are on board, which can result in a holdup of the entire shoot if the youngest is in power-play mode. Youngest kids are usually the most tied in to the parents. They know they can squawk and mom will make the older kids bend to the baby's will (**FIGURE 2.20**).

For families with younger kids, I usually let mom handle the youngest while I'm working with the older kids. I'll get everything set and then pop the baby in at the last minute. For older-aged kids, I'll still get all the "big kids" set and then act like I forgot the youngest with a comment like, "Hmmm, who are we missing here?" Eager to not be left out, the youngest is usually ready to jump in and be part of the group.

Parental Units

The key to successful parent interaction is to manage expectations. Set the tone of the shoot ahead of time in the client consult (mentioned earlier). During the consult you let the parents know how you work, what they can expect, and what you need from them to make the shoot a success. (You'll find more specifics about working with parents during the shoot in Chapter 10.)

The most important thing to tell every parent is "no threats": Caution parents against threatening or bribing the kids ahead of time to "be good" during the shoot because this puts the photo shoot in the same category as going to the dentist. Instead, encourage them to say things like, "We're going to Miss Allison's studio to have fun, play, and take some pictures (**FIGURE 2.21**). Afterward, we'll go get a treat!"

Common Mistakes When Photographing Kids

Any mother knows that kids are not mini-adults. They are creatures unto themselves, and photographing them requires a specific skill set that has nothing to do with camera gear. As the mother of seven kids, you'd think I'd have this kid thing figured out. Not so much. The following list describes lessons I've learned the hard way:

1. **Not ready to go.** Kids are a ticking time bomb from the second they walk in the door. They won't wait for you to set up your gear and test it. You should have everything pre-tested and ready to shoot the minute they arrive.

2. **Not taking control.** Taking charge of everything that happens on your set, regardless of where that set is located, is the mark of a professional. It is your job to create amazing images of your client's children. You must call the shots in order to make that happen. Establish this expectation in the client consult.

3. **Taking too much control.** You need to be in control, but you also have to go with the flow of what's happening at the moment. If you are stuck on a certain pose or getting frustrated because the kid isn't performing to your expectations, take a deep breath and look for what *is* in front of you rather than what isn't. Don't stay with the same setup for too long; if it's not working, move on.

4. **Trying too hard.** Kids can smell a phony a mile away, and if you come on too strong too soon, you'll turn them off. Treat them as you would any adult. You wouldn't talk in a patronizing or syrupy sweet voice to a peer, so don't use that tone with kids either.

5. **Not being in the moment.** Worrying more about the shot you have in your mind than the shot right in front of you is a sure path to frustration. The beauty of children is that they live in the moment. Let their energy and personality take you on a journey; you might be surprised where you end up.

6. **Not being true to the kid.** Some kids are natural smilers; others have a more somber countenance. If you ask your subjects to do something

FIGURE 2.21 Caution parents against threats and bribes. This communicates to the kids that the photo shoot is not going to be a fun time.

ISO 100, 1/200 sec., f/11, 70–200mm

and they really don't want to do it, move on to something else. Don't try to force something that's not natural for that child because it won't ring true in the final image.

7. **Too amped too soon.** Remember to start with the calmer, more posed shots and work up to the crazy. Once you enter into the three-ring-circus stage, there's no pulling it back to a place of calm. You have been warned.

8. **Not rescheduling when the kid is sick.** Sick kids can't perform well, and even if you manage to capture some decent images, the mom will look at the photos and say things like, "Oh, that's so sad. Look at him. I can tell he's sick. He just doesn't look like himself." Reschedule. Reschedule. Reschedule.

9. **Not doing a client consult.** I've heard every excuse in the book for why photographers don't do a consult, and none of them is valid. Take the time to get the lowdown on the kids, and let the parents know how you work. By doing so, you'll eliminate about 80 percent of the problems you run into during a shoot (and after). Do it.

10. **"Smile!"** Seriously? Don't say it. Ever.

Everyone has a point of view. Some people call it style. When you trust your point of view, that's when you start taking pictures. —Annie Leibovitz

Developing Your Style

YOUR CLIENTS ARE more visually sophisticated than any other consumers in history. Commercials, magazine editorials, and the array of images on the Internet have influenced how they expect to see their children in photographs. Some clients may even own the same camera that you use. Others might dabble in Photoshop. It seems everyone has a photography business on the side these days. You might consider quitting photography before you even start. How can you possibly set yourself apart? The only way is by developing your unique style.

In this chapter you'll learn how to cultivate your style by improving your critical eye, defining what attracts you, identifying your influences, finding your muses, and staying inspired.

ISO 100, 1/200 sec., f/11, 70–200mm lens

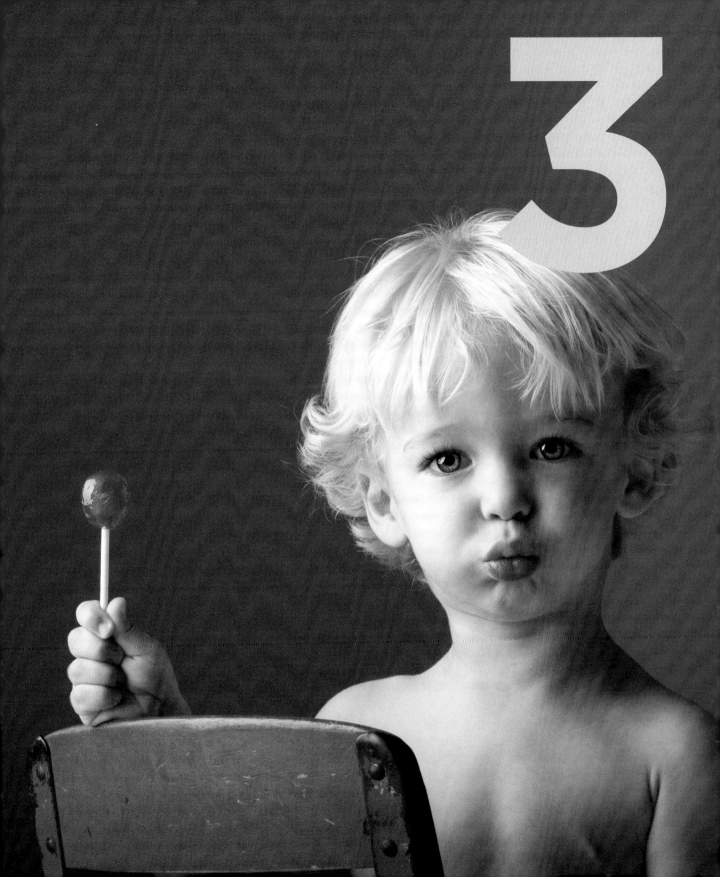

3

It's Been Done

When it comes to photography (or painting or sculpture, or any other art), there's nothing new. It's all been done before, and that is both frustrating and freeing at the same time. It's frustrating when you come up with this great new concept, and before you have a chance to shoot it, you see someone pinning the same idea on Pinterest. It's freeing because, although it's all been done before, it hasn't been done by *you*, and *you* are the X factor—the element that no one else can duplicate. Your eye, your vision, your ability to interact with your subject, and your choice of lighting and setting are all ingredients in the creative stew of your next photography project.

You simply cannot afford to waste time comparing yourself to anyone else. Keep in mind that Picasso used the same tools that were available to everyone else. He didn't buy a book on *How to Paint Like Picasso*. He used the available tools and with his unique vision created something new. So how do you find your unique vision? Let's explore the elements that will help you develop your style.

Your Critical Eye

Pay attention to photographers whose work you admire and whose images are a source of inspiration to you. What is it, specifically, that you are drawn to? What is their subject matter of choice? How do they use light? How do they employ the use of color or the lack of color? What angles or perspective do they shoot from, and how does that change how you view the subject? What do you feel when you look at their work?

Carefully analyzing what you respond to, positively or negatively, in another artist's work helps develop your critical eye. Over time, your critical eye will become an increasingly refined lens through which you will view your own work. Rather than being discouraged by the difference between your work and that of your heroes, you'll be able to see what they do and be inspired by why they do it. You can then incorporate those techniques into your own work and evaluate whether they work for

Pay attention to photographers whose work you admire.

your style. When I experiment with a new technique, it never works out the way I think it will. It's always harder than I thought, but it leads me to something new. So it's not whether the attempt was successful or not but what it led me to.

As a senior in high school I attended a lecture given by the Pulitzer Prize winning photographer Brian Lanker. Lanker won the Pulitzer for his images on the new trend of fathers being allowed in the delivery room. I don't remember a word of his lecture, but I still get goose bumps when I recall how I felt when I saw the slide show of his images of a mother and father sharing the moment of seeing their baby for the first time. As I sat in that darkened auditorium, I realized that this is what I wanted to do—to capture images that would evoke real emotion.

Imitate Those You Admire

Like a child learning to write the letters of the alphabet, in the early stages of your photographic education you'll imitate to learn. If you are influenced by great photographers, your imitation will pale in comparison to the work you seek to imitate. But in the beginning, imitation can teach you method and technique. As long as you don't try to pass off the work as your own idea, it is a useful approach to help you develop your own style. As Austin Kleon, author of *Steal Like an Artist* says, "Don't just steal the style; steal *the thinking* behind the style. You don't want to look like your heroes; you want to *see* like your heroes."

Be Selective

Tip: As you are editing each shoot. Pay attention to the images that interest you. Even if you can't say exactly why.

Throughout this book I'll nag you to be selective, to embrace restraints, and to limit your variables. The reason is that although I love having lots of options, I've learned that too many options can be your enemy. Be selective about:

- **Who influences you.** Select your heroes carefully. Study the masters of portraiture in photography and painting. Learn from the best of the best. Look for excellence, not just popularity.

- **What you photograph.** When you start out, you may generalize in photography, but pay careful attention to what you love to shoot. You don't want to make the same mistake that I see on many photographers' websites: *We specialize in families, kids, seniors, corporate head shots, weddings, and bar mitzvahs.* That's not specializing. Resist the temptation to try to be everything to everyone.

- **Trends.** New trends occur in photography every day, or at least it seems that way. A photographer posts an interesting shot online, and before you know it, everyone's trying that Photoshop action, texture, or lighting pattern. Stay true to your vision of how you want to portray your subjects, even if you don't have a solid idea of exactly what that is. If you love rich, saturated color and everyone else is desaturating their work, who cares? Pursue your own vision. Don't worry about what others are doing. What you decide *not* to include in your work is as important as what *to* include. Don't chase trends. Chase excellence.

Beware of the Rabbit Hole

Beware of the rabbit holes of other photographer's blogs, photography forums, and constantly comparing yourself to others. You'll get discouraged. These influences can distort your vision, so take a break from them. Clear your head and instead go shoot something for yourself. Mom said it best, "Don't worry about what everyone else is doing; worry about yourself!"

What Attracts You?

The simplest way to begin developing your style is to pay attention to what you are visually attracted to. Do you love rich, vivid color, or is a neutral palette more your style? Are you drawn to images that are light and bright, or do you prefer a dark and somber treatment? As you pull inspiration images from magazines or websites, watch for common elements that you are repeatedly drawn to.

My sister is an interior designer, and when she starts a project with a new client, style is their first consideration. Style informs every subsequent decision they will make in designing the house. The most immediate way for her to determine a client's style preferences is by using a visual method. She pulls hundreds of photographs of different rooms, furniture, and finishes, and gives her client the interior design version of an eye test by asking "Do you like this better or this?" The images left on the table after this weeding out process give my sister a clear idea of what her client does and does not like, allowing her to proceed with confidence as to how she will combine her client's preferences with her own unique vision of the design project.

Developing your style can work in a similar way. It begins by simply concentrating on what you like. What do you love to shoot? What types of images attract your attention in your own work and in the work of others? What do others comment on in your work? Can you identify a common theme in what you are attracted to and what you shoot?

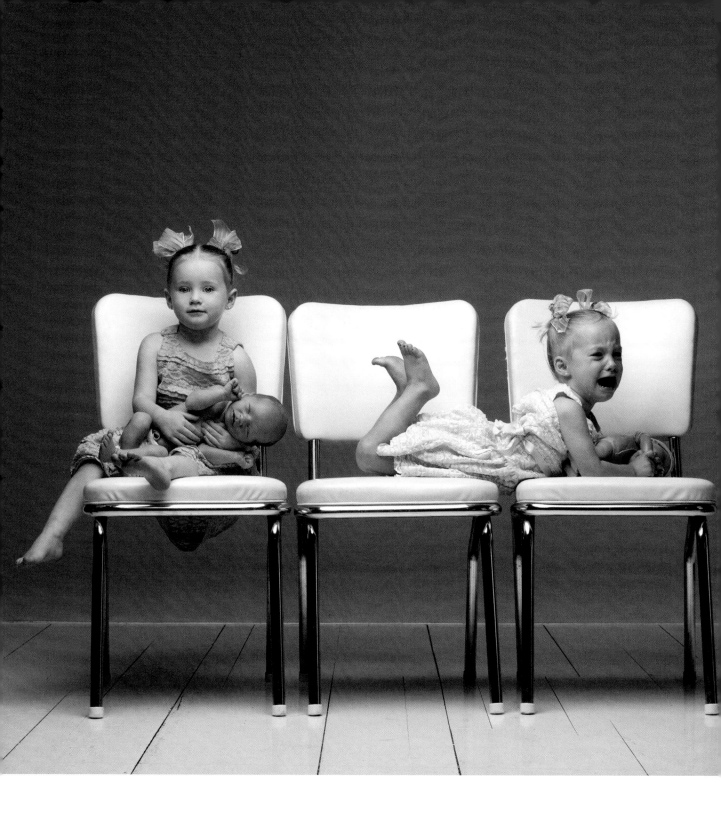

What Do You Love or Hate to Shoot?

No matter how cranky or naughty they are, I love to photograph kids (**FIGURE 3.1**). I get a charge from hanging out with the short set. On the other hand, I hate shooting weddings. For a couple of years I shot weddings but had to quit because I realized that I couldn't care less about the bride and groom. All I wanted to photograph at the weddings were the kids and the old people. Even within the genre of children's portraiture I have likes and dislikes. For example, photographing newborns is boring to me unless a sibling or parent is in the photo with them. And I like to shoot relationships, either a relationship between two people or an interaction between my subject and me. I love to photograph kids who are just a little (or a lot) mischievous. The unpredictability of the less well-behaved child injects some sass and personality into the images.

Determine what you love and hate to shoot. What images do you want your clients to buy? How can you shoot more of what you love?

Editing for Style

During the process of editing your own work, identify the images that most attract you. Keep an eye out for that bit of something unexpected, when there's just something about a certain image that draws you in (Figure 3.1). Even if you're convinced your clients won't get it, show it to them anyway. If you love it and it represents the kind of work you want to do more of, put it up on your website or your blog. Posting the images that you love best will draw clients who love your style of work. And the opposite is true. If you don't like photographing newborns but you post an entire newborn gallery because you think you should, be prepared to shoot more newborns. Show only those images you want to shoot more of. As I edit my shoots, I find I am consistently drawn to negative space, simplicity in composition, and an element of the unexpected in my subject's pose or expression. What elements are you repeatedly drawn to in your own work?

Shoot for You

During every shoot, you should make time to shoot something just for you. Disciplining yourself to do this will help you develop your style by giving you the freedom to try something new. After I've already captured the safe shots (**FIGURE 3.2**), the shots that I know the client wants, I shoot something just for me (**FIGURE 3.3**). During the proofing session, I'll show both images to my client. When I first started doing this, the

FIGURE 3.2 There's nothing wrong with delivering a nice, traditional portrait for a client (right).

ISO 100, 1/200 sec., f/11, 70-200mm lens

FIGURE 3.3 Take some extra time to shoot a couple of images just for you (opposite page).

ISO 100, 1/200 sec., f/11, 70-200mm lens

clients liked "my shot," but they didn't usually order it. Now, they'll order my shot about 50 percent of the time. Clients want to see your most creative work on your website, even if they'll select a more traditional shot for their home. Clients also want to see that you've pushed the creative envelope during the shoot of their children. Shooting something for yourself keeps you interested, keeps your skills sharp, and keeps you moving forward in your work and style.

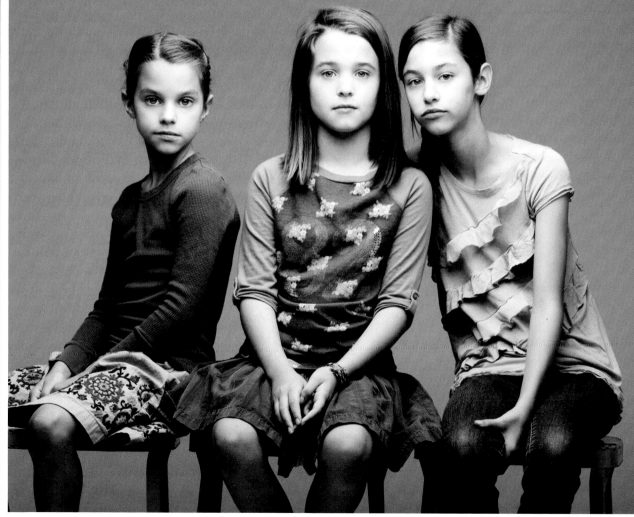

Staying Inspired

As an artist, it is essential to replenish your creative stores on a regular basis. And that's never been easier with all the technology at your fingertips. Here are a few ideas that might help you refuel your inspiration:

- **Smartphones.** I'm not sure how we ever survived without smartphones. I use the camera in my phone constantly to capture visual reminders of concepts I'd like to try in my work. Looking back over the last year's photos in my phone, my inspiration images are as varied as photos of paintings from a visit to the Metropolitan Museum of Art to an interesting piece of graffiti on a wall. I also use the voice memo feature if I have an idea I need to get down quickly, or the notes feature to type a quick note to myself.

- **Evernote.** Evernote has largely taken the place of my physical, three-ring binders full of images and notes. I still take handwritten notes from lectures and workshops I attend, but now I scan them into my computer. With Evernote's searchable PDF function, I can find the topic I'm looking for quickly and easily without having to search through every notebook.

- **Pinterest.** Who doesn't love Pinterest? The online, mood board maker makes it so easy to "pin" favorite images and group them into boards for easy reference and sharing. Just don't limit yourself to looking only at Pinterest. There's a big Internet out there, so use it.

- **Dropbox.** Dropbox is essential to my daily functioning. I use it to upload images or files that I'm working on so I can access them on every computer and device. If I'm traveling and need files on the road, I upload them to Dropbox on my desktop computer at the studio and then access them on my laptop, iPad, or phone. This book would have taken double the time to write if I hadn't had Dropbox.

- **Notebooks.** I need a 12-step program to help with my notebook addiction. I can't pass up a cute spiral-bound notebook or journal. I always have one with me wherever I go to sketch ideas or jot down notes about something I've seen or want to try. Later I scan the notes into my computer and put them into Evernote.

- **Crossing disciplines.** Instead of looking at another portrait photographer's blog, check out some of the great commercial or fine art photographers working today. Venture further and experience art in other disciplines. The worlds of photography, graphic design, interior design, architecture, film, dance, art, and fashion are inextricably linked to and influence one another. Attend a ballet, and notice how the dancers are lit and how they present themselves to the audience. Check out the behind-the-scenes bonus material that comes with many DVDs or on YouTube. Watching how cinematographers light their sets will give you a million ideas for lighting your own portraits.

- **Getting away.** The media at your fingertips is astounding, and yet there is something about going somewhere, being in a new environment, and actually touching and seeing new things that gives you a fresh perspective and renews you creatively. You don't have to go far. When was the last time you went to a museum in your home town or out to eat at a cool new restaurant? Make the time, on a regular basis, to get out of your normal routine and go see something new and inspiring.

Elicit Other Opinions

It's difficult to be objective about your own work, especially in the early stages. Sometimes it's helpful to gather opinions from those around you. Create a PDF of ten of your best images. They should be your favorite images—work that you want to do more of. Email the PDF to people whose opinion you value (not just your mom). For example, send the file to fellow photographers, clients who love your work, a sister or friend who always tells you the truth, or all of the above. Ask them to carefully look at the images and then email you a list of ten words that come to mind when they look at your images. Then compare their responses and see if any words are repeated from person to person. This exercise will give you an objective idea of how others see your work. It may validate what you already know, or it may surprise you. When I performed this exercise, the most common words in the responses I received were *motion, expression, light*, and *humor*. These words have been the guiding themes for me in my work. What are the words that represent your work?

Find Your Muses

Have you noticed that there are some kids you just jell with? You get them and they get you. The camera loves them, and what you create together is some kind of magic. These children may be your muses. My muses are not the best-behaved children; in fact, they are some of the wildest kids I photograph. But somehow the combination of their personalities and mine forms a creative chaos that makes for my most dynamic images. It's not difficult to get a nice image of a perfectly behaved, beautiful child. The challenge comes when the child wants to do it his way, and I love that challenge. I have seven children and two of them have autism, so I am no stranger to bad or crazy behavior. My experience with my own kids allows me to enjoy my subjects' crazy antics rather than being upset by them—that, and the fact that I can send them home in an hour!

The relationship I form with my subjects is my favorite aspect of what I do.

Each year for the past seven years I've been photographing the boys in **FIGURE 3.4**. Brothers Maxwell and Henry first came to me as two and four year olds. Every year the shoot is completely crazy, and every year they deliver the goods. Henry has the face of an angel, but don't let those blue eyes fool you, he gives me a run for my money. Maxwell has Asperger's Syndrome, a form of autism, and is in constant performance mode. He has no inhibitions and is only too happy to bust a move or tell you about his latest Jedi mind tricks. These boys have taught me to go with the flow and keep shooting. Some kids have great instincts; you just need to let them do their thing and be there to capture it.

At their most recent shoot, Maxwell sidled up to me and said, blushing, "I love you." Henry's friend who had tagged along to the shoot scoffed at this and said, "You *love* her?" Maxwell defended himself by saying, "Hey, I've known her for a long time!" I see these boys just once a year, but in that one concentrated hour each year we've formed a relation-ship that I count as priceless. The relationship I form with my subjects is my favorite aspect of what I do. I feel connected to my clients and their children. They are my people and I love them. Who are your muses? Take some time to think about particular shoots in which you've captured your favorite images. It might be because you're a great photographer, or it might be great because you were photographing your muse.

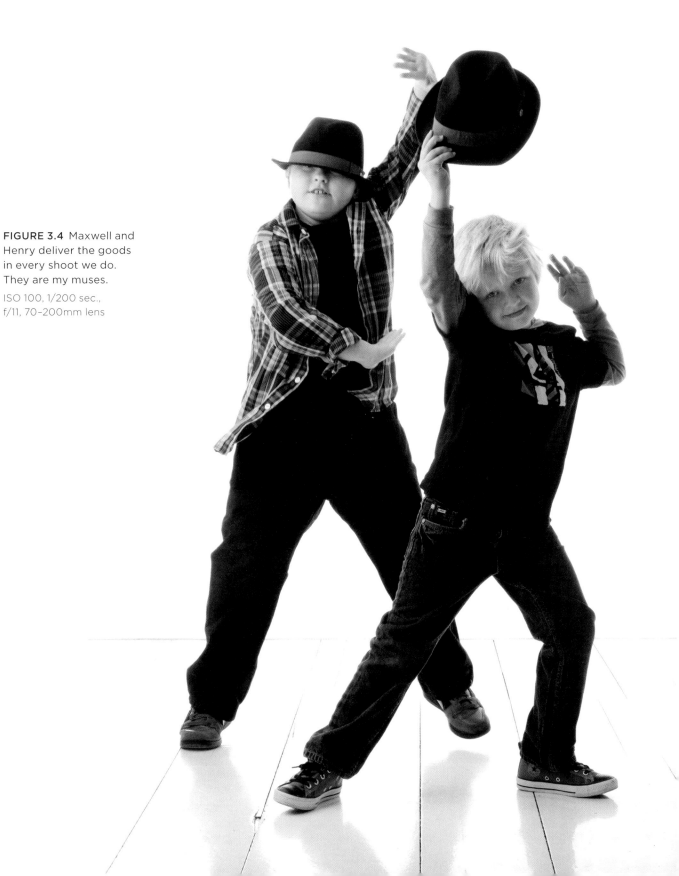

FIGURE 3.4 Maxwell and Henry deliver the goods in every shoot we do. They are my muses.

ISO 100, 1/200 sec., f/11, 70–200mm lens

Learn by Doing

You might think you need to hurry and nail down your technique so you can move on to developing your style. Actually, both happen concurrently. It's while you are learning technique that you make some happy mistakes and luck into a compelling shot. Then you figure out how you did it and how to repeat it. You can't wait until you've completely mastered the medium before you turn your eye toward style because, honestly, you will never, ever feel like you've mastered the medium of photography. There's always something new to learn. As author David McCullough says, "The beauty of the arts is that we learn by doing."

With a specific vision and a willingness to solve the problems that lie between you and a great image, there is very little that can stand in your way. If you have the "what" in mind, you can always find the "how."

Experiment. Evaluate. Continue.

The next section of this book is all about the "how," but before we delve into the essentials of lighting it's important to highlight what you already know. In a nutshell, photography is problem solving. With all the variables of exposure, lighting, you, and your subject, every situation will present a unique set of problems for you to solve. Every time I step on the set of a shoot I'm in problem-solving mode, my mind whirring a mile a minute. If I'm lucky, I arrive at the solution quickly; if not, the inward swearing begins. So cut yourself some slack and realize that problem solving is what we do. Experiment. Evaluate. Continue to problem solve. Don't worry about how others are doing it. Learn good skills, and then photograph your subjects the way you think it should be done (**FIGURE 3.5**). Trust your instincts; you might be wrong, but you might be right. Now put down this book and go shoot something.

Every situation will present a unique set of problems for you to solve.

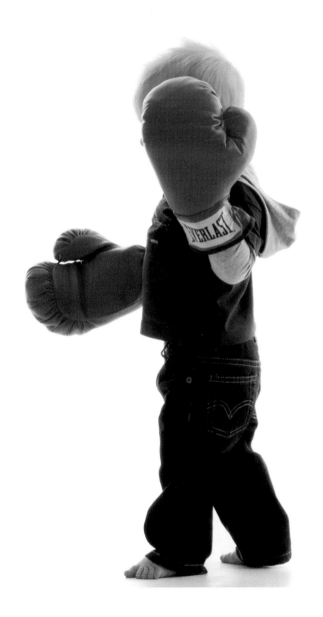

FIGURE 3.5 Don't worry about what anyone else is doing. Focus on the work.

ISO 100, 1/200 sec., f/11, 70–200 mm lens

PROCESS

Anyone who has never made a
mistake has never tried anything new.

—Albert Einstein

Lighting Gear

YOU ALWAYS SHOOT in natural light, you know how
it works, where to look for the good light, and how
to get the results you want. Isn't photographing
kids hard enough without having to mess with even
more gear? Learning to use flash can feel like trying
to learn photography all over again. It's easy to get
overwhelmed and quit before you discover the benefits
that having complete control of your lighting gives you.

In this chapter, you'll get the rundown on how to use
and how *not* to use your flash. You'll also explore the
studio lights that photographers use the most and learn
how to set up your camera and trigger those lights.

ISO 100, 1/200 sec., f/11, 24–70 mm lens

Light Is Your Medium

Let's compare the art of photography to the art of painting. A painter's medium is paint; the brush is a tool the painter uses to apply the medium. For a photographer, the camera and lenses are the tools, but light is the medium for expression. The word photography is derived from two Greek words that literally mean to write (graphy) with light (photo).

The type of light you choose to write with is a selection process, much like the painter choosing which paint to use. Your lighting "palette" might include the natural-light source of the sun, or a flash, such as a studio strobe or speedlight. It's as simple, and as complicated, as that.

Natural light is the gold standard of light. But nature is fickle and doesn't always cooperate when you need it to. Rain may threaten, and toddlers are usually in full meltdown during the "golden hour" of light just before sunset. Learning to use flash gives you the tools and the confidence to light any kid, anytime, anywhere.

A Word About Flash

Flash gets a bad name, mainly because of the less-than-stellar results of on-camera flash. On-camera flash is like using the headlights of your car to illuminate your subject. They will get the job done, but the result won't look good. Because all the light is coming from directly in front of your subject and the light is so close to the lens, the result is a harsh, flat, and sometimes red-eyed image that could be mistaken for a mug shot like the before photo in **FIGURE 4.1**.

If you love the look of depth and dimension in your portraits—the type of light that highlights the texture in the skin and hair of your subject—like the boy in **FIGURE 4.2**, get that flash off your camera.

Just getting your flash off your camera is no guarantee that the photo will look good. Everyone can agree that off-camera lighting can go horribly wrong; just take a look at your kid's most recent school photos or *any* photo taken by the big chain portrait studios located in a department

Get that flash off your camera.

FIGURE 4.1 Before: On-camera flash creates harsh background shadows and flattens out your subject (top right).

ISO 100, 1/200 sec., f/13, 70-200mm lens

FIGURE 4.2 After: An off-camera flash provides a dimensional light that enhances your subject (bottom right).

ISO 100, 1/200 sec., f/13, 70-200mm lens

store near you (which shall remain nameless, but you know which ones they are).

Those high-volume portrait studios have done nothing to further the art of portraiture. The trend of poorly lit photos of kids in matching outfits posed in a triangle on a mottled blue muslin backdrop deserves to fade away—forever.

However, just because someone did a bad job with the tools doesn't mean the tools are bad. It's not the tools but how they are used that makes the difference. The types of lights used to photograph all those scary kid photos are the very same lights that have created gorgeous editorial images in *Vogue* and *Vanity Fair* magazines. These are the same lights used to photograph ads for companies you love, like The Gap and J. Crew.

Lights, Camera, Action

What follows is a brief introduction to the types of light sources typi-cally used by portrait photographers in the studio and on location. In Chapter 5 you'll find an in-depth discussion of light modifiers and how to actually work with these lighting tools. For now, there are three decisions you need to make to begin working with flash:

- **Lights.** Select a light source.
- **Camera.** Set your camera to sync with the light.
- **Action.** Choose a method to trigger the flash from your camera.

Lights

The sheer number and variety of lighting choices on the market can be daunting, but you'll find that most portrait photographers use only one or two types of light sources: studio strobes or speedlights. Studio strobes come as either monolights or strobe pack systems. Speedlights are small flash units used mostly for location work.

Studio strobes

Studio strobes are powerful flash units that plug into an AC outlet in the wall. The term *strobe* refers to lighting units that use a flash of light to illuminate the subject. Flash and strobe are interchangeable terms. When you're shopping for strobe lighting, there are two main items to consider:

- **Strobe power.** The amount of light produced by the strobe unit, measured in watt seconds.
- **Recycle time.** How long it takes for the flash to recycle and be ready to shoot again.

Digital cameras are very light sensitive, so you don't need the most powerful lights on the market. But recycle time is a major issue if you are planning on capturing action shots of kids.

Monolights

Monolights are manufactured with the power pack and bulb housed in the same unit. Monolights are the most common form of lighting used by studio portrait photographers (**FIGURE 4.3**). The pros of working with monolights are:

- They are easy to use.
- They are more affordable than strobe pack systems.

- If one light goes down and you have a backup monolight, you can still keep shooting.
- Monolights come with continuous modeling lights, which allow you to visualize how the light will fall on your subject. Modeling lights also make it easier for your autofocus to lock onto your subject in a darkened studio.
- They are made to work with a wide range of light modifiers, such as softboxes, umbrellas, grids, and so on (see Chapter 5).
- Some monolights (like the Profoto D1 Air) come with dedicated radio controls that allow you to control your lights from a remote on your camera.

The cons of working with monolights are:

- Monolights are heavier than power pack heads because the power pack is built into the light. This can make it more difficult when you're using the light up high and overhead, especially with heavy modifiers like softboxes.
- Monolights don't pack as much power and can have slower recycle times than strobe pack systems.

FIGURE 4.3 Monolights are usually the most affordable type of strobe lighting you can buy.
ISO 100, 1/200 sec., f/18, 70–200mm lens

Strobe pack system

FIGURE 4.4 More expensive than monolights, power pack strobes pack more power. You may not need all that lighting power, but they come in handy when photographing kids because of their fast recycle times (below left).

ISO 100, 1/200 sec., f/18, 70–200mm lens

A studio strobe pack system consists of lighting heads that are run from a separate power generator or "pack." All the lighting controls are on the pack. Power packs are used by both portrait and commercial photographers (**FIGURE 4.4**). The pros of working with strobe pack systems are:

- The heads are lighter weight than monolights because the power pack is separate.
- Power packs tend to have more power and faster recycle times than monolights.
- You can run three or more heads off one power pack.
- The power pack is usually closer to the camera than a monolight, which makes adjusting the lights faster and easier.

FIGURE 4.5 Speedlights are compact, lightweight, and ideally suited for location work (below right).

ISO 100, 1/200 sec., f/22, 70–200mm lens

- Like monolights, they are made to work with a wide range of modifiers.
- Like monolights, they come with modeling lights.

The cons of working with strobe pack systems are:

- If the power pack dies, you have no lights at all.
- They are more expensive than monolights.
- Cords from the head to the pack can restrict light placement.

Speedlights

Speedlights are dedicated flash units that can be used on the hot shoe of your camera or set up to use off-camera (**FIGURE 4.5**). Speedlights are manufactured to be used with your particular brand of camera and can work with your camera's metering system and program modes. They are most commonly used by portrait and wedding photographers on location. The pros of working with speedlights are:

- They are small and lightweight, perfect for location work.
- They are slightly more affordable than strobes.
- They can be used with the program modes in your camera.
- Tons of great new modifiers are available for this type of flash.
- They are battery powered, so there is no need for an AC outlet.

The cons of working with speedlights are:

- They are powered by batteries (so are not as powerful as strobes).
- They have slower recycle time than strobes.
- They require adapters to mount to a light stand.
- Speedlights do not have modeling lights.

So what do you buy? If you are primarily a location shooter, stick with speedlights or find a battery pack for your studio strobes. If you prefer to work in the studio, the monolight/strobe pack may be a better equipment decision for you. Start with what makes sense for how you work and add gear as your needs develop.

Note: Constant light sources don't flash; they are either on or off. These lights are commonly referred to as "hot lights" because they are usually tungsten or halogen bulbs that are very hot. With the development of daylight balance fluorescent bulbs and LED lights, which are "cold" constant sources, more photographers have switched to using these constant light sources. If you photograph newborns exclusively, a constant light source might be the way to go. No flashing lights to disturb baby, and the lower power allows you to work at wide apertures, ensuring the shallow depth of field that newborn photogs love. I shoot kids in motion, so for me, a constant light source doesn't have the power I need to freeze motion at low ISOs the way studio strobes or speedlights do.

Benefits of Lighting with Flash

Off-camera lighting in the form of studio strobe flash or speedlights puts powerful tools at your disposal. Here are just a few of the fringe benefits:

- **Predictable.** Once you dial in your light position and exposure you can lock down your camera settings, allowing you to spend more time relating to your subject and less time fiddling with your camera.

- **Controllable.** Using flash gives you the ultimate control over lighting in *any* situation. You can mix in existing, natural light or completely overpower the sun if that's the look you want.

- **Consistent.** When shooting in manual mode with flash, your exposure is consistent from shot to shot. Shooting with flash makes postproduction editing a breeze compared to the inconsistency of natural-light, location shooting, and this saves you time and money.

- **Repeatable.** Those happy mistakes are infinitely repeatable if you make note of your lighting setup and exposure controls. I often take a wide shot of my lighting setup to remind me of the setup later.

- **Not weather dependent.** Time of day and weather become irrelevant when you carry your light sources with you. Shoot whenever and wherever you want.

- **Portable.** We've all had those location shoots where the clients assure us that they have "great light" in their home, only to show up and find a dungeon. Rather than trying to *find* good light, bring good light with you.

- **Freeze-able.** OK, that's not a word, but flash allows you to freeze action like no other light source, and if you're photographing kids, freezing action is a very good thing.

Camera

My best advice on camera bodies is to buy the one that accommodates the way you actually shoot, not the camera you think you *should* buy. I learned this lesson the hard and expensive way when the Nikon D800 was released. It had been almost four years since I'd upgraded my camera, and when the D800 was announced as *the* camera for shooting in studio, I couldn't wait to get my hands on one. I promptly dropped the requisite four figures and began shooting. I hated it, immediately. What I had failed to realize was that although I *do* photograph kids in a studio, I don't shoot like a typical studio photographer. For instance, I don't shoot on a tripod.

I am constantly in motion and my subjects are rarely, if ever, still. I should have realized that a camera advertised as *the* studio camera means that it has lots of resolution and is great for still subjects. The camera produced gorgeous files with amazing detail, but the focusing system just couldn't run with me. So I put the D800 back in its box and, painfully, laid out another four figures for the Nikon D4. Why the D4? The D4 is the photojournalist's workhorse; it's made for capturing action anytime, anywhere in just about any light. Duh! The moral of this story is, buy the camera with features that facilitate *how you shoot,* not necessarily *where* you shoot with it.

Sync speed

Using any type of flash requires you to know your camera's *sync speed*. The sync speed is the fastest shutter speed at which the shutter is completely open when the flash fires. If you select a faster shutter speed than your sync speed, you'll notice a shading or dark black area on one side of the frame. The reason is that the shutter is opening and closing faster than the flash can fully illuminate the scene.

Nikon and Canon cameras list their sync speeds as 1/250 of a second, but that is when you are using one of their dedicated speedlights (i.e., a Nikon- or Canon-manufactured flash). If you are using studio strobe lighting, your sync speed for Nikon or Canon will be closer to 1/200 of a second.

Tip: To avoid buyer's remorse when it comes to cameras, try before you buy. Most major cities have equipment rental houses that will rent cameras and lenses. Or you can try an online rental source like www.borrowlenses.com. Rent a camera for a weekend and see if it fits the way you shoot. It's not free, but it's a lot less expensive than buying two cameras.

Manual

When using flash, I shoot in all manual mode all the time. I don't use any program modes through my camera, even when using a dedicated speedlight. Shooting in manual means my results are consistent from shot to shot, which saves me hours in postproduction time. Because every exposure in a given lighting setup will be the same, I can use the Sync tool in Lightroom to apply color or tonal correction to all of those images at once versus having to adjust each frame individually. Some photographers love the TTL (through the lens) metering features available through their cameras and can rock it like no other (I'm looking at you, Joe McNally). As for me and my studio, we'll be over here shooting in manual.

Action

You have the lights and the camera, now how do you make the lights flash? When you're shooting with flash units that are not attached to your camera, you'll need a way to trigger the lights. You have two ways to do that: Use a PC cord or a PocketWizard.

PC cord

For about $20 you can get a cord that connects your camera directly to the light (**FIGURE 4.6**). PC cords are cheap and easy but are not recommended when you're photographing kids. It's always good to have one on hand for emergencies when your other gear goes down, but with kids running around, PC cords can be a tripping hazard. If you want to use a PC cord when you're first starting out, buy the longest cord possible and tape it down when you're shooting.

PocketWizards

The industry-standard radio transceivers, PocketWizards mount to the hot shoe of your camera and transmit wirelessly to trigger your flash (**FIGURE 4.7**). Most strobes come with built-in radio receivers that work with the PocketWizards. Other, older strobes and speedlights require you to have a second PocketWizard connected to the flash to receive the signal sent by the PocketWizard on your camera.

Start Somewhere

My first attempt at studio lighting involved a paint-covered set of garage lights. You know, the kind that will burn your house down when you're not looking? I wasn't a working photographer at the time and wanted to try out the whole studio lighting thing. I was shooting film so I knew the lights needed to be very bright to give me the exposure I needed, thus the high-beam garage lights. I used a white bedsheet in front of the lights to soften and diffuse the light, which seemed like a good idea until the smell of a smoking sheet alerted me to the fact that I had it a little too close to the lights.

It wasn't the safest lighting situation, but it solidified for me that perennial pearl of photographic wisdom, *light is light*.

Regardless of the source, be it sunlight or flash, light is the medium and our job is to manipulate that medium until we get a look that we like. In the end, it all comes down to one thing, *how does it look*?

Get a light—rent one, borrow one, buy one. Put it on a stand, set your camera's sync speed, and start experimenting with light. Make some really bad pictures and learn from those mistakes. *Start somewhere.*

FIGURE 4.6 A PC cord connects your camera to the light source (far left).

ISO 100, 1/320 sec., f/14, 70–200mm lens

FIGURE 4.7 A PocketWizard is a radio transceiver that triggers your flash wirelessly (left).

ISO 100, 1/320 sec., f/14, 70–200mm lens

Before you can think out of the box,
you have to start with a box.
—Twyla Tharp

The Five M's of Studio Lighting

EVERY PHOTOGRAPHIC ENDEAVOR starts with a vision—a glimmer of what you want the end result to be. Then begins the selection process of lighting tools and techniques to bring that vision to life. Ironically, the very process of learning to use new tools and techniques can cloud your creative vision for a time until the skills become second nature.

When learning something new, I try to break the basic skills into bite-sized chunks that I can get my mind around quickly. In this chapter I outline the five steps I use to apply lighting theory in my work. I've reduced five basic lighting concepts—mood, main, modify, measure, and move—into a decision-making process; it's a process that I use every time I shoot.

ISO 100, 1/200 sec., f/9, 70–200mm lens

1 MOOD
HOW DO YOU WANT IT TO **FEEL?**

3

MODIFY HOW DOES THE LIGHT *LOOK?*

MAIN
WILL YOU USE JUST **ONE LIGHT** SOURCE?

2

4

MEASURE
THE AMOUNT OF LIGHT

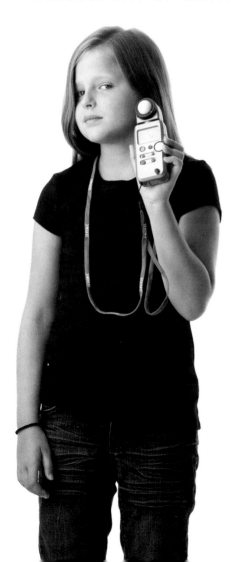

MOVE
THE LIGHT UNTIL YOU LIKE HOW IT LOOKS

5

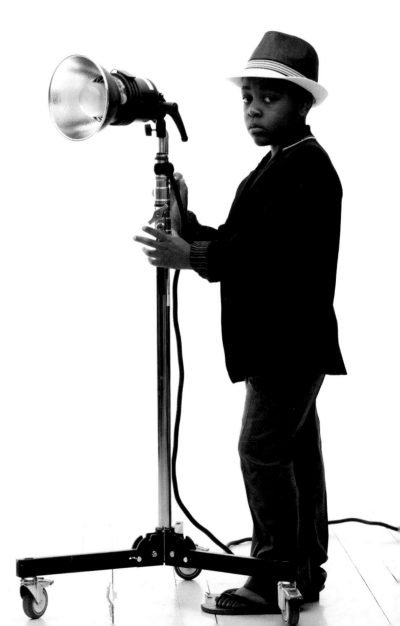

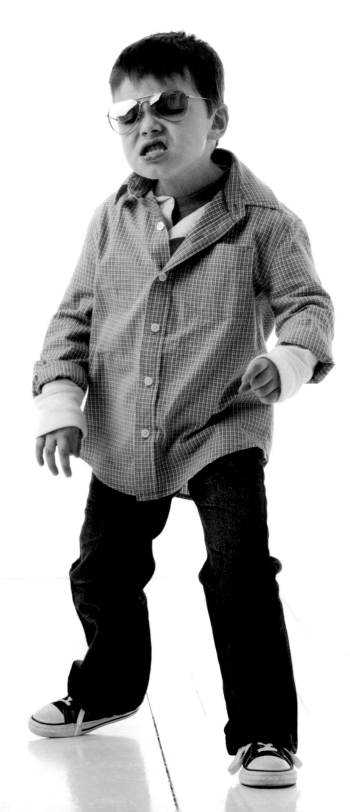

Mood

Before you set up any lights, first decide how you want the image to *feel*. In other words, establish the *mood* of the image you want to create. Do you envision a light and airy feel, a dark and dramatic mood, or something in between? Your approach for photographing a sweet, newborn baby might be different from how you would envision a portrait of a moody preteen. What mood do you want to bring to the portrait of this specific child? A good place to begin is with the *key of light*.

The Key of Light

The key a piece of music is composed in affects the overall tone and feel of the work; photography is no different. The key of lighting you select affects the overall tone and feel of the final image. When lighting an image, there are three basic *keys* of light that you can use to help convey mood in an image: high-key, mid-key, and low-key lighting. All the keys of light are intended to draw attention to your subject, but they do so in different ways.

FIGURE 5.1 A high-key lighting setup provides a large area of light that allows plenty of room for kids to get their groove on and still be properly lit.

ISO 100, 1/200 sec., f/9, 70–200mm lens

High-key lighting

Light, bright, and energetic are words that describe the mood of a high-key portrait. High-key lighting, commonly used in advertising, is simple and clean, and highlights the subject with no distractions. My favorite high-key setup is a white, featureless background that is 1½ stops brighter than the light on the subject.

A high-key lighting setup typically uses three lights: one to light the subject and two (or more) to light the background. The high-key setup is versatile but can be tricky to get right, so I've devoted Chapter 7 to it.

I choose high-key lighting when I want to convey energy and motion, as shown in **FIGURE 5.1**. This setup creates a large area of light for kids to move around in, making it a good choice for capturing girls twirling in their dresses or boys showing off their karate moves. High-key lighting draws attention to the pose and shape of the subject, as in **FIGURE 5.2**.

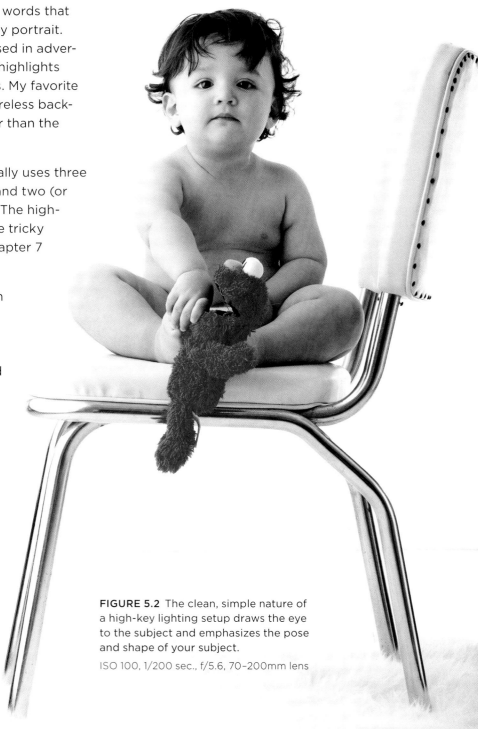

FIGURE 5.2 The clean, simple nature of a high-key lighting setup draws the eye to the subject and emphasizes the pose and shape of your subject.

ISO 100, 1/200 sec., f/5.6, 70–200mm lens

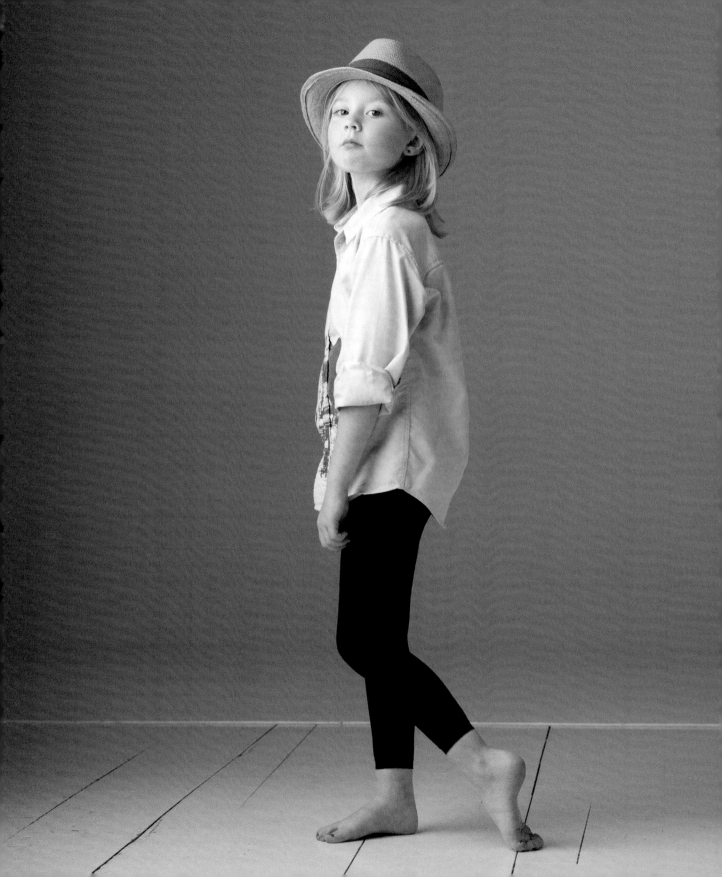

FIGURE 5.3 This mid-key gray background was created by simply not lighting the white wall behind the girl (opposite page).

ISO 100, 1/200 sec., f/5.6, 70-200mm lens

FIGURE 5.4 The neutral look of mid-key lighting highlights the subject's skin tone, eye, and hair color (left).

ISO 100, 1/200 sec., f/8, 70-200mm lens

Mid-key lighting

The mid-key portrait is made up primarily of midtones; the only area of strong contrast is created by the light falling on the subject, which draws the viewer's attention. More subtle and nuanced than high- or low-key lighting, a mid-key portrait can get boring in a hurry unless you carefully create depth and dimension with the light falling directly on your subject. My mid-key lighting setup consists of a single light source on the subject and sometimes a fill reflector opposite the main light (more on this later in this chapter).

Neither light nor dark, a plain, gray background gives a modern, almost commercial feel to a mid-key portrait. The gray background can be achieved by using a roll of gray seamless paper or by simply not lighting a white seamless background portrait, as in **FIGURE 5.3**.

I love the look of mid-key lighting when I'm photographing in color, especially with naked babies. With this combination the image appears almost monochromatic, so the only color is the baby's skin tone, hair, and eye color (**FIGURE 5.4**).

Note: High-key lighting is also a good choice when you plan to use the final images in a custom album or card design, because a white background is perfect for use with graphic type treatments. It's also easy to expand that white background in Photoshop if you want to change how the image is cropped.

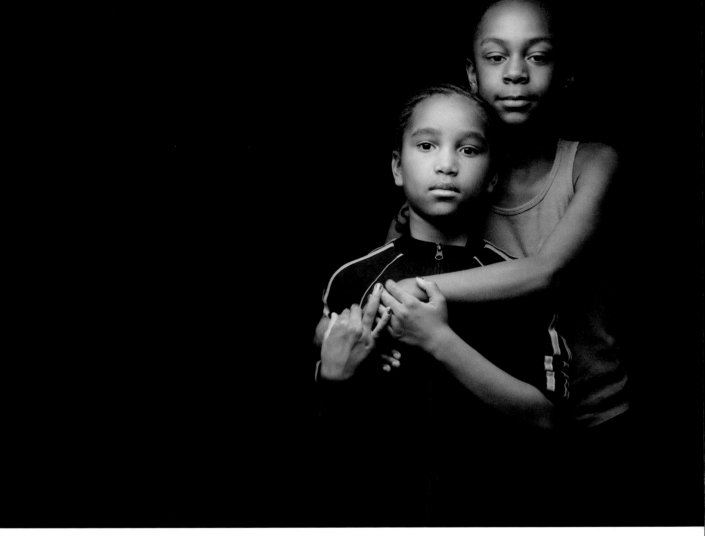

FIGURE 5.5 In this low-key lighting setup, these sisters seem to be emerging into the light from a darkened background.

ISO 100, 1/200 sec., f/8, 70–200mm lens

Low-key lighting

"Moody" describes the feel of a low-key portrait. Composed of predominantly dark tones, the subject of a low-key portrait draws the viewer's attention, as shown in the photo in **FIGURE 5.5** by the appearance of two sisters emerging from shadow into the light.

This classic style references the techniques of old master painters, like Rembrandt and Vermeer, who painted their subjects in darkened environments by the light of a single window. The light on the subject is dramatic and dimensional, with little or no light on the background.

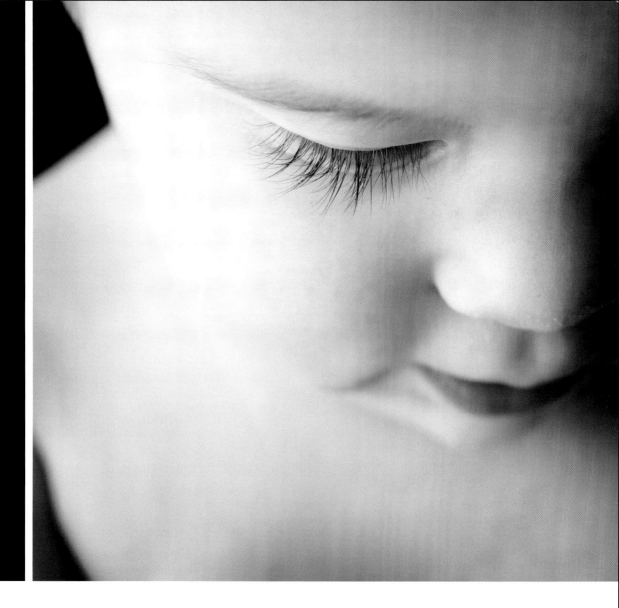

Low-key lighting has a classic, fine art feel to it and is the most emotional and dramatic of the three keys of light. Because it has a heavenly ray-of-light look to it, I use low-key lighting when I want to show off the texture of a child's skin and focus on every eyelash, as shown in the close-up of the baby in **FIGURE 5.6**. For low-key lighting, I typically use one light, tightly controlled, to light my subject. There's nothing like a low-key portrait in black and white. With no color to distract the eye, you see only line, shape, and texture.

FIGURE 5.6 A low-key setup is perfect for isolating features like eyelashes or skin texture.

ISO 100, 1/200 sec., f/2.8, 60 mm Macro lens

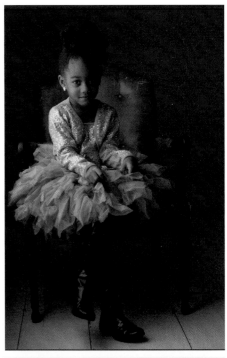

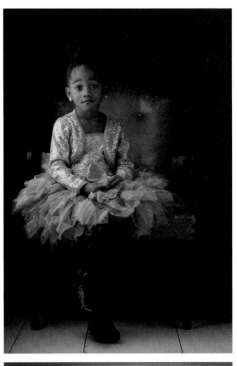

FIGURE 5.7 The subject is lit by a main light only and an Octabank is camera left.

FIGURE 5.8 The subject is lit by a main light plus a white reflector fill, camera right.

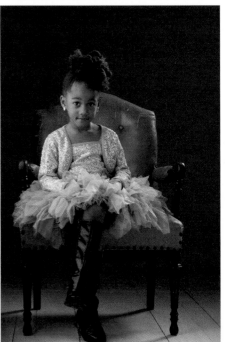

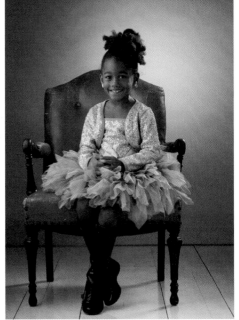

FIGURE 5.9 The subject is lit by a main light, and a reflector fill and kicker light are camera right behind the subject. Notice how the kicker light also acts as a hair light.

FIGURE 5.10 The subject is lit by a main light, a reflector fill, a kicker, and one background light.

ISO 100, 1/200 sec., f/5.6, 70–200mm lens

Main

Once you've decided on the mood you want to convey, it's time to create a lighting scheme to communicate that mood. Creating a lighting scheme is a process of addition: You start with a main light and then add in more as needed. Studio portrait photographers have a language all their own that refers to the various lights they use to create a lighting scheme. Even if you only ever use one light, it's helpful to know what all the lights are called and what they are expected to do.

Main or Key Light

Also referred to as a key light, the main light is the primary source of illumination on your subject. The main light is usually the brightest light and determines the overall *mood* of the scene. It is also responsible for the look of the shadows falling on your subject, as in **FIGURE 5.7**.

Fill Light

A fill light (or a reflector used as fill) is added to a scene to lift or "fill" the shadows created by the main light (**FIGURE 5.8**). I prefer using a white reflector versus an actual fill light if I use any fill at all. Nothing kills drama in an image more than badly applied fill light, so use it sparingly.

Accent or Kicker Light

A kicker light is pointed at the subject either from the side or from a rear angle, giving definition to the subject and providing separation from the background. I rarely use kicker lights when photographing kids because they require the subject to be glued to a specific spot, and I like to let kids move. I might use a kicker light when photographing a family, where there is less movement going on, or for a particularly cooperative child, as in **FIGURE 5.9**.

Background Light

A background light is used to illuminate all or part of the background to provide separation of the subject from the background, as shown in **FIGURE 5.10**. I rarely use a background light unless I'm shooting a high-key setup. Then I use two lights to create a completely white background (more on this in Chapter 7).

Hair Light

A hair light is an overhead light that illuminates the subject's hair and provides separation from the background. I confess that I never use hair lights. A kicker light can double as a hair light (as in Figure 5.9) if I'm photographing a brunette child on a dark background. However, I just don't like the look of adding in another light for hair. For me, the extra light starts to add too many accents and takes the eye away from the expression.

Less Is More

When it comes to photographing kids, using more than one or two lights to light my subject is too much. The image starts to look over-lit, and the emphasis is taken away from the subject. Using accent lights also requires the exact placement of a child (i.e., the child has to be still), and that doesn't usually happen in my world. My preference is to use lighting setups that allow kids to move a little and that give me the maximum possible margin of error. Most of the time that means using one light and a reflector to light my subject.

Modify

The third M refers to modifying the bare light source to achieve flattering, dimensional light on your subject.

When you're first learning to use lighting in your work, it's easy to get hung up on the *quantity* of light—how bright or dark your image is. As you learn to properly nail your exposure, you'll understand that it's actually the *quality* of light that will make or break the image. Ironically, the easiest way to see the quality of the light is to pay attention to the shadows.

From your experience shooting in natural light, you know that if you shoot in harsh, direct sunlight, the result will be harsh, hard-lined shadows on your subject. If you move your subject to a setting with open shade or light that is diffused in some way, you'll see a softer gradation from light to shadow on your subject's face. Studio lighting is no different. Harsh, direct light created by a bare flash bulb, as in **FIGURE 5.11**, creates harsh, hard-lined shadows. Placing a modifier between the light and your subject, like the Octabank in **FIGURE 5.12**, will change those shadows from hard to soft. The point at which the light on your subject changes from light to shadow is called *shadow transfer*. Placing something between the light source and your subject *modifies* the light and changes how the shadow transfer appears—in this case from hard to soft.

Light modifiers are to your lights as lenses are to your camera. Like lenses, light modifiers dramatically affect how the final image *looks*. Because modifiers come between the light and your subject, they directly affect the quality of the light falling on your subject. Some modifiers diffuse the light, whereas others increase contrast and concentrate the light. You use modifiers to shape and control the light in distinct ways—for example, by diffusing, reflecting, concentrating, or subtracting light from your subject.

Diffusers

As mentioned earlier, diffusers (e.g., an Octabank) soften light and can also enlarge the source by diffusing light over a larger area. Shooting with a strobe bulb that is 3 inches across into a 60-inch Octabank dramatically diffuses *and* enlarges the light source, and as you'll soon learn, when it comes to flattering light, bigger is better. The most commonly used lighting diffusers in portraiture are umbrellas, softboxes, and Octabanks.

Ironically, the easiest way to see the quality of the light is to pay attention to the shadows.

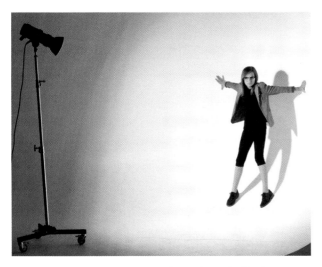

FIGURE 5.11 A monolight used as a bare-bulb, direct light source creates cut-out shadows behind the subject.

ISO 100, 1/200 sec., f/5.6, 70–200mm lens

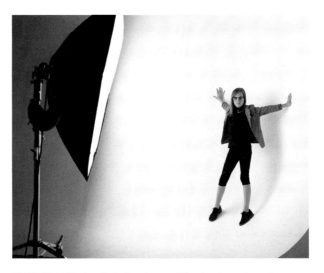

FIGURE 5.12 An Octabank modifier is placed on the monolight to diffuse the light on the subject. Notice how the shadows are either filled in or considerably softened by diffusing the light.

ISO 100, 1/200 sec., f/5.6, 70–200mm lens

Umbrellas

Umbrellas are the least expensive light modifiers on the market. They are available in black with white, silver, or gold interiors. It's best to start with the convertible umbrella with a white interior. Use the convertible umbrella in reflective mode by shooting your flash into the umbrella, and the light will reflect onto your subject. Or, use it in shoot-through mode by removing the black fabric and shooting the flash through the umbrella toward your subject. In reflective mode, the light is more contrasty and specular. In shoot-through mode the light source becomes much larger and more diffused, but it can also be harder to control because a big, shoot-through umbrella scatters lots of light everywhere.

Softboxes

FIGURE 5.13 The soft, dimensional light in this image was created by a light diffused with a 4 x 6-foot softbox to one side of the subjects.

ISO 100, 1/200 sec., f/5.6, 70–200mm lens

Softboxes, aka light banks, are collapsible fabric boxes manufactured to direct and diffuse light. Softboxes are black on the outside and have a front diffusion panel to diffuse the light. They come in all shapes and sizes from very small to enormous enough to light a car. A large softbox acts like a big, gorgeous window of light. Softboxes with recessed diffusion panels allow you to control the light spill better than softboxes with diffusion panels that are flush with the front of the box. A 4 x 6-foot softbox is big enough to produce the look of a very large window of soft light (**FIGURE 5.13**). A smaller softbox allows you concentrate soft light in a smaller area.

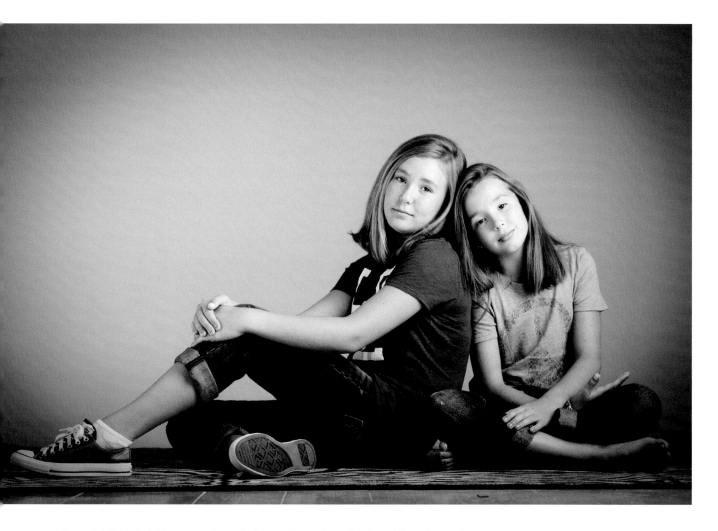

Octabanks

All photographers have a favorite modifier that they wouldn't be without, and for me that is my 60-inch Octabank. Octabanks are shallower than softboxes, allowing you to feather the light more easily across one or more subjects and sometimes eliminate the need for a fill light or reflector (more about feathering light in Chapter 6). Because they are not as deep and directional as softboxes, Octabanks create a huge, forgiving wall or ceiling of light. This makes lighting wiggly kids easier because it gives them more room to roam and still be in good light. When I'm photographing more than four kids or kids with their family, I'll bust out the 7-foot Octabank to create an even larger light source, as shown in **FIGURE 5.14**.

FIGURE 5.14 Using a large diffuser, like a 7-foot Octabank camera right, made it easy to get good light on five very wiggly kids.

ISO 100, 1/200 sec., f/8, 70–200mm lens

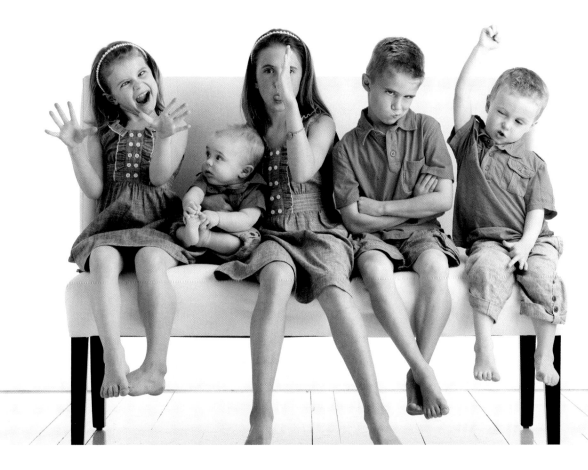

Strip banks

Strip banks are softboxes that are twice as long as they are wide. They are used for accent lighting (e.g., as a kicker light or even a hair light for a group of people). Long and skinny, strip banks can provide head to toe rim lighting (light that highlights the edges of a subject) for a child, which can help separate the child from the background.

Photek Softlighter

If you've seen any of the YouTube behind-the-scenes videos of Annie Leibovitz's photo shoots, you've seen the Photek Softlighter modifier in action. Part umbrella, part softbox, and part Octabank, the Photek 60-inch Soft-lighter is the perfect all-in-one modifier, espe-cially if you're just starting out. It is relatively cheap (around $100) and creates gorgeous light. The Softlighter can be used as a reflec-tive or shoot-through umbrella, and with the diffuser sock attached to the front, it acts as a 60-inch Octabank. The shaft on the umbrella is removable, which allows you to position the light very close to your subject without the shaft appearing in the photo. I take the Photek Softlighter with me on every location shoot; it's like a portable Octabank. If it's good enough for Annie, it's good enough for me.

Reflectors

You've probably used reflectors in your natural-light work when you needed to open up the shadows or reflect sunlight onto the shadow side of your subject. In the studio, reflectors are most commonly used opposite a main light to keep the shadow areas in an image from becoming too dark. In this way they can act as a fill light. However, I'd rather use a reflector than a fill light because reflectors are easier to control and faster to set up than an additional light.

V-flats

I love the look of a single light source, but sometimes you need a little reflection to act as a fill light. My hands-down, favorite reflector to use in the studio is the white side of a V-flat. V-flats are made by bookending two pieces of Z-board with gaffer tape (see the sidebar "The Beauty of V-flats," later in this chapter). Z-board comes in 4 x 8-foot sheets, which are white on one side and black on the other. The board has a plastic finish to it with a foam cen-ter and is about 3/16 inch thick.

When I suspect the shadows are too dark and may need some fill, as in **FIGURE 5.15**, I'll pop in a V-flat as a reflector by positioning it oppo-site my main light to catch some of that light and throw it back onto the shadow side of my subjects.

If the reflector is filling in my shadows too much, as in **FIGURE 5.16**, I'll back it farther away or remove it altogether. The dull, white side of a V-flat provides just the right amount of reflec-tion, so I rarely use reflectors with a metallic finish (such as silver) because the light is too specular for my taste.

I'd rather use a reflector than a fill light because reflectors are easier to control and faster to set up.

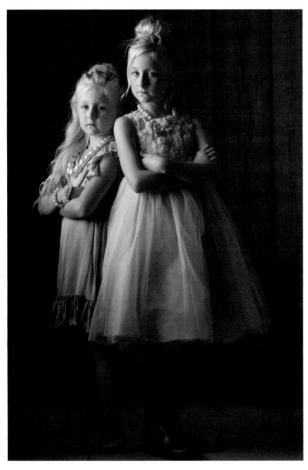

FIGURE 5.15 I was going for a dark and moody look in this image but thought the shadows might be a bit too dark.

ISO 100, 1/200 sec., f/5.6, 70–200mm lens

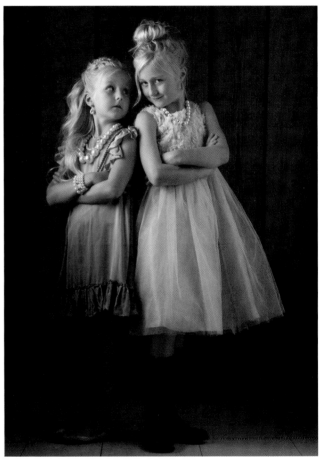

FIGURE 5.16 Adding a V-flat opposite the main light added too much fill, and I lost the drama I was originally looking for.

ISO 100, 1/200 sec., f/5.6, 70–200mm lens

V-flats don't travel well, so when I'm shooting on location, I'll take my two favorite reflectors with me—the Lastolite TriGrip and the California Sunbounce reflectors.

Lastolite TriGrip reflector

The TriGrip reflectors come in various sizes, but the one I use most is 48 inches, with white on one side and silver on the other. I like the TriGrips because of their sturdy handles, which allow you to use them without needing an assistant.

California Sunbounce reflector

The California Sunbounce reflector is *huge* when it's set up (4 x 6 feet) but great on location when you need to either block the sun or reflect light onto a group of kids. It has a sturdy frame and is easy to attach to a light stand. Although the California Sunbounce reflector can be a pain to set up and break down, when you need a reflector that's almost the size of a V-flat that can be packed in your car, this is the one to use. The one I use is white on one side and matte silver on the other.

Concentrating the Light

Light modifiers that concentrate light by either restricting or directing the light source are most often used as accent lights, but sometimes they can make for an interesting twist on your main light. These are the, not-necessary-but-nice-to-have kinds of modifiers that you'll want to explore once you've established your foundation of lighting with the aforementioned modifiers.

Beauty Dish

Somewhere out there is a seasoned studio photographer reading this section and rolling his eyes at the mere mention of a Beauty Dish in a book about photographing children. The reason is that Beauty Dishes are notoriously difficult to use, because the placement of the light is critical, and lighting modifiers that require critical placement are not usually the type of modifiers you use when photographing children. So what?

The Beauty of V-flats

V-flats are huge pieces of foamcore-type material bookended together with gaffer tape, as shown in **FIGURE 5.17**. They stand up in a V, hence the name. Among the most useful pieces of equipment in my studio, V-flats are a multipurpose wonder. The most common uses for V-flats are:

- As a reflector (use the white side) for your main light.

- As a gobo to block light from hitting your lens (more about gobos later in this chapter).

- To block light from falling on your background.

- To reflect black onto your subject. The black side subtracts light and deepens the shadows.

- As a background to shoot on. You can paint them to vary your background color.

And that's not all:

- V-flats create a little "fort" area between the V-flat and the main light that kids like to get in, making it easier to keep kids where you want them.

- V-flats stand easily on their own; you don't need an assistant to hold them.

The only downside of a V-flat is that it is *big*. A full-size V-flat is 8 x 8 feet (4 x 8 feet when closed). If you have 8-foot ceilings, have the Z-board cut to 6-foot lengths. You can also have them rip cut (on the long edge) and bookend them to use as gobos for your background lights in a high-key lighting setup (more on that in Chapter 7).

Z-board, aka Zebra board, is so called because it's white on one side and black on the other. The

FIGURE 5.17 V-flats made from Z-board are my favorite type of reflector.

ISO 100, 1/200 sec., f/5.6, 70–200mm lens

white and black sides are coated with matte plastic, which is laminated onto black foamcore. Be sure to use white gaffer tape on the white side and black on the black side when you're making your V-flats. My local camera store sells Z-board, but you may also want to check sign shops or art supply stores in your area. You can also make V-flats from insulation board, available from your local hardware store.

You'll find an online source for Z-board or Gator-foam at www.graphicdisplayusa.com/gatorfoam/substrate.

FIGURE 5.18 Lighting a toddler with a Beauty Dish is a photographic recipe for disaster, but this calm little boy was actually the perfect subject on which to try this dramatic lighting technique.

ISO 100, 1/200 sec., f/5.6, 70–200mm lens

There's something about the quality of light from a Beauty Dish that's unlike any other modifier on the market. The concentrated light that bathes the face and creates dark (but not too dark) shadows beneath the chin is very appealing, and I love it. It's not the easiest modifier to work with, but the image in **FIGURE 5.18** reminds me that I never regret it when I take chances.

Grid spots

Grid spots are rigid, honeycombed discs that concentrate the light source to varying degrees. Grid spots focus and narrow your light to a tightly controlled beam that you can place wherever you want. I have a set of 7-inch round grids that come in 10, 20, 30, and 40 degrees. The smaller the number, the narrower the beam of light. The modeling light in studio strobes is invaluable when you're using grid spots, because

you can see where the light is falling. I don't use grid spots very often with kids, but every now and then they come in handy, like when I want to create a spotlight effect. In **FIGURE 5.19** you can see the effect of just a bare bulb flash with no grid spots. In **FIGURE 5.20** I used a 30-degree honeycomb grid on the front of the light to concentrate the spotlight on this movie-star-in-training.

Soft honeycomb grids

Honeycomb grids (aka egg crates) are big, soft grids that you can use on big, diffused light modifiers like an Octabank or a softbox. At first, this may seem counterintuitive. Why would you use what is typically a hard-light modifier on a diffused light source? Remember that the primary use of grids is to concentrate and control the light. Used on an Octabank or softbox, the honeycomb grid actually does three things: It cuts the light by one stop, it increases the contrast, and it controls the spill of light. So, if you feel like the light from a softbox is losing its drama, just pop on a honeycomb grid; you'll still have a big, soft light

FIGURE 5.19 A bare-bulb flash with no grid spot makes a spotlight but spills light more than I want it to (above right).
ISO 100, 1/200 sec., f/5.6, 70–200mm lens

FIGURE 5.20 Adding a 30-degree grid spot to the front of the light narrows and concentrates the light right where I want it (right).
ISO 100, 1/200 sec., f/5.6, 70–200mm lens

source but with an extra punch of contrast and total control of where you want the light to fall. This is especially important for me because my studio is a white box, and if I don't control the light, it bounces everywhere, making it almost impossible to get a dark, moody look.

Subtractive Lighting

An often overlooked, yet valuable type of light modification is subtractive lighting. Subtractive lighting is somewhat of an oxymoron, but

FIGURE 5.21 My typical beginning setup for lighting my subjects creates a "fort" of light with a main light camera left and a V-flat camera right.

ISO 100, 1/200 sec., f/5.6, 70–200mm lens

the term refers to methods used to reduce or eliminate light from reaching your subject. You can also use subtractive lighting to block light from spilling onto your background or to block light from hitting your lens if the light is aimed toward the camera.

V-flats

V-flats are also used for subtractive lighting, but in this situation the black side faces your subject. A black modifier actually reflects black onto your subject, intensifying the shadows and increasing the contrast in the image.

Gobos

Gobo (*goes before/between optics*) is a term used in the film industry that refers to anything used to control the shape of the light; gobos are also called *flags* or *cutters*. In the photography world, gobos are most often used for blocking a light source from striking your lens or to keep light from hitting your background. A V-flat can act as a gobo if you put it between a light and the camera. You'll learn how to use V-flats as gobos in Chapter 7.

A Place to Start

The lighting setup I start with most of the time consists of one main light and a V-flat reflector as fill. I almost always light my background separately from my subject. Sometimes I light the background separately to create a high-key look, and other times I turn off the background lights. Either way, the setup in **FIGURE 5.21** is my typical starting point. This setup creates a light

sandwich with the kid as the meat in the middle. With the softbox on one side and the V-flat on the other you have a nice little pocket of light that feels like a fort to the kid being photographed. It creates a feeling of privacy and safety, in addition to reflecting the light the way I like it. I know I can get a good result from this setup, and then I can add or subtract light from there.

Measure

It's been established that the *quality* of light is much more important than the *quantity* of light, but at some point you have to evaluate the results you're getting. Is the image overexposed? Is it underexposed? You need to measure the light. Just like it took time to learn to see the light when you began photographing in natural light, it will take time to learn to see how a given studio lighting setup will look in the final image. Measuring the light with a meter can help you learn the results of a lighting setup faster. However, you first need to have a solid knowledge of some exposure basics.

When you're shooting in natural light, you have only three exposure variables to be concerned with on your camera. The three are commonly known as the *exposure triangle* (**FIGURE 5.22**):

- **ISO.** Your camera sensor's sensitivity to light
- **Aperture or f-stop.** How wide or small the opening in your lens is, creating depth of field
- **Shutter speed.** How fast or slow the shutter opens and closes, freezing or blurring action

Once you decide to incorporate flash into the mix, you add two additional variables to the exposure triangle, which are the two P's of flash exposure (**FIGURE 5.23**):

- **Power of flash.** The amount of light being produced by the flash
- **Proximity of flash.** How close or far away your light is in relation to your subject

FIGURE 5.22 The famous exposure triangle shows the relationship of ISO, aperture, and shutter speed.

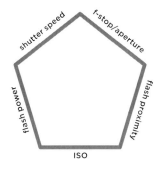

FIGURE 5.23 The not-so-famous exposure pentagon shows the relationship of ISO, aperture, and shutter speed plus power and proximity of flash.

My Lighting Gear

During my career, I've used many different brands of lighting gear, including the garage lights mentioned in Chapter 4. When I could afford to upgrade my gear, I bought a Profoto strobe system. Most rental houses all over the world rent Profoto gear, which indicates how reliable it is. Profoto strobes give me the power, consistency, and fast recycle times I need when photographing wild children.

My first studio lights were a used pair of ancient Bowens monolights that only had on/off settings. I purchased them from an established photographer who was getting rid of old equipment, and they served me well for a couple of years until I could save up to buy more powerful and more controllable lights. My current lighting gear consists of:

- **Two Profoto D1 Air 500 Monolights** (used mostly as background lights). The D1 Airs have their own wireless transmitter, which lets me control these lights from my camera, eliminating the need for an assistant (or me) to run around changing power settings.

- **Profoto Acute 1200R Power Pack strobes with two heads** (I use one head as my main light).

- **Manfrotto heavy-duty rolling light stand with boom arm and sandbag as counterweight.** This rolling light stand and boom are heavy enough to help place my 7-foot Octabank up and over my subjects (more details on this in Chapter 6).

My favorite modifiers were always softboxes, until the Octabank was introduced a few years ago. Octabanks spread the light better because they are shallower than softboxes. The modifiers I use include

- **Seamless Octabank.** I use the 120 cm (approximately 5 feet) Octabank for shooting up to four kids. I use the 250 cm (approximately 7 feet) Seamless Octabank when I need a bigger area of light or when photographing a family or a group of more than four children. Seamless is a relatively new brand of modifier from Ireland. Its modifiers create gorgeous, consistent light and are reasonably priced.

- **Soft honeycomb grids.** Currently, a honeycomb grid is my favorite modifier for my Octabanks, but I also use a honeycomb grid on a Beauty Dish occasionally to concentrate light for dramatic effect. The grid I use the most is the soft honeycomb grid for the front of my 60-inch Seamless Octabank (more on this in Chapter 6).

- **Two Profoto Beauty Dishes.** Both dishes have white interiors and sock diffusers for the background lights, which I use when I'm shooting a high-key setup. I also have a 25-degree honeycomb grid for the Beauty Dish, which I use when I want to concentrate the spill of light.

- **V-flats.** For reflectors and subtractive lighting I prefer V-flats to any commercially manufactured reflectors.

Do these five variables now create an exposure pentagon? Just kidding. The easiest way for me to remember how to incorporate the two extra flash variables is to first break them down into two shooting scenarios:

- **Shooting in studio.** No ambient light
- **Shooting on location.** Using ambient light

Ambient light, also called available or existing light, is the light that exists in a scene but was not put there by the photographer. You can decide to use ambient light as part of your lighting or not. For now, let's proceed as though you are shooting in a studio. You won't consider the ambient light. For lighting setups that take ambient light into consideration, see Chapter 8, "Lighting on Location."

Limit Your Variables

As mentioned earlier, when I'm photographing in the studio, the only light I want in the photo is light that I've put there. In other words, I don't use any of the ambient lighting. My first task is to determine which of the five variables in the exposure pentagon (**FIGURE 5.24**) I can lock down immediately.

Initially, I dial in the settings that won't change during the shoot:

1. **ISO.** I set the camera's ISO to the lowest native ISO setting (usually 100 or 200 ISO) that will give me the cleanest file with the least digital noise possible.

2. **Shutter speed (sync speed).** I then set my shutter speed to my camera's sync speed, which on a Nikon D4 is 1/200 of a second (sync speed was discussed in Chapter 4).

You can see by the shooting data on virtually every studio photo in this book that my ISO is at 100 and my shutter speed is 1/200 second. Two variables are locked down—check.

Now all I have to decide on is my aperture setting, or f-stop. Remember that the aperture setting will be determined by the main light's *power* setting and the *proximity* to the subject.

STUDIO LIGHTING CHECKLIST

- ☑ ISO
- ☑ SHUTTER
- ☐ F-STOP
- ☐ PROXIMITY
- ☐ POWER

FIGURE 5.24 Five elements in the exposure pentagon.

Next, I shoot a picture and evaluate the exposure. If it's not right, I'm back to just three variables to adjust:

1. Change my f-stop (wider or smaller).
2. Change the power of the light (brighter or dimmer).
3. Move the light closer or farther from the subject (brighter or dimmer).

This process is much easier to figure out in practice than it is in theory. So, go shoot something, measure the results, and then readjust your settings. That's the only way you'll learn how to measure your results and make good photos.

Move

The last variable to consider in the five M's of lighting is the proximity of the light to your subject. In other words, if the light still doesn't look the way you want it to, you may need to *move* it (or your subject). Where you move the light will affect the look of your image more than any other variable. You can measure and modify the light all you want, but if the light is in the wrong spot, your image still won't look good.

The two most important factors to remember when you're positioning a light to produce a soft, flattering look are:

- A bigger light source is better in relation to your subject.
- Move the light in close to your subject. Very, very close.

It's All Relative

Close and far, big and small are all relative terms to describe where you place the light *in relation to your subject*.

As portrait photographers, you want soft, diffused light with a smooth shadow transfer. To get this look, it's wise to use a *big* light source. But how big is big? Are you photographing a newborn or a 12-year-old? In relation to a newborn, a 24-inch softbox is big, but not so much for the 12-year-old. So you want a big light in relation to your subject.

Where you move the light will affect the look of your image more than any other variable.

Do You Need a Flash Meter?

It is possible to use the LCD screen on your digital camera as a kind of light meter. It's not as accurate as a light meter, but it will get you in the ballpark of correct exposure. When you begin shooting with strobes, take note of how accurate your LCD screen is by comparing how the exposure looks once you load the files onto your computer. You might be surprised at the difference. Pull up a file on your computer and then adjust the brightness of your LCD screen on your camera so it matches what you see on your computer screen. This will help you make your exposures more accurate.

Another handy way to evaluate your exposure without a flash meter is to set your camera's LCD screen to show the "blinking highlights." These will indicate when you have blown out or "clipped" your highlights because they will blink on and off to alert you that there is no information or detail in the highlights. I prefer this method to reading a histogram on the LCD. The reason is that I tend to use dramatic lighting with lots of shadow or high-key setups with very bright background light, and trying to keep the histogram curve in the middle doesn't allow for that dramatic lighting. If you try to keep the histogram in the middle, you'll have all the information but none of the drama. So find the blinking highlights; they will save you from complete exposure disaster.

Either of these methods will work to get acceptable exposures. Especially if you are using just one light, you may never need a flash exposure meter. However, if you'll be using more than one light—for example, when you're lighting your background separately from your subject as in a high-key lighting setup—it is *much* faster and more accurate to use a flash meter to determine your exposure.

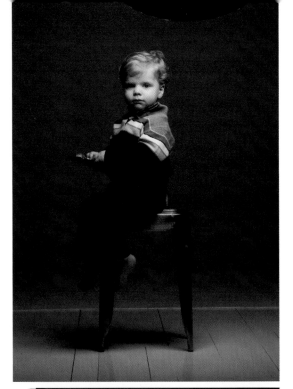

Moving the light changes the size of the light in relation to your subject. The easiest way to make a light source bigger is to move it closer to your subject. Move the light out farther from your subject and it becomes smaller in relation to your subject.

A *small* 24-inch Beauty Dish can become a relatively large light source when you place it 6 inches from a toddler's head, as in **FIGURE 5.25**. On the other hand, a *big* 60-inch Octabank can become a relatively small light source if you place it 15 feet across the room from your subject.

So when you hear that a bigger light source is best for portraits, that means a bigger light source *in relation to your subject.* All you need to do to make almost any light source bigger is just bring it closer to your subject, *very close.* At my studio we are constantly having to retouch the lights out of a shot because I work with the light in very close. In **FIGURE 5.26** you can see that the Octabank is just inches from the little boy.

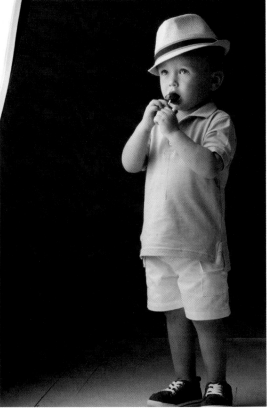

FIGURE 5.25 A relatively small light source, a 24-inch Beauty Dish, becomes big when it's brought in closer to the subject (above right).

ISO 100, 1/200 sec., f/5.6, 70–200mm lens

FIGURE 5.26 A light source so close to the subject that the image will have to be recropped or retouched because the light was in the frame is just an occupational hazard (right).

ISO 100, 1/200 sec., f/5.6, 70–200mm lens

If you are a natural-light shooter, the concept of bigger is better when it comes to lighting may not be foreign to you. But somehow when you make the leap into the world of flash, you might forget the lessons that your natural-light experience taught you. A common mistake when you start shooting with flash is that if the light from the flash is too bright, you think you should move the light farther away so it will be softer. But, actually, the opposite is true. The farther the light is from your subject, the smaller the light source becomes *in relation to your subject,* which makes the light harder. So, if the light is too bright, instead of moving it away, *power down the light and keep it close* to your subject.

If you power down the light as low as it will go and it's still too bright, close down your aperture to cut the light or use a neutral density filter, but don't move that light farther away from your subject!

When you're considering how close or far the light should be from your subject, use this general rule of thumb: Keep the light closer than a distance of 2x the width of the modifier you are using. For example, if you are using a 60-inch Octabank, don't place the light farther than 120 inches away from your subject. Once you approach a distance of about 2x the width of the modifier, the light looks harsh and unflattering.

Remember that closer equals softer light and farther away equals harder light. The easiest way to visualize this concept is to think of the light you're using as a window.

Tip: If you've dialed your strobe light power down as it as low as it will go and it's still putting out too much light for a wider aperture setting, try using a neutral density (ND) filter on your lens to cut the light. Variable ND filters are designed to cut the light in a scene, allowing you to shoot with wider apertures for shorter depth of field.

The Light as a Window

A vivid "aha" moment in my lighting education came at a workshop, watching the instructor set up a window-light portrait. I admired portraits lit using only the light from a window. The dimensional quality of window light seems to caress the skin of the subject. But somehow *my* window light portraits never looked like the shots I admired, and I couldn't figure out why.

I watched as the instructor positioned the model with her shoulder right up against the window casing and her face just inches from the window, and there it was, the light I'd been searching for bathing her face. In an instant I saw that the closer the subject is to the light, the softer the light becomes. The reason I didn't like my window-lit portraits was because I had been shooting with my subject too far from the actual window, which resulted in hard light. I also realized how my lighting results could differ dramatically just by changing where I placed my subjects in relation to the window—not just closer or farther from the window, but their angle in relation to the window. This made it easier to make the transition to shooting with studio flash.

In an instant I saw that the closer the subject is to the light, the softer the light becomes.

Once I made the jump to using studio flash, I incorporated my experience with window light and thought of my softboxes as windows, which made it easier to figure out where to move my lights in relation to my subject.

Imagine that an Octabank is your window. Where would you place your subject in relation to the window to get the best quality of light?

In **FIGURE 5.27** I placed the boy on the back side of the light—the same place you would begin with a window light portrait. The light falling on him had some dimension; the shadow transfer was soft with no harsh shadows (**FIGURE 5.28**).

For the next shot (**FIGURE 5.29**) I moved him closer to the middle of the light. Placing him at almost 90 degrees to the light created more drama with darker shadows, but the shadow transfer was still soft because he was still very close to the light. If he had turned more straight on to the camera, the effect would have shown more split light on his face, with one side in light and the other in shadow (**FIGURE 5.30**). When I moved him closer to the front side of the Octabank (**FIGURE 5.31**), I started to lose detail in the shadow side of his face because most of the light was now behind him (**FIGURE 5.32**).

FIGURES 5.27 AND 5.28 Using the Octabank like a window, I positioned my subject on the back side with most of the light in front of him. Positioning your subject on the back side of the light allows the Octabank to light the area in front, resulting in soft, flattering light.

ISO 100, 1/200 sec., f/5.6, 70–200mm lens

FIGURES 5.29 AND 5.30 By moving the boy to roughly 90 degrees to the light, most of the light is still in front of him, but he is closer to the center of the light. The 90-degree position creates more drama in the shadows, but the shadow transfer is still soft because he's still very close to the light. This position creates a split light pattern (half in light, half in shadow) on his face.

ISO 100, 1/200 sec., f/5.6, 70–200mm lens

FIGURES 5.31 AND 5.32 Moving the boy closer to the front of the light results in most of the light being behind him. The closer the boy gets to the front of the light, the darker the shadows on his face become. The reason is that he has moved past the center of the light, and there is not enough light in front of him to illuminate his face.

ISO 100, 1/200 sec., f/5.6, 70–200mm lens

Grip Equipment

Grip equipment consists of the all the gear that holds up your lights or allows you to move and keep the lights where you want them. Getting the light where you want it and keeping it there are critical. Here is a list of the essential equipment you'll need:

FIGURE 5.33 Get a grip on your lights with the right stands and grip equipment (opposite page).

ISO 100, 1/200 sec., f/5.6, 70–200mm lens

- **Light stands.** Invest in light stands with wheels, especially for your main light (**FIGURE 5.33**). Movable stands allow you to move your lights quickly and easily. Light stands by companies like Avenger and Manfrotto are heavy duty, and you'll get years of use from them. C-stands are heavy chrome stands that are great for a light that you don't need to move. If you buy a C-stand, make sure you purchase the C-stand arm that clamps to the C-stand. This is helpful to clamp reflectors to and also allows you to use it as a short boom arm to position your light up and over your subject.

- **Boom arm.** A boom arm mounts to your light stand and allows you to get your light up and over your subject. The bigger the modifier, the bigger the boom you'll need. Chapter 6 discusses more about light placement.

Note: Light stands with strobe heads on the top are, by nature, top heavy, so having a stack of sandbags on hand is a good idea to help counterbalance that weight and keep kids from pulling over your equipment during a shoot.

- **Sandbags.** If you're using a light on a stand, you need a sandbag to keep it from tipping over if it is bumped. You're photographing kids and kids can get crazy, so take precautions.

- **Gaffer tape.** A cloth tape available in white, black, or gray, gaffer tape is like duct tape except it's thinner and doesn't leave a residue. And like duct tape, gaffer tape has a million uses. Use it for taping down cords to avoid tripping on them. It's a must-have for creating V-flats. You can also use it for taping down the ends of your seamless background paper to the floor. I've used it for weird things too—to "hem" a child's dress or pants, or to cover a power outlet in the floor or a light switch on a white wall, making them easier to remove later in Photoshop.

Use the five M's the next time you have a shoot. Begin with the mood in mind, select the main light, modify the light, measure the exposure coming from the light, and then finesse and move the light until it looks the way you like it. Make it easy on yourself and start with just one light.

Skill in photography is acquired
by practice, not by purchase.
—Percy W. Harris

One Light, Five Ways in the Studio

THERE'S NO NEED TO RUN OUT and spend a fortune on lights when you can get gorgeous results with a single studio strobe. In fact, you may never want to use more than one light. Working with just one light makes learning how to light faster and easier. Your only concern is that one light, and that's plenty to concentrate on, because when you're photographing kids, you have enough to worry about.

In this chapter you'll explore some time-tested, one-light methods and a few you may not have thought of. You can use one light in many ways. Here I'll detail my five favorites: feathering the light, up and over, Rembrandt-ish, one-light silhouettes, and spotlight drama. The first three are the starting point for almost every studio shoot I do.

ISO 100, 1/200 sec., f/9, 70–200mm lens

#1 Feathering the Light

I am constantly working on the "back edge" of whatever light modifier I'm using. That means I start by placing my subjects slightly behind the back side of the softbox, Octabank, or whatever modifier I'm using on my main light. I then move the light toward my subject an inch or so at a time until I like how the light looks. This technique is called *feathering the light.* When you're feathering the light, you place your subjects toward the back edge of the light modifier, as illustrated in **FIGURE 6.1**, essentially lighting the area just in front of them. This sends the brightest part of the light past the subjects, allowing the less powerful rays at the side of the light modifier to illuminate your subjects. The result? Gorgeous light (**FIGURE 6.2**).

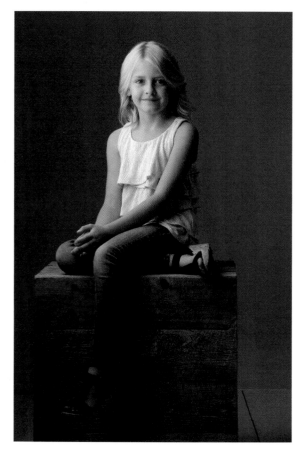

FIGURE 6.1 Feathering the light across your subjects requires correct placement of your light. Then place your subjects a tiny bit behind the light and have them inch forward until the light just starts to fall on their faces (above).

FIGURE 6.2 Working off the back edge of the light feathers the light across your subject and results in a gorgeous, soft, dimensional light (right).

ISO 100, 1/200 sec., f/9, 70–200mm lens

When you're photographing a single child, feathering the light is pretty straightforward. But when you're photographing more than one kid, it can be a challenge to achieve an even lighting pattern on all of them. Some photographers may resort to using multiple lights to light a group, but I much prefer the look of a single light source. To me, the image has a more organic, less contrived feel, and working with a single light allows me to worry less about equipment and more about connecting with my subjects. The only downside to using a single light when photographing a group is the challenge of creating consistent lighting on every kid.

In fact, the most common question I'm asked about lighting is, "How do you get the light even across a *group* of kids?" The reason this question is asked so often is that when you're lighting a group of kids, the child closest to the light is usually brightly lit and the kid farthest from the light is in shadow, even when you're using a reflector opposite the main light, as in **FIGURE 6.3**.

FIGURE 6.3 Here is a common mistake when lighting a lineup of kids. The kid closest to the light is too bright, and the kid farthest from the light is too dark.

ISO 100, 1/200 sec., f/11, 24–70mm lens

Why does this lighting dilemma occur? It is because of the inverse square law that photographers use every day but that only engineers seem to be able to explain. Basically, the inverse square law means that when your subject is close to the light, the light falls off more quickly than when your subject is farther away from the light. The answer to the problem then would seem to be to place your subjects farther from the light; however, for portraits, I want soft light, which means I need to use a big light source in relation to my subject, and making the light big usually means it needs to be close to my subject. Recall that when you place the light farther away from your subject, the light becomes harder, and I try to avoid that harsh light in my portraits. So, how can I have the light close and *still* get even light across my subjects?

The solution is a combination of three components:

1. **Use a very big light modifier on your strobe.** I like to work with my light in very close to my subject to keep the light soft, but when you're photographing a group, you may need to pull it back a bit to get a better light spread across all your subjects. Having a very large modifier on your light allows you to pull it back a little and still keep the light source large (i.e., soft) in relation to your subjects. So start with as big a modifier as you can, and remember that little rule from Chapter 5: Don't move your light farther away from your subjects than 2x the diameter of your light modifier. If you have a 60-inch Octabank, keep your light 120 inches or closer to your subjects (I suggest a *lot* closer).

2. **Feather the light across your subjects.** Feathering light across a group of kids is a little different than doing it with one child. The trick is to aim the center (or brightest) part of your light source toward the child that is farthest from the light. Feathering the light this way requires that you angle your light toward your subjects, as shown in **FIGURE 6.4**. This directs the brightest part of the light at the kid who needs it most (the one farthest from the light source) while allowing the softer light at the sides of the modifier to illuminate the kids closer to the light (**FIGURE 6.5**), resulting in nice, even light across the board. Everyone wins.

The trick is to aim the center (or brightest) part of your light source toward the child that is farthest from the light.

FIGURE 6.4 In this feathering scenario, the light has been brought forward and then angled back toward the group, with the center of the light angled toward the child on the far right. The V-flat reflector opposite the light lifts the shadows on the kid farthest from the light.

FIGURE 6.5 Although the softbox on the left is very close to my subjects, angling the center of the light toward the boy on the far right gives him plenty of light and prevents the girl on the left from being overlit. The softer light from the sides of the softbox evens out the light on everyone in between.

ISO 100, 1/200 sec., f/8, 70–200mm lens

3. **Work the angles of the kids toward the light.** Another way to get even light across multiple kids is to stagger where you place the kids when posing them so they are at an angle to the light (**FIGURE 6.6**), making sure there is light on each kid's face. In addition, make sure that there aren't any weird shadows being cast from one kid to the next. This usually requires small adjustments to get the light to fall on everyone evenly. If you are working with a large group and the kid farthest from the light is getting a bit too dark, just pop in a reflector on that far side to fill in any dark shadows (**FIGURE 6.7**).

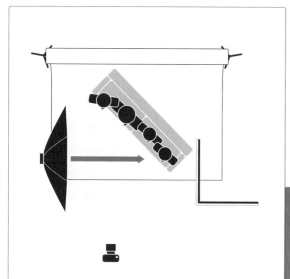

FIGURE 6.6 You can angle the light toward your subjects or angle your subjects toward the light. Either way, notice that the center (bright part) of the light is still pointed toward the subject farthest from the light (left).

FIGURE 6.7 Even light was achieved here by angling the sofa toward the light and carefully positioning each child. Light is on each face, and no distracting shadows are being cast from one kid to another (right).

ISO 100, 1/200 sec., f/11, 70-200mm lens

Catchlights are those desirable little reflections you see in a subject's eyes that provide life and sparkle to a portrait. You don't *have* to have catchlights for a portrait to be successful, but it's good to know how to get them if you want them. Seeing catchlights is also a perfect way for you to determine if your main light is in the right position (not too high or too low). If you think of eyes as clocks, look for catchlights in either the 10 or 2 o'clock position in your subject's eyes (depending on whether you are lighting the subject from the right or left side). To see catchlights in the 10 or 2 o'clock position, the center of the main light should be positioned slightly above your subject's eye line. You usually want to have only one set of catchlights in a subject's eyes; this is another good reason to use just one light.

#2 Up and Over

My next, most commonly used lighting setup is what I call the *Up and Over*. Basically, it consists of a 60-inch Octabank positioned up and over my subjects (**FIGURE 6.8**). Again, I work the back side of the light modifier just like I do when I have my light to the side. I'll pose my subjects on the back side of the light and inch them forward until I like how they look. A common mistake with the Up and Over setup is the *Panda Eye Effect*, which produces dark eye sockets and no light in the subjects' eyes (**FIGURE 6.9**). This happens when your subjects have unusually deep-set eyes, if your light is a little too flat on top, or if the child is too far forward under the light.

The solution to the Panda Eye Effect is to slightly angle the light so the side of the box closest to the camera is lower than the side of the box closest to the subjects. In other words, I angle the light toward my subjects, not a lot, just a little, as shown in the side view of Figure 6.8. Having your subjects slightly lift their chin a bit will also help get light in their eyes.

Having your subjects slightly lift their chin a bit will also help get light in their eyes.

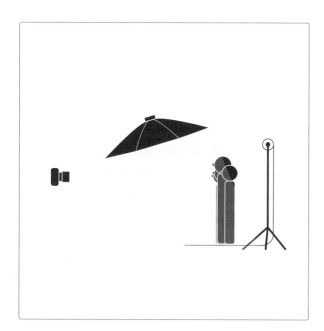

FIGURE 6.8 Up and Over lighting is created by placing the light up and over your subject using a light stand with a boom arm and a big light modifier (left, below left).

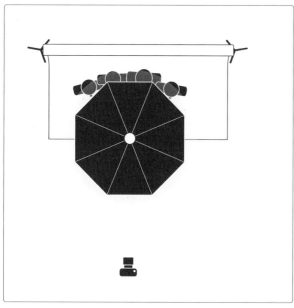

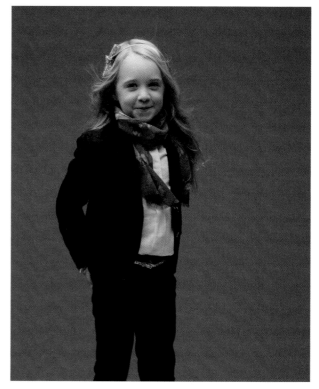

FIGURE 6.9 Watch for the dreaded Panda Eye Effect in your subjects when you're using an Up and Over setup (above).

ISO 100, 1/200 sec., f/9, 70-200mm lens

The official name for the Up and Over lighting pattern is *Butterfly Lighting* because the shadows that fall create a butterfly shape under the nose of the subject. I use this lighting setup for two main reasons:

1. When I want to light an entire group quickly and evenly, and I'm working with kids who won't stay still for long. The Up and Over setup gives me more room for good light front to back and allows for a few wiggles (**FIGURE 6.10**).

2. When I want variation. The Up and Over setup produces a look that is more modern and editorial in feel—a different look than the light coming from a side angle. I also like the look of an illuminated face with shadows falling under the chin.

FIGURE 6.10 The Up and Over setup can easily and evenly light a group of kids, and it allows a little more room for them to move around than a side lighting pattern.

ISO 100, 1/200 sec., f/11, 70–200mm lens

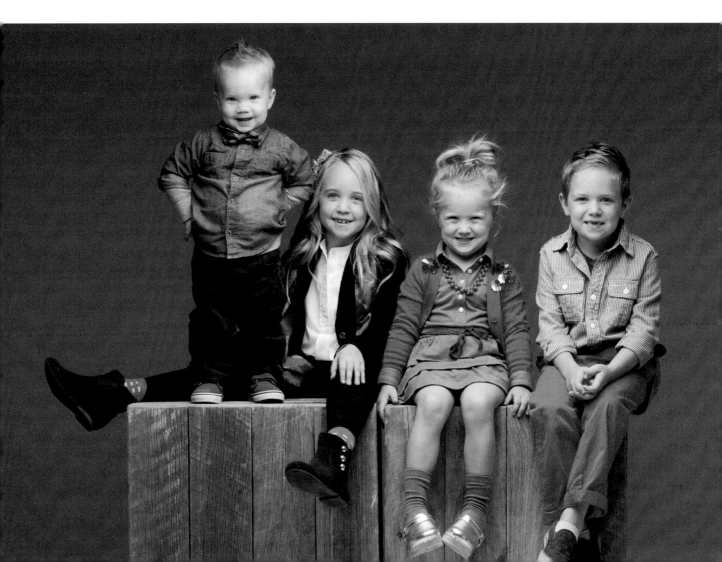

It's important to remember that even though the light is positioned above your subjects, you still want to keep it in close so the light stays soft and flattering. The only downside to the Up and Over setup is that you need decent ceiling height to position your light up high enough to be over your subjects. Fortunately, because you're photographing kids, you don't need ceilings as high as you would for adults. Still, if you have eight-foot ceilings, it may be a challenge to place the light high enough. The shallower your light modifier, the easier it is to get the light higher.

The Up and Over Grip

Getting your light up and over your subjects can be a challenge with a large light modifier on your strobe. Because I often shoot with a 5- to 7-foot Octabank on my light, I mount my light to a heavy-duty rolling light stand from Avenger (the A5042CS). On top of the light stand, holding the light up and over is the Avenger D600 Boom Arm counterweighted with a sandbag on the back (**FIGURE 6.11**). My camera store rigged up a super clamp with a connector that clamps directly to the boom arm, enabling all that metal to hold the light versus the small sleeve that normally holds a strobe head. You just clamp the light into the speed ring directly, and the super clamp holds the weight (**FIGURE 6.12**).

FIGURE 6.11 A rolling light stand with a boom arm and a sandbag creates a sturdy setup for Up and Over lighting.

FIGURE 6.12 A speed ring is rigged up to hold a heavy Octabank to the boom arm.

#3 Rembrandt-ish

The lighting pattern that everyone seems to have heard of is the Rembrandt lighting pattern. It's the one where your light is at a 45-degree angle to your subject with one side of the face mostly in shadow, except for a little upside-down triangle of light on the cheek farthest from the light. The Rembrandt look is all about creating dimension using light and shadow. Almost all of Rembrandt's work appears as though it was lit with the subject at a 45-degree angle to a single light source, such as a window or doorway.

As I've experimented with various angles using one light for the Rembrandt look, I've found that I like to work with my subject at a sharper, almost 90-degree angle to the light. This angle lets me control the light hitting my background better than the 45-degree angle. Because the light is angled past my subject and not toward the background, it is easier to get a dark, low-key look. A 70- to 90- degree angle also creates darker, more dramatic shadows—a good fit if you're trying to achieve a moodier, more fine-art feel to your image.

Rembrandt with a Grid

The honeycomb grid is my favorite "modifier of a modifier" when I need lighting that produces a dramatic and painterly feel. When I'm working with one subject and I want a low-key look, I'll attach a honeycomb grid to the front of my Octabank.

When used on the front of the Octabank, a grid increases the contrast in the image, cuts the power of the light (allowing me to use wider apertures), and completely controls how much light is falling on my background. Notice in the image in **FIGURE 6.13** that the girl (and my light) are fairly close to the background, but there is very little light falling on it. The reason is that the grid is corralling the light and sending it only where I want it to go.

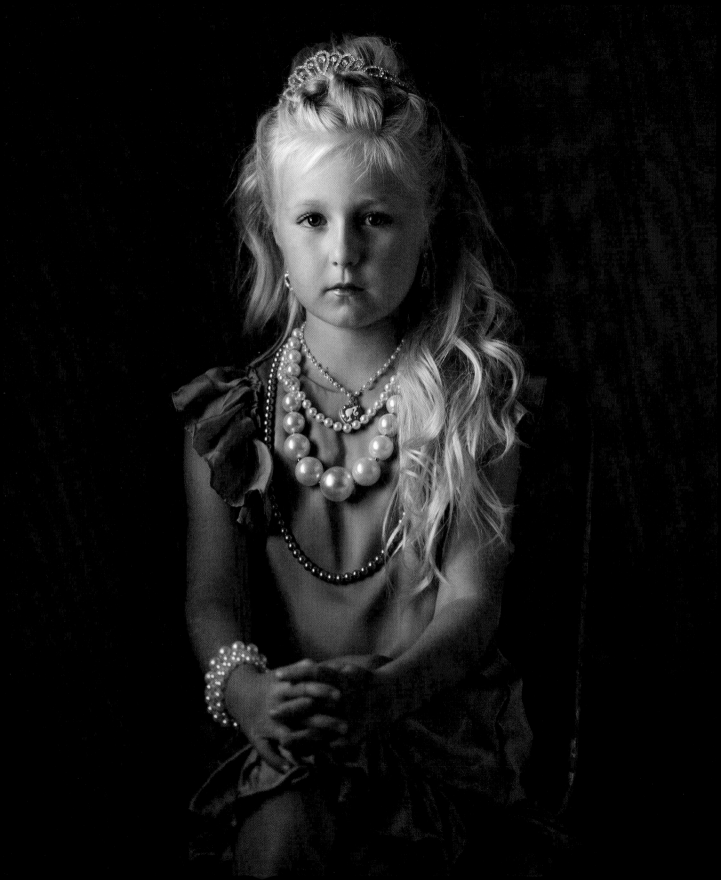

The Rembrandt look is all about creating dimension using light and shadow.

Notice also that the grid concentrates the light so well in the image that the girl's hands are darker than her chest. If the grid wasn't attached, the light would be pretty even on both areas. Using the honeycomb grid to modify the Octabank allowed me to concentrate the light right where I wanted it, on the girl's face.

FIGURE 6.13 Set between 45 and 90 degrees, a 5-foot Octabank fitted with a honeycomb grid cut the light power by almost two stops (opposite page).

ISO 100, 1/200 sec., f/2.8, 70–200mm lens

#4 One-Light Silhouettes

The one-light silhouette technique usually requires a minimum of three lights and a white seamless background. But it is possible to create beautiful silhouettes with just one light; here's how:

1. Place one light with a large modifier, such as a softbox or Octabank, facing straight on to the camera, as shown in **FIGURE 6.14**, so you are shooting directly into the light.

2. Place a low stool in front of the light to anchor your subject to the spot in front of your light. I prefer a stool for this because I don't want a chair back or arms getting into the shot.

3. Place your subject either in profile or with his or her back to the light.

4. Set your camera exposure based on the type of results you want to create.

For the silhouettes with no detail and the sort-of silhouettes (both discussed next), I set my light power at its lowest setting so the light isn't blasting at full power into my lens.

FIGURE 6.14 In this setup I used a 60-inch seamless Octabank, which is sufficient for one or two subjects (above).

ISO 100, 1/200 sec., f/5.6, 70–200mm lens

FIGURE 6.15 When you create a silhouette with no detail, the pose and shape of the subject is most important because the outline is all you see.

ISO 100, 1/200 sec., f/5.6, 70–200mm lens

Tip: With both silhouette styles you are shooting directly into a strobe light source, and not all lenses are well-suited for this technique. Some will produce bad lens flare and others will be fine. My Nikkor 70–200mm 2.8 G VR works the best, but my Nikkor 50mm 1.2 shows the flare horribly and is unusable in this type of lighting scenario. Experiment with your own equipment; if it doesn't work with one lens, try another.

Silhouettes with No Detail

Silhouettes with no detail (e.g., the iPod commercial look) require you to set your exposure for the light and let the subject fall completely into shadow. The full silhouette can be shot in profile or in full body pose. A bit of detail may still appear, but you can easily get rid of it in postproduction by using the Levels tool in Photoshop to increase the contrast until the silhouette is completely black. In Levels, just pull the black slider to the right until there is no detail left in the dark areas of the shot. With the full silhouette, the shape of the profile or pose is critical because there is no detail in the features. Therefore, it's important to pose the child so it's obvious what the child is doing (**FIGURE 6.15**).

Sort-of Silhouettes

Sort-of silhouettes are silhouettes with some detail left in the features and are my favorite way to shoot silhouettes. Sort-of silhouettes are shot in profile to show expression and some detail (**FIGURE 6.16**). Set your camera exposure by metering for the light. If you don't have a light meter, just use the LCD on the back of your camera to evaluate and adjust the lighting or your exposure until you like how the silhouette looks. You want the background to be completely white and your subject to be completely dark except for a bit of detail in the profile of the face. Remember to keep your ISO and your shutter speed constant, and just fiddle with the power settings on the light or your aperture to get the look that you want. If you have a light meter, you'll want the light to be about two stops brighter than the front (camera side) of your subject, and because there is no light on the front of your subject, the child will fall into shadow—hence the silhouette.

Sort-of silhouettes are shot in profile to show expression and some detail.

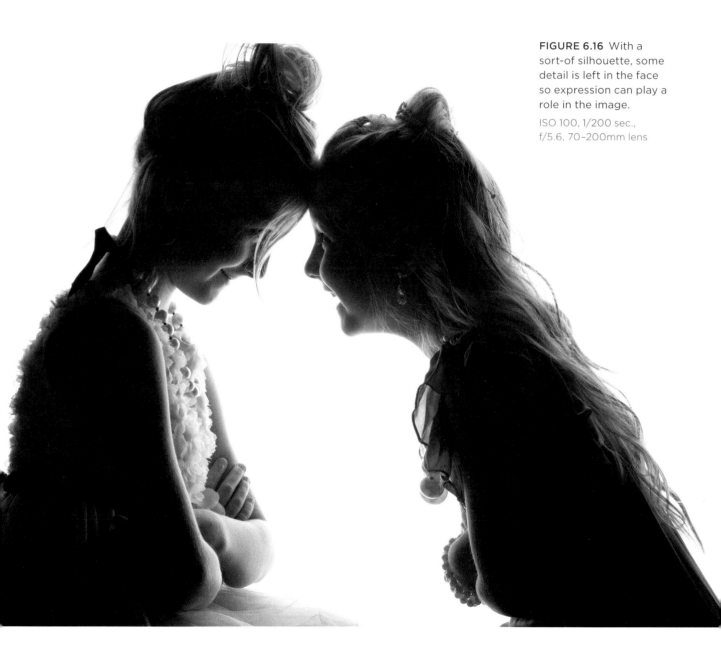

FIGURE 6.16 With a sort-of silhouette, some detail is left in the face so expression can play a role in the image.

ISO 100, 1/200 sec., f/5.6, 70–200mm lens

#5 Spotlight Drama

Grid spots make lighting with one light fun. With a grid on your light, you control exactly where the light goes, illuminating only what you want to light and nothing more. If you use the Up and Over setup and then add a grid, you can create a feeling of heavenly light from above. A quick way to position your subjects correctly is to have them look directly at the lightbulb. If they can see through the grid to the light, they are in the right spot; if all they see is black, the grid will be directing the light past their face. When you're working with grids, correct light placement becomes a matter of inches, so if at first you don't succeed, move the light just a little until you do.

When the light is up and over the subject with a grid attached, it will create very dark shadows in the eye sockets, so have your subjects lift their chin or even tilt their head directly toward the light. The image in **FIGURE 6.17** was lit with a Beauty Dish fitted with a 25-degree honeycomb grid, which was placed up and over the girl and her harp using a C-stand with an arm.

FIGURE 6.17 Using a 25-degree grid on a Beauty Dish positioned over the top of this little girl playing her harp gave a dramatic feel of heavenly light to the image (opposite page).

ISO 100, 1/200 sec., f/2.8, 70–200mm lens

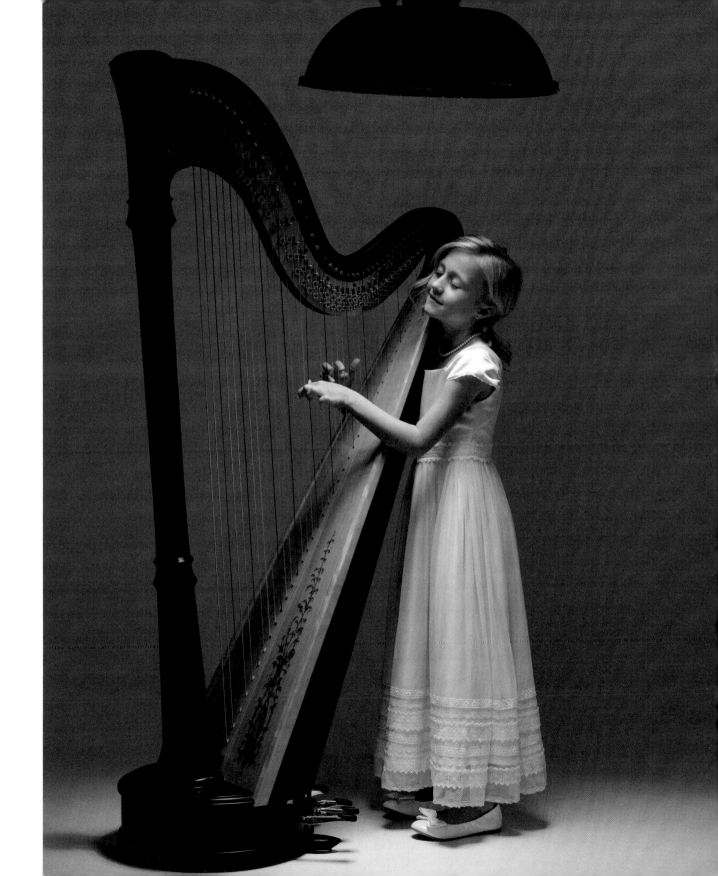

Working with one light is easier than with multiple lights in that you have fewer variables to consider, but it becomes even more important to position the light correctly and avoid these common beginner mistakes when you're learning to light with studio strobes:

1. **Light height too low.** Kids are little people, but even so you want to make sure you don't position your light too low in relation to your subject's face. This creates unflattering shadows that just don't look right (**FIGURE 6.18**). Keep the center of the light slightly *above* your subject's eye level for the best results and proper catchlight placement.

2. **Subject too close to the background.** If your subject is too close to the background, you'll be fighting with your subject's shadow falling onto the background, as in **FIGURE 6.19**. Pull your subject forward at least 4 to 6 feet in front of your background to make lighting your subject much easier.

3. **Light too far away from subject.** I know I've said this a million times, but if you've set up your lighting and hate the results, your light is probably too far from your subject. Get the light as close as you can without it being in the shot, or let the light be in the shot and eliminate it later in post. Good light is the most important goal; the corner of a softbox appearing your image is a small price to pay for gorgeous light on your subject.

4. **Too many lights.** When you're not getting enough light on your subject, it can be tempting to just set up more lights. Don't do it. Start with a single light source. Add in reflectors as fill if needed, and only when you've explored the limits of that single source should you add in more lights. More lights can create weird cross shadows (**FIGURE 6.20**) and make lighting more confusing for you because it's difficult to isolate the problems when you're working with too many variables. Keep it simple, especially when you're learning. You'll learn faster and be able to see what you are doing.

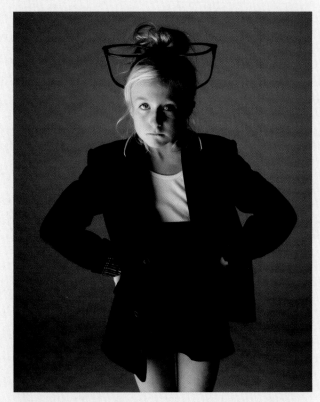

FIGURE 6.18 Positioning your light below your subject's eye height results in the unflattering "monster lighting" made famous by horror movies. Unless you are using this technique intentionally, plan on positioning the center of your light just above your subject's eye level.

ISO 100, 1/200 sec., f/5.6, 70–200mm lens

5. **Boring light.** There is no shortage of images with boring light in this world. Just because the exposure is correct doesn't mean the lighting is interesting. To make the light in your images more interesting requires a little risk taking. You must be willing to get the light wrong before you get it right. A good place to begin experimenting is with your lighting angles. Work the light at an angle to your subject or vice versa until you get the dimension and drama you are looking for. I've found that good lighting is created in incremental movements, usually a matter of inches. You're closer than you think to getting great lighting, just keep working it until you get the look you want.

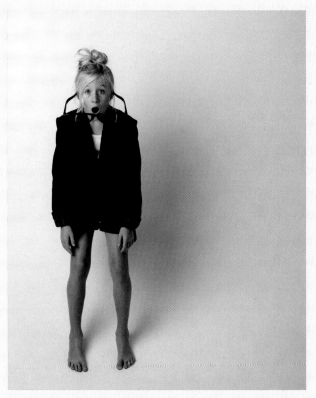

FIGURE 6.19 If your subject is too close to the background, you run the risk of casting the subject's shadow onto the background with your light. Pull your subject 4 to 6 feet in front of the background for better control of how the light affects your background.

ISO 100, 1/200 sec., f/5.6, 70–200mm lens

FIGURE 6.20 Adding more and more lights is almost never a good solution. Too many lights can result in distracting shadows.

ISO 100, 1/200 sec., f/5.6, 70–200mm lens

If art is the bridge between what you see in your mind and what the world sees, then skill is how you build that bridge. —Twyla Tharp

The White Seamless Manifesto

A WHITE SEAMLESS BACKGROUND is something you see every day but never think about. Popular in advertisements, the white seamless background features the subject, while allowing a clean space for type and graphics.

But the white seamless isn't just for commercial use. Portrait photographers have been shooting on white backgrounds for a long time. Richard Avedon used the white background with a wide range of subjects, from celebrities to migrant farm workers. With nothing to distract from the subject, his images are immediate and arresting.

In this chapter, you'll learn how to properly light the background and your subject for successful white seamless portraits of your own.

ISO 100, 1/200 sec., f/9, 70–200mm lens

The Setup

At this point in the studio lighting discussion, let's consider the background you're using. Before you get lured down the path of using the mottled, muslin backdrop, I want to make a case for the white seamless. White seamless is an ideal background for shooting high-energy kids and highlighting their expressions and antics (**FIGURE 7.1**).

A white seamless background looks simple enough to use; however, lighting it right is anything but. When lit correctly, the background will be a featureless white, meaning there is no detail in the white behind your subjects. Your subjects will be lit separately from the background and have perfect, dimensional light falling on them without any flare or crazy light coming from the all-white background behind them. Easy, right? Not exactly. Let's review the process step by step.

The Seamless Paper Background

The most commonly used background for a white seamless setup is a white seamless roll of paper. Seamless rolls come in standard sizes of 26-, 53-, 107-, and 112-inch widths in varying roll lengths. If you're photographing newborns or one or two kids at a time, you could get away with using the 53-inch width, but I'd recommend starting with the 107-inch width for maximum flexibility, and at approximately $65, white seamless paper is the cheapest background available. A well-stocked camera store will carry seamless rolls of paper, or you can order them online. Seamless paper comes rolled onto a cardboard core, which you can hang using a commercial background stand with a crossbar. Background stands come with two light-stand-like supports with a crossbar to put through the roll of paper. I've used several of these background stands, and although they are inexpensive (about $100), they tend to be flimsy. These days when I have to set up a white seamless, I use two C-stands with their arms extended at right angles to each other and put one arm in each side of the seamless roll to hold it up. This eliminates the need for a separate background stand and crossbar setup. I prefer to purchase photographic equipment that has more than one use, and C-stands can double as light

Tip: Two activities that you never should do alone are swim in the ocean at night and put up a seamless paper background. Get help; you'll be glad you did.

White seamless is an ideal background for shooting high-energy kids.

FIGURE 7.2 A white seamless gripped to a C-stand arm using an A clamp to keep the seamless from unrolling.

Tip: If you don't have C-stands or a dedicated background stand, you can gaffer tape the seamless directly to the wall behind your subject and then roll it out and cut it to the desired length.

stands and background stands. They are heavier and sturdier than commercial background stands, and I haven't broken one yet.

To set up a seamless paper background, first remove the seamless from the box and plastic bag it comes in, but *leave the tape on* until you have loaded the paper onto your background stand. You'll want the paper to roll out under the roll core (**FIGURE 7.2**).

With your helper, raise both sides of the background simultaneously to about 4 to 5 feet and carefully remove the tape holding the roll closed. *Don't use a razor* to cut the tape unless you have a steady hand, because it's very easy to cut through several layers of the paper (not that I've ever done that). With one person holding onto the roll, have the other slowly roll out the seamless so there's about 6 to 8 feet on the floor. Set a sandbag on the end of the paper to keep it in place and then simultaneously raise the seamless up to about 6 to 8 feet in height. Don't just let the seamless unroll by itself, or it will unroll completely. Then you'll have a $65 wad of worthless munched up paper. Once you have the background at the desired height, clamp the paper core to the background crossbar on one (or both) sides with an A clamp to keep it from unrolling (refer to Figure 7.2). Setting the background height at 6 to 8 feet allows you to avoid having the top of the background in your shot, especially if you like to shoot from a low camera angle like I do. Using gaffer tape, tape the front end of the seamless to the floor. I tape the entire width of the seamless to the floor because kids, inevitably, trip over the paper and tear it. Tape it down; you won't be sorry.

The Permanent Seamless Cyc Wall

So convinced am I of the value of a white seamless background, I had my brother build a cyc wall for me in my studio. Formally called a *cyclorama*, a cyc wall is a cove sweeping from the wall to the floor, creating a seamless background. My cyc wall is 15 feet wide by 10 feet deep with a 3-foot radius and corner cove, and it takes up one side of my studio (**FIGURE 7.3**). Almost all of the images shot on white in this book were shot using my cyc wall.

Some of the images you see have a white background and shiny plank flooring underneath the subject. The reason is that most often I use my cyc wall as the background and stand my subjects on my white, painted wood floor in front of the cyc wall. Because the wood floor is painted with epoxy paint (the kind used to paint garage floors) it has a glossy sheen to it. I like the context the planks create in the image, which keeps the subject from appearing to float in space. The glossy surface reflects light, making it easy to get all-white floors in the shot. For commercial work, we often remove the planks in postproduction or just use the tile board butted up to the cyc wall floor for a smooth, white floor that reflects the subject's feet and legs (more about tile board in a minute).

FIGURE 7.3 A corner cyc wall takes up the south end of my studio space. This is where I shoot 99 percent of the time, and by varying how I light this seamless wall, I can create images with a white, gray, or black background. (Photo courtesy of Christiaan Blok.)

If you do decide to build your own cyc wall, make sure it's strong.

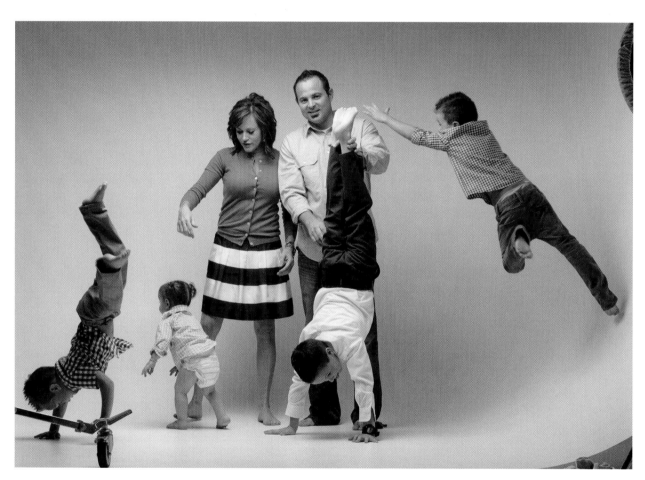

FIGURE 7.4 If you're considering the cyc wall/ photographing kids combo, be sure to build it to withstand the punishment of wild children. No matter how many rules you have about "staying off the wall," it's just too tempting for kids.

ISO 100, 1/200 sec., f/9, 70–200mm lens

If you research cyc walls, you'll discover that you can buy them ready made (expensive) and that they are fairly fragile. They come with lots of warnings about not allowing anyone to step on that curved area. The manufacturers have no idea that we photograph kids for a living!

I knew there was no way I'd be able to keep kids off that cove. So I asked my brother to build the cyc wall similar to a skateboarder's half-pipe and just as sturdy. Once the wall was built, we primed and painted it with exterior household paint.

Although using flat paint on a cyc wall is recommended to control reflections and hot spots on the background, that paint lasted for about a week. Flat paint plus a white floor plus kids equals a very dirty wall and floor. Many commercial studios repaint every few weeks. But our wall needed to be repainted after every shoot. Enter eggshell finish exterior paint. It cleans up easier than flat but isn't as shiny and reflective as semi-gloss paint. I do have to be more careful of how I light the background and get the angles of the light just right, but it's worth it not to be constantly repainting. If I had it to do over again, I would make the cove radius smaller (1 or 1.5 feet). The 3-foot radius takes up a lot of space, which limits where I can place my lights and my subjects. At this writing, I'm installing a rail system above the cyc wall to get my lights off the floor and give me a larger area to position my subjects.

If you are contemplating building a cyc wall in your studio, shoot with a white seamless in that space a few times before you build the wall. It will give you a better idea of what your space and shooting constraints will be, and will help you make a more informed decision. And if you do decide to build your own cyc wall, make sure it's strong (**FIGURE 7.4**).

Lighting the Background

To light the white seamless background, I use two studio strobe monolights with 60-inch reflective umbrellas. You don't have to use umbrellas; you can use softboxes or Beauty Dishes, or any modifier that will direct and spread light across your background. In **FIGURE 7.5**, the lights are shooting into the umbrellas and reflecting onto the background. (See page 146 for Figures 7.5–7.8.) The lights are placed 4 feet from the

Angling the lights just past the center of the seamless creates an even spread of light across the background.

background and are angled at 45 degrees to the background. Angling the lights just past the center of the seamless creates an even spread of light across the background. Once the lights are set, I add two half-V-flats. Each is created from one 4 x 8-foot piece of Z-board scored vertically on the black side and bent to create a half-size V-flat (**FIGURE 7.6**). Placing the V-flats to the subject side of each background light blocks the lights from illuminating the subject and prevents stray light from hitting the camera lens. The black V-flats also "reflect" black onto the subject, which helps to outline the subject nicely against the white.

What About the Floor?

Seamless paper creates your background and your floor, but paper as a floor is less than ideal. It gets dirty quickly, and if you're shooting on a carpeted area, the paper will get wrinkled as it gets mashed into the carpet. Spend a few bucks on cheap tile board from your local hardware superstore. Tile board comes in smooth, white, 4 x 8-foot sheets. It has a semi-gloss coating on one side and a masonite-type backing on the other. If I'm shooting one kid, I'll lay the tile board vertically toward the camera (Figure 7.5). If I'm shooting more than one kid, I'll lay it down horizontally. The tile board helps protect your paper; more important, it creates a reflection of your subjects' feet, which grounds them rather than having them floating in white space. You can also use a sheet of Plexiglas, but Plexiglas is pricey at more than $110 per 4 x 8-foot sheet; tile board is about $12–$15 per sheet. Lots of photographers use tile board, but I think the credit goes to Zack Arias for popularizing this idea with his now-famous White Seamless Tutorial blog post back in 2008. Be sure to read it at www.zarias.com/white-seamless-tutorial-part-1-gear-space.

The only downside to using V-flats in this scenario is that they cut the light falling on the floor. So if you want the floor under the feet of your subject to be completely white, it's best to use just the umbrellas without the V-flats for better light spread on the floor. If you decide not to use the V-flats, make sure that you place your subject far enough forward so that no direct light from your background lights hits your subject.

Background Exposure

For a completely white background with no detail, your background lights should be 1.5 stops brighter than the main light you're using to light your subject. Here is where a flash meter comes in handy. I use a flash meter to measure my background lights first with my main light turned off (**FIGURE 7.7**) and make sure that the background lights are providing even light side to side and top to bottom on the seamless. My meter reading for just the background lights is f/11. Using a flash meter in this situation is faster and more accurate than shooting and chimping, but it can be done without a meter by using the blinking highlights setting on your camera's LCD screen. If you've exposed your background correctly, the background will blink, which means the white is blown out with no detail.

Main Light Exposure

The white seamless setup in Figure 7.7 uses three lights, but when it comes to lighting the subject, I'll still use only one light source. All the lessons you've learned so far about light placement and subject position still hold true; the only difference is that I've lit the background separately. The key to using white seamless successfully is to light your background and your subject separately.

With the two background lights firing at an exposure of f/11, I know I want my main light to read at f/7 (halfway between f/5.6 and f/8), which is 1.5 stops less than the background lights. I then set my camera to f/7 to capture the proper exposure on my subject and allow the background to go completely white (**FIGURE 7.8**).

The key to using white seamless successfully is to light your background and your subject separately.

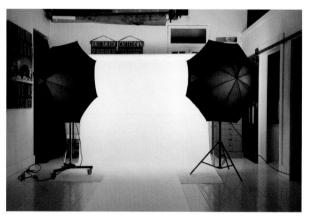

FIGURE 7.5 This white seamless lighting setup uses two 60-inch reflective umbrellas angled just past the center of the background for even, edge-to-edge lighting. Notice the tile board on top of the seamless on the floor.

ISO 100, 1/200 sec., f/11, 24–70mm lens

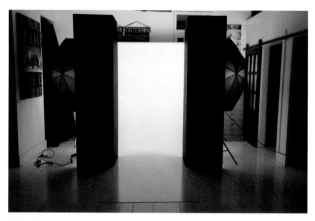

FIGURE 7.6 Adding two half-V-flats on the subject side of each background light controls the spill of light and reflects black onto the subject, increasing the contrast against the white background.

ISO 100, 1/200 sec., f/11, 24–70mm lens

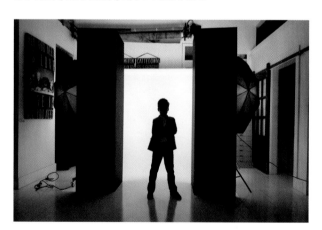

FIGURE 7.7 The white seamless setup with only the backlights firing. Notice how the boy is pulled far enough away from the background—in this case 8 feet in front of the background—that he falls completely in shadow, so I can light him separately from the background.

ISO 100, 1/200 sec., f/7, 70–200mm lens

FIGURE 7.8 The main light is added in only to light the subject and is set to 1.5 stops lower than the background lights. This exposes my subject correctly and lets the background go completely white.

ISO 100, 1/200 sec., f/7, 24–70mm lens

Common Lighting Mistakes

It's easy to dump a bunch of light on your seamless and hope for the best. But if you want your subject to pop off the background and your final image to have that dramatic, dimensional light I keep talking about, you'll have to keep an eye out for a few common mistakes when lighting your background. Sweating the details during setup will make all the difference in the final image (**FIGURE 7.9**). Here are a few mistakes you can easily remedy:

- **Too much power.** If you set the power on your background lights too high, the light reflects off the white background and blasts forward, flaring around your subject and into your lens, and degrading the image with a loss of contrast, as shown in **FIGURE 7.10**. The background lights for this image were more than two stops brighter than the main light. Remember that the exposure on your background should be no more than 1.5 stops brighter than the exposure on your subject.

- **Light flare.** Light flare in your image may also happen as a result of direct light from one of the background lights hitting your lens. Use V-flats or other light modifiers (e.g., umbrellas or softboxes) to keep your background lights on the background.

- **Detail in the background.** If you set the background lights to the same exposure as your main light, you'll end up with a not-quite-white background (**FIGURE 7.11**). That's OK if you meant it to be that way, but if you want a completely white background, the background needs to be 1.5 stops brighter than the main light.

- **Uneven white.** It can be difficult to get an even white background from edge to edge and top to bottom. This is most quickly achieved by using a flash meter that can instantly tell you where the light is falling off on your background. I find that using umbrellas or Beauty Dishes as the modifiers on my background lights spreads the light better than softboxes. Also, remember to angle each background light just past the center of the background to get an even spread of light.

FIGURE 7.9 A successful white seamless portrait will have flattering, dimensional light on the subject and a separately lit, completely white background with no detail.

ISO 100, 1/200 sec,. f/7, 70–200mm lens

FIGURE 7.10 If the background lights are too bright, you'll notice light flare around the subject and the loss of contrast in the image. The meter reading on this background is f/16, more than two full stops brighter than the main light.

ISO 100, 1/200 sec., f/7, 70–200mm lens

FIGURE 7.11 If the background lights are set at the same power as the main light, the background has some detail and starts to turn gray. The background meter is at f/7, the same as the main light, which is not enough light to make the background completely white.

ISO 100, 1/200 sec., f/7, 70–200mm lens

One Background, Multiple Looks

A white, seamless background is the most versatile background you'll shoot with. Just by varying the light falling on it or changing how close your subject is to it can completely change the way it looks in an image. **FIGURE 7.12** and **FIGURE 7.13** were both shot on the same background with the same main light in the same spot. The only difference, besides the outfits, was that the background lights were turned off. This is a great exercise for you to try to see how many different looks you can get with one seamless background. Another reason I love the versatile white seamless is because I work very quickly and want to keep the energy up while I'm shooting. Kids won't wait around for me to string up another background or fiddle with lights. With a single white seamless background, I can go from white to gray to black in a matter of seconds, just by turning the background lights off and increasing the distance between my subject and the background.

White to Gray

To turn a white background to gray is simple. You just turn off the background lights to create a gray background.

The closer your main light is to your background, the lighter gray the background will be. To deepen the gray, pull your subject and main light farther away from the background so less of the main light is falling on the background; the gray will be darker.

Gray to Black

What if you want a completely black background, and you don't want to switch to black seamless? You can still accomplish this with a white seamless, but you have to control exactly where your main light is falling *and* pull your subject as far away from the background as you can. If you use a grid to control your light, you can work closer to the background

FIGURE 7.12 These triplet siblings are working the white seamless with all three lights firing (opposite page).

ISO 100, 1/200 sec., f/11, 70–200mm lens

FIGURE 7.13 The same triplets (different outfits) and the same background are used, but the background lights are turned off, letting the background fall into gray shadow (above).

ISO 100, 1/200 sec., f/11, 70–200mm lens

and still make it turn black. For the photo in **FIGURE 7.14** the subject was about 10 feet from the background, but I used a honeycomb grid on the Octabank, my main light. The grid controls and directs the light right where I want it to go and keeps it off the background. You can create a similar look by using a reflective umbrella half closed or by using black-sided V-flats to block the main light from hitting the background.

Lighting for Action

Kids like to move, and a white seamless setup is the perfect lighting scenario to accommodate the craziness that ensues when kids leap into action. My two favorite positions for the main light when shooting white seamless are the same as when I'm shooting a darker background, the Up and Over and On the Side.

Up and Over on White

The Up and Over setup highlighted in Chapter 6 is a perfect companion to the white seamless setup because this technique allows for the maximum area of good light for kids to move around, which is perfect for the full-length antics going on in **FIGURE 7.15**. This image was shot using a 60-inch Octabank up and over the subjects. I removed the V-flats from my background lights to allow more light to bounce around the studio, which made the placement of the kids less critical and allowed them to move about more and still be well lit.

FIGURE 7.14 A honeycomb grid on an Octabank controls the light, allowing a white seamless 10 feet behind the boy to appear black in the image (above).
ISO 100, 1/200 sec., f/5.6, 70–200mm lens

FIGURE 7.15 Positioning the main light up and over my subjects and using two lights to separately illuminate the background creates a scene with enough light for kids to dance and be silly, and still be correctly exposed (opposite page).
ISO 100, 1/200 sec., f/7, 70–200mm lens

On the Side on White

Tip: When you're photographing kids in action, make sure you have plenty of sandbags on hand to weigh down your background stands and light stands. Better safe than sorry.

I can get a large area of light with the On the Side technique as I can with the Up and Over technique, by positioning a 60-inch Octabank to one side of my subjects, as shown in **FIGURE 7.16**. This setup is one of my favorites because it gives me the dimensional shadows of a low-key portrait on my subjects but with the modern feel of a white seamless background. The On the Side setup requires more careful posing to keep the kids in the light, so I'll use a sofa or parent to anchor them into position and then let them do their thing. Lighting from the side is less forgiving than the Up and Over. But if you have a very low ceiling that prevents you from placing your light up high enough for the Up and Over, then the On the Side position is the way to go.

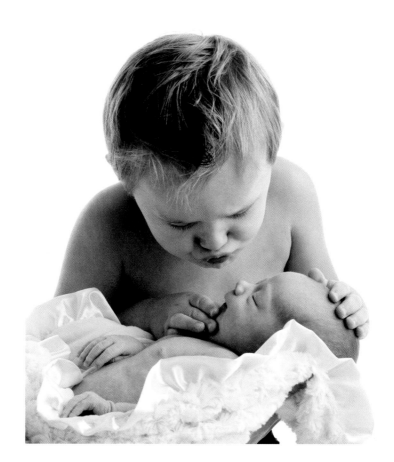

FIGURE 7.16 Positioning the main light to one side creates dimensional, Rembrandt-ish light on the kids' faces while the white background keeps the image fresh and current.

ISO 100, 1/200 sec., f/7, 70–200mm lens

Cleaning Up in Postproduction

The white seamless background is, bar none, the easiest background to clean up in postproduction. At my studio we use a few basic Photoshop edits to accomplish a perfectly white background if it doesn't exist in the image. **FIGURE 7.17** shows an example of a not-quite-white background. Here is the Photoshop postproduction process we use:

1. For overall background adjustment, open your image in Photoshop, press Command+J (Ctrl+J) to create a duplicate layer, and then press Command+L (Ctrl+ L) to bring up a Levels window. Hold down the Option (Alt) key, and move the (highlight) slider on the right slowly to the left to see how much detail you have in your background (**FIGURE 7.18**). I find it helpful to see where there is still detail showing in the background so I know what area to clean up. Warning: You can drag your highlight slider to the left to clean up the background, but be careful not to clip highlights in your subject. If you do clip highlights, create a layer mask to paint back in detail in the highlight areas.

2. To clean up select areas like the floor, edges of the frame, or in-between areas like the space between the girl's legs and chair legs, press Command+J (Ctrl+J) to create a working

FIGURE 7.17 Sometimes, despite your best efforts, you'll end up with a white seamless that isn't completely white, which requires a few simple tricks to fix in postproduction.

ISO 100, 1/200 sec., f/11, 70–200mm lens

FIGURE 7.18 To see any areas of detail left in your white background, open Levels and hold down the Option (Alt) key while sliding the right (highlight) slider. This quickly highlights any area of detail left in the background.

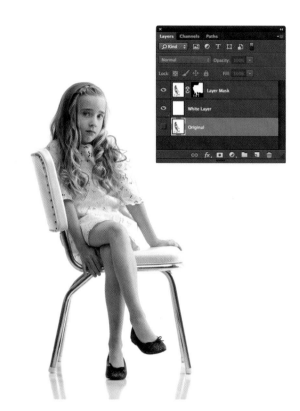

FIGURE 7.19 Use a layer mask over an all-white layer to quickly remove distracting elements in the floor, corners of the image, or even in-between areas.

FIGURE 7.20 Once your background is cleaned up to a pristine white, you can use the Crop tool to create more background or completely change the crop on the image.

image layer. Directly below the working image layer add a blank layer. Choose Edit > Fill or use the Paint Bucket tool to fill the layer with white. Next, select the working image layer and create a layer mask. Select the newly created mask and choose a soft black brush, slightly smaller than the area you are painting, to paint out the distracting areas. This reveals the all-white mask below, cleaning up your background (**FIGURE 7.19**). If you accidentally paint out something important, simply press the x button to switch your brush to white, which will fill back in whatever you painted out. Toggle back and forth between white and black to add or subtract from your layer mask.

3. To extend the white background for cropping or graphics, complete the preceding steps first so you have a completely white background. Then make sure your background is set to white. Crop the image to your desired size by extending the Crop tool past the existing frame and cropping as shown in **FIGURE 7.20**. The white background will fill in your desired crop area, making a clean, white canvas for you to apply graphics to (**FIGURE 7.21**).

FIGURE 7.21 Here is the after-crop image with added white background, which creates negative space or room to add type or graphics for an album or card layout.

Photography is 1 percent talent
and 99 percent moving furniture.
—Arnold Newman

Lighting on Location

IF YOU'VE BEEN SHOOTING primarily in natural light, then you are no stranger to shooting on location. You know how to find the light and work it. But you may have been places where the light wasn't good, you needed more light, or just wanted to shoot children in their home but the light wasn't ideal. Perhaps you want to create a different look, something dramatic that will wow your clients and keep them coming back. All of these are good reasons to try using flash on location.

In this chapter you'll learn the step-by-step technique I use to quickly determine the correct exposure for creating a blink of light, a mix of flash with the light in the location, or the surreal lighting that creates dramatic skies and saturated color in your image. By applying the skills you already have and combining them with these new tactics, you'll be lighting with confidence at your next location shoot.

ISO 200, 1/160 sec., f/5.6, 70–200mm lens

Location Flash Technique

The previous few chapters focused on how to use off-camera flash in the studio. But what about lighting on location? If you're using off-camera flash as your only light source on location, the technique is no different than the studio lighting technique you learned in Chapter 5. Recall that in the studio my exposure settings were determined by only the light that I added to the scene.

Shooting on location presents creative opportunities to add environment and context to your image; it also presents some technical challenges when it comes to lighting the environment and your subject at the same time.

The main difference between lighting in the studio and lighting on location is the complexity of using the ambient light in the scene in addition to the off-camera flash you are using to light your subject.

Mixing Flash with Ambient Light

As you learned in Chapter 5, ambient light is also called *available light*. Ambient light usually refers to the natural light in a scene, but if you're working indoors, the ambient light might be created by lamps or light fixtures in the home of your client. On location, your exposure-finding process is different than in studio because instead of just worrying about the flash you are lighting your subject with, you are mixing flash *with* the ambient light. The technique used to mix ambient light with flash is the same whether you are working with the sun as the ambient light outdoors or household electrical lights as ambient light indoors.

The two most important factors to remember when you're mixing flash with ambient light are:

- **Aperture** controls the base exposure.
- **Shutter speed** controls the ambient light.

LOCATION LIGHTING CHECKLIST

- [] ISO
- [] PROXIMITY
- [] FLASH POWER
- [] SHUTTER @ SYNC
- [] APERTURE
- [] TEST SHOT
- [] ADJUST
- [] SHUTTER TO MIX

FIGURE 8.1 Lock down your aperture and ISO first, and then vary your shutter speed, depending on how much ambient light you want in the scene.

The Exposure Checklist

When I'm photographing on location and want to mix my flash with the ambient light, I use the Exposure Checklist in **FIGURE 8.1** as a quick reminder to help me determine my base exposure for an image. This process is explained in detail below.

The images to illustrate the Exposure Checklist were shot on a 110-degree, sunny Arizona afternoon. At five o'clock the sun was still quite high in the sky and very bright. Notice my assistant Jeff wiping sweat out of his eyes in the setup shot in **FIGURE 8.2**. I was lying on the 150-degree sidewalk shooting this image. You can see that there is a lot of light in the scene. How do you wrangle all that light to get a shot that looks like the image in **FIGURE 8.3**? The Exposure Checklist tells you how:

1. **ISO.** I started with my camera set to its lowest native ISO (ISO 100 on the Nikon D4). Recall that low ISOs produce the cleanest files with the least digital noise. I start at 100 and increase my ISO only if I have to (see step 6 for exceptions).

2. **Proximity.** Because I want soft, flattering light, I always work with my light as close as possible to my subject (Figure 8.2).

3. **Flash power.** Unless I'm shooting in extremely low or extremely bright light, I'll start with my flash set on half power. With the Profoto AcuteB strobe, half power is 300 watt seconds. I start in the middle because I find it's faster to adjust up or down from the middle setting.

FIGURE 8.2 The behind-the-scenes shot for Figure 8.3. A big light, in close, and a patch of sky are all you need.

ISO 100, 1/200sec., f/11, 70–200mm lens

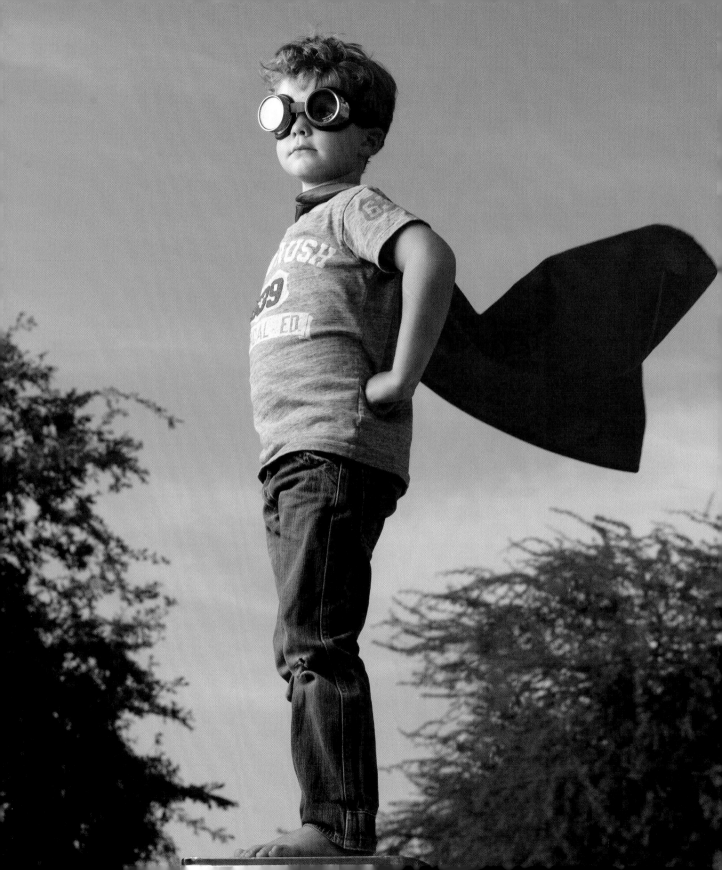

I focus on establishing the base exposure on my subject first before I consider anything else.

4. **Shutter speed.** I usually start with the shutter speed at my camera's sync speed of 1/200th of a second. If you are shooting with a dedicated speedlight, you may be able to shoot with a sync speed of 1/250, which is helpful when you want to darken the ambient light even more. I started with my shutter at 1/200.

5. **Aperture.** Next, I figure out what I want my aperture to be by considering the depth of field I want. For example, if I'm photographing a single child and want a very short depth of field, I'll dial in a wide-open aperture, like f/2.8. If I'm photographing more than one child, an aperture of f/8 or smaller allows for a longer depth of field, or more of the image in focus. In this instance, I wasn't choosing aperture for creative reasons. I chose a relatively small aperture of f/11 due to how bright it was outside, and I knew that a wider aperture would likely overexpose my subject.

6. **Take a test shot.** Once I have the ISO set, the light positioned, flash power, and shutter speed and aperture set, I take a test shot and see what the light looks like on my camera's LCD screen (that's if I'm not using a flash meter). At this point, I'm not looking at the ambient light. I'm only looking at the light falling on my subject. Is it too bright? Too dark? This is the process of establishing my base exposure. In **FIGURE 8.4** you can see that the boy's face is overexposed. He doesn't look too happy about it either.

FIGURE 8.3 The finished shot of Super Max. Being able to light kids anytime anywhere gives you superhero-like confidence (opposite page).

ISO 100, 1/250 sec., f/16, 70–200mm lens

All Manual, All the Time

Recall that in Chapter 4 I advised shooting in manual, especially when you're using flash. The reason I do is that I want to have complete control over my exposure and not let cameras or lights make any decisions for me. Shooting in manual also makes postproduction much faster and easier because the exposure is consistent in any given setting. This consistency allows me to use the sync feature in Adobe Lightroom to apply color and tonal corrections across an entire set of images rather than having to work with each image separately because an auto setting on my camera or flash changed my exposure. Manual is a beautiful thing.

Tip: If the light is too bright and your flash isn't powerful enough to overpower the sun, you can shoot earlier or later in the day, when the sun is less powerful. You can also place your subject in the shade (as we did in the Exposure Checklist example).

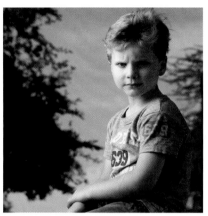

FIGURE 8.4 A test shot at f/11 shows the boy's face is overexposed.

ISO 100, 1/200 sec., f/11, 70–200mm lens

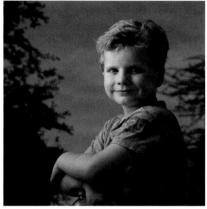

FIGURE 8.5 Closing down my aperture to f/16 provides the correct base exposure.

ISO 100, 1/250 sec., f/16, 70–200mm lens

7. **Adjust.** Don't worry if the first test shot is completely wrong; it's no big deal. It doesn't mean you're a bad photographer. It's just an experiment, and the test shot is the result of that experiment. Once you see the results of the test shot, you need to make adjustments. In this instance, the exposure on the subject was too bright, so I had to decide whether to close down my aperture or decrease the flash power. I chose to close down my aperture a full stop, to f/16, which resulted in a correct exposure on my subject (**FIGURE 8.5**). If the exposure on the subject had been too dark, I could have either opened up the aperture or increased the power output of the flash. I work with these two variables of aperture and flash power until I have a correct

base exposure on the subject. If the flash power is maxed out, the aperture is as wide as I want it to go, and the exposure on my subject is *still* too dark, I'll increase the ISO setting to make the camera sensor more sensitive to light. I adjust these variables until the base exposure on the subject is correct and only then consider the ambient light. It's easy to get distracted with all of these settings to think about, so *I focus on establishing the base exposure on my subject first* before I consider anything else.

8. **Shutter speed to mix in ambient.** With the base exposure on the subject established, it's time to look at the ambient light and determine how much I want it to factor into the image. To allow in more ambient light, I can slow the shutter speed down to 1/200,

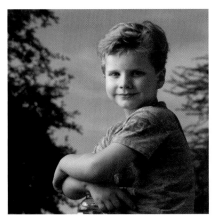 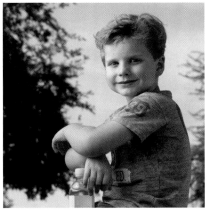 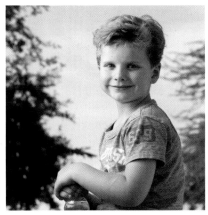

FIGURE 8.6 Keeping my aperture the same at f/16 slows down my shutter to 1/200, allowing in more ambient light and resulting in a lighter sky.

ISO 100, 1/200 sec., f/16, 70–200mm lens

FIGURE 8.7 Slowing down the shutter to 1/125 creates an even lighter sky, but the base exposure on the boy remains the same.

ISO 100, 1/125 sec., f/16, 70–200mm lens

FIGURE 8.8 With a shutter speed of 1/60, the sky in the background is lighter still. The base exposure on the boy doesn't change.

ISO 100, 1/60 sec., f/16, 70–200mm lens

as in **FIGURE 8.6**, or slower to 1/125, as in **FIGURE 8.7**, or even slower to 1/60, as in **FIGURE 8.8**. Notice how the base exposure on the boy doesn't change, but each image looks different when the shutter speed is slowed down and more ambient light is allowed to register in the image. As I incrementally slow the shutter speed, the sky becomes brighter and brighter. Remember that changing the shutter speed controls only the ambient light; it doesn't affect the base exposure on the subject. The base exposure on the subject is controlled by the aperture setting.

Location Lighting Styles

You can apply the aforementioned technique for mixing ambient light with flash on location in three distinct ways: using barely a blink of light to fill in shadows, mixing it up with indoor lighting, and adding the surreal look of dramatic skies in a landscape. The ability to mix ambient light with flash in each of these three ways is a significant skill set to add to your lighting toolbox.

Why Aren't You Using Flash Yet?

When I talk to photographers who want to learn to use flash in their location work, I hear two common excuses that keep them from making the leap to location lighting:

1. **Working with a light is restricting. It's stifling my creativity.** Working with flash versus shooting in all natural light will feel restricting at first. You're adding flash to all the variables that photographing kids brings with it, plus the environment you're shooting in. It can be daunting, and it *will* slow you down in the beginning. Be prepared for that. But if you think about it, shooting in natural light is not a complete free-for-all. You still have to find good light and, within reason, keep your subjects in that light. Even if you are a photojournalistic purist, you still need to look for an angle that will take best advantage of the light. The major benefit of working with flash is that it gives you the freedom to put that light wherever you want it. And nowhere is it written that once you learn to light with flash that you have to give up shooting in natural light. When I'm on location, I'll shoot some images in natural light and some with flash. I'm constantly on the lookout for wherever there is good light or, failing that, wherever I can create good light. Using flash lighting on location is a different way of working than shooting in all-natural light, but you'll get used to it with a little practice.

2. **I don't have time to practice.** As a working photographer with a business to run and a family to care for, it's difficult to find time to practice new lighting techniques, so I've learned to find ways to practice on the job. At the end of a shoot, after I know I have everything I needed to capture for the client and everyone is still cooperating (usually a shoot with older kids), I'll ask the clients' permission to try something new. I'll explain that it might not even turn out well, but there's something I've been wanting to try and would love to try it with their child. Usually, they love that you are trying something new with their kid, and there's no pressure for performance because you've already admitted that it might not work. I'll work with their best-behaved child and try whatever new technique I'm working on at the moment, which is how I practiced this location lighting technique before I began to use it regularly in my client work. By practicing this way you're not stressing out about the light and if it will work or not. Take a few extra minutes at the end of your next shoot to try the lighting technique in this chapter. In Chapter 3, I talked about setting up a practice shoot to explore new concepts and techniques. That would be another good time to try out your new lighting technique. If you've been shooting successfully in natural light, you already have a basis in exposing images correctly. That foundation will help you to learn new techniques quickly. You just have to make the time to practice.

Barely a Blink

Sometimes the light on location is just right, and all you need is a blink of light to clean up distracting shadows. In **FIGURE 8.9**, the sun was high at about 11 a.m. and was casting some harsh shadows on the boys' faces. I thought I might be able to shoot with no flash and establish my base exposure at f/16 at 1/200. Placing a flash at three-quarter power (400 ws) camera left was just powerful enough to clean up the shadows (**FIGURE 8.10**) and even out the exposure. Notice that the exposure was the same in both images, with and without the light. The reason is that the main light was firing at the exact exposure of the sun. This is a subtle mix of ambient light and flash. Because the exposure of the sun and flash were equal, you almost can't tell the flash is there. The resulting image looks like it was lit with natural light, but better.

FIGURE 8.9 The marine layer (slightly overcast) near the beach provided rich blue skies and saturated color in the scene. But at 11 a.m. the almost-overhead angle of the sun created harsh shadows on the boys, especially on the eyes of the boy wearing the hat (top right).

ISO 200, 1/200 sec., f/16, 70-200mm lens, No flash

FIGURE 8.10 The Photek Softlighter Umbrella positioned camera left created a big, diffused fill flash that complemented the good light already in the scene. I didn't need to completely change the light in the setting; I just needed to correct the light by lifting the shadows on my subjects' faces (bottom right).

ISO 200, 1/200 sec., f/16, 70-200mm lens

Mix It Up

Before I started using flash in my location work, I'd often arrive at a location and find a perfect room or setting, only to realize that there wasn't enough light to create a decent image. Sure, I could have cranked my ISO through the ceiling, but the resulting image would be noisy and degraded. Bringing a lighting rig with me gives me the freedom to make any setting work.

The kids in **FIGURE 8.11** had decided to put on a show using the kitchen counter as their stage. Their parents had recently built a beautiful home, and I wanted to show it off, but there wasn't enough light in the kitchen to properly capture the kids' antics. With the Photek Softlighter on a strobe head positioned camera right and my California Sunbounce 4–by–6-foot reflector camera left, I created a sandwich of light that allowed the kids to dance and sing and be well lit. After I established my base exposure at f/8, I dialed down my shutter speed to 1/125 to allow some of the ambient light from the kitchen light fixtures to bleed into the image. Slowing down my shutter even more would have allowed more of the room light to register, but these kids were really moving, and because I didn't want any motion blur, I kept my shutter at 1/125.

Surreal Skies

Annie Leibovitz popularized the Surreal Skies look when she shot the American Express campaign back in the 90s. She lit celebrities by flash and used deep and dramatic skies as background; there was no doubt that the lighting had been manipulated.

When shooting for a surrealistic look, I light the subject and the background separately for a dramatic effect. In **FIGURE 8.12**, the light in the form of flash is the primary illumination on the subjects; the ambient light, the sunset, provides the light for the background. The light in the scene has obviously been dramatically wrangled into submission, creating rich, saturated color and dramatic skies. This is my favorite use of location lighting, and it isn't that difficult to achieve.

Bringing a lighting rig with me gives me the freedom to make any setting work.

FIGURE 8.12 Two brothers ham it up on the beach in front of a surreal sunset. When shooting on a windy beach with a big light modifier, it is wise to have an assistant or parent hold the light.

ISO 200, 1/160 sec., f/5.6, 70–200mm lens

The Exposure Checklist provided earlier in this chapter outlines the step-by-step method for establishing a base exposure on your subject and creating darker or lighter skies in the background. The same method was used for the image in Figure 8.12. The sun was setting and the light was getting low, so I set my ISO at 200 and opened up my aperture to f/5.6. I then slowed down my shutter speed to 1/160 to allow more of the ambient light in the background to register in the scene. I love how the warm sunlight reflecting off the water and wet sand contrasts with the cool blue of the sky.

FIGURE 8.13 shows the same boys in the same setting lit only by natural light. This isn't an either/or situation; it's not that one image is bad or the other good. Both lighting techniques are simply options to choose

FIGURE 8.13 Here is another shot of the same brothers on the same beach—this time using only natural light.

ISO 500, 1/160 sec., f/2.8, 70–200mm lens

from—tools you can use to create the look you're after. Using the Exposure Checklist as your guide, try out this technique on your next location shoot. You, and your clients, will love the way it looks.

Studio or Location?

One of the first questions my clients ask when they call to book a session is, "Where should we do the session?" The consultation with the parents, mentioned in Chapter 2, is when we make the decision about where to shoot. During the consultation I make it a point to find out what types of images the clients already have of their children. If they have lots of location images hanging on their walls, I suggest that maybe a studio shoot would be a nice change. If they've had their children photographed mostly in studio, I suggest shooting on location.

My Location Lighting Gear

I didn't make the investment in Profoto gear lightly. It's pricey; there's no question about it. I shot with Nikon speedlights for years (and sometimes still do), but I increasingly found myself in situations where I needed more power, faster recycle time, and longer battery life than the speedlights could offer. So when I found a used Profoto Acute B600 for sale, I bought it. As a result, my location lighting gear is bulkier and heavier than a speedlight rig. But because I don't shoot weddings or events, it's OK if the gear is a bit heavier. I'm not usually carrying it far or running around with it. Other than the battery pack, I travel pretty light. Here is a list of the gear I use on location:

- Profoto Acute B600 Battery Strobe Pack with one strobe head
- Two PocketWizard Transceivers to trigger the light
- Photek Softlighter Umbrella, 60-inch
- Avenger light stand
- California Sunbounce 4-by-6-foot reflector (white/silver)

If you shoot in the clients' home, you can get a studio look and location setting all in the same shoot.

During the consultation I focus on the end product: What we are shooting for? What are their plans for what we'll create with these images once they are captured? If we are creating an album with a clean, graphic design, I prefer to shoot in studio on seamless so I can easily extend backgrounds. On the other hand, if we are creating a Day in the Life album, which requires more of a storytelling approach showing the children engaged in their daily activities, shooting on location is the obvious choice. I alternate between studio and location shooting, depending on what the kids are doing and what stage they are at in their life.

If you don't have a studio, don't worry. When I refer to "in studio," I'm simply referring to a studio lighting setup, which you can *set up* anywhere. If you shoot in the clients' home, you can get a studio look *and* location setting all in the same shoot.

My favorite times to photograph kids on location are when they are newborns, when I'm shooting kids with their families, and when I'm creating images for a Day in the Life album. For all of these types of sessions I plan on shooting with natural light *and* flash lighting. The plan to shoot both ways gives me variety in my images and complete control over the lighting in the environment.

Tip: Shooting on location with lighting is a big job for one person to handle. Consider hiring an assistant. You will be more relaxed and able to concentrate on the client if you have some help.

Newborns at Home

My favorite place to photograph newborns is in their home, because new moms feel more comfortable. They have everything they need right there, and I like the idea of adding context to the images by using the family's natural environment as background. Newborns alone are not that interesting to me; what *is* interesting is the change in the family structure brought about by the arrival of a new person.

Always keep your eyes open for areas of good light.

Tip: Don't overlook bathrooms for great lighting opportunities. Frosted or glass block windows combined with white, reflective tile surfaces create a white box that is an ideal spot to look for great light.

Because most families will move multiple times during a child's life, it's an important memory for them to have photographs of their baby in the home they lived in when the baby was born. It also gives you a chance to document all the hard work that went into that baby nursery.

During a location newborn shoot, I'll capture a variety of natural-light and flash-lighting images. Even if I'm using flash lighting, I still try to make it appear as though the image was lit with natural lighting, such as in the **FIGURE 8.14** image of the twins on their parents' bed. The room was very dark so I shot with a Photek Softlighter Umbrella from the side while I stood over the two swaddled babies. I shot the exposure in this image just like I would a studio image, not taking into account any ambient lighting and exposing only for the flash.

FIGURE 8.14 As I stood on a bench at the foot of the parents' bed to get up and over the babies, I shot this image using a strobe head inside a Photek Softlighter Umbrella positioned to one side.

ISO 400, 1/200 sec., f/10, 24–70mm lens

The beauty of photographing newborns at home is that, because babies are small, you need to find only small areas of good light or interesting backgrounds. Big vistas of amazing-ness are not required for beautiful images. For example, the shot in **FIGURE 8.15** was "discovered" as we were wrapping up a newborn shoot. As we were packing up to leave, I walked by a guest bathroom and saw beautiful light coming from the doorway with the cat asleep on the bathmat in front of a frosted French door to the backyard. We swaddled the baby again and placed her on the bath-mat, bathing her in gorgeous, natural light that also helped show her reflection in the marble floor in front of her—pure location lighting luck.

FIGURE 8.15 Always keep your eyes open for areas of good light. Here I exposed for the baby, allowing the high-light from the backlit door to overexpose, or "blow out."

ISO 200, 1/250 sec., f/2.8, 70–200mm lens

Family on Location

When I photograph kids with their family on location, I prefer that the location mean something to the family. The shoot might take place at their home, at a location that has some significance for them, somewhere they often spend time together, or a place that symbolizes something about their family, such as a lake setting for a family who enjoys water sports or a house of worship for a deeply religious family.

It's easy to fall into the trap of the common photography spot. Some locations around my town have become notorious for their popularity with local photographers. In one large subdivision is an enormous rock waterfall. It seems like an ideal place to photograph a family until you get there and see ten photographers lined up with their clients waiting to be photographed in front of it. When any of my clients suggest this location to me, I gently steer them toward a location that has more integrity and meaning for their family.

Tip: If you need to "turn down the sun," try using a variable neutral density (ND) filter on your lens. Variable ND filters act like a dimmer switch for your lens, allowing you to use a more powerful (bright) light source and still get a shallow depth of field on your subject. A good ND filter isn't cheap, so buy one ND filter the size of your largest lens and then purchase step down rings to use it on your smaller lenses.

A favorite client of mine had a specific location in mind: A new LDS Temple was being built close to her home and she wanted a photo of her family in the field in front of it. I scouted out the requested location beforehand and confirmed that the alfalfa field across the street from the temple would provide an uninterrupted view of the temple behind the family. The temple was still under construction so I knew we'd be retouching out cranes and construction trailers. I shot some scouting images to determine the best angle to shoot from.

We lucked out on the day of the shoot. Gorgeous clouds filled the sky (a rare occurrence in the desert). A couple of shooting problems usually accompany beautiful, cloudy skies; one of which is wind. The combination of wind and clouds means that your exposure will constantly change as the clouds move across the sun. That and the fact that when you're shooting with a large light modifier like the Photek Softlighter, it becomes a sail for your light. Therefore, it's helpful to have an assistant hang on to the light and keep it where you want it.

An alternate way to determine your base exposure is to start by metering the sky with your in-camera meter. With the camera on Auto, fill the frame with the sky, press the shutter release halfway, and read the

FIGURE 8.16 The before shot, where I metered for the background and used the kids as an outline.

ISO 100, 1/200 sec., f/8, 70–200mm lens

meter in your camera. Switch your camera to manual mode and dial in the metered exposure settings to lock in the exposure. For **FIGURE 8.16** the meter reading for the sky was f/8. You can see from my test shot that without flash my subjects are backlit and dark.

I knew with the sky that bright that I'd need my flash to be close to full power to expose my subjects correctly. So I added a strobe flash with the Photek Softlighter camera left with the flash power set at three-quarter power (400 ws). **FIGURE 8.17** shows the family exposed correctly with a dramatic sky as a background.

As the sun set, the ambient light became darker, so I had to open up my shutter more to allow the decreasing ambient light to register in the image. The image in **FIGURE 8.18** was shot after the sun had set, but some ambient light was still in the sky. I had to increase my ISO to 200 and open up my aperture to f/5.6; slowing my shutter speed to 1/125 allowed what little light was left in the sky to register in the image.

FIGURE 8.17 The family photographed in a field in front of an LDS Temple (above).

ISO 100, 1/200 sec., f/8, 70–200mm lens

FIGURE 8.18 Faith with Dad throwing her in the air (opposite page).

ISO 200, 1/125 sec., f/5.6, 24–70mm lens

A Day in the Life

Children in the four-to-ten-year-old age range—preschoolers through school age—are my preferred candidates for a Day in the Life series that documents them in their home environment. The two brothers in **FIGURE 8.19** are two of my favorite kids to photograph. They'll do anything, and they do it with style. Here, they were trying out their latest tricks on their backyard half pipe. I had been shooting in natural light at f/4 at ISO 200 with a shutter speed of 1/125 of a second, but the sky was blown-out white and I just wasn't getting the color saturation or drama I wanted in the shot.

I had my assistant grab the light and climb up on the half pipe with me, and let the boys do their thing with minimal direction. It was late afternoon but still pretty bright because the sun was facing us directly. I powered the flash to max power (600 ws) and shot with my shutter at 1/200 of a second to get the sky as dark as possible and also to freeze the boys' action. The resulting exposure was too bright on the boys so I closed down my aperture to f/8 for a correct base exposure. Once I liked how everything looked, I let the sun flare in the lower right of my lens, which added to the energy of the image (Figure 8.19).

Two sisters in princess dresses wanted a shot together in their newly decorated, shared room. Jumping on the bed developed into a pillow fight with the photographer. Notice that the lamp between the beds provides a nice warm glow in the background because my shutter was set at 1/100 of a second, which allowed the ambient light from the lamp to register in the image (**FIGURE 8.20**). The main light was provided by a strobe in a Photek Softlighter Umbrella at camera left.

FIGURE 8.19 Natural light was just not cutting it for the energetic vibe I was getting from these two brothers. I turned their backs to the sun, leaving their faces in shadow, and lit them with the Photek Softlighter and Profoto Acute B strobe at full power (600 ws). The shutter at sync speed gave me the dark blue sky (opposite page).

ISO 200, 1/200 sec., f/8, 24–70mm lens

To Learn More About Lighting on Location

The Internet is abuzz with every possible lighting configuration for location shooting, but the guys who really know their stuff are:

- Joe McNally (www.joemcnally.com/blog)

- David Hobby (www.strobist.blogspot.com)

- Zack Arias (http://zackarias.com)

- Scott Kelby (www.kelbytraining.com)

These guys are great resources for furthering your knowledge and for troubleshooting issues you encounter in the field. Check out their blogs for valuable information and hilarious tales from life in the field as a working photographer.

When you bring your light with you and know how to use it, the world becomes your studio.

Better in Studio

My preference is to photograph older babies and toddlers in the studio because it's a more controlled environment. I like to focus intently on capturing every eyelash and chubby body. I don't advise chasing toddlers around a park; there's just too much for them to be distracted by. If you're shooting outside, typically you're trying to get that golden hour of light and young kids tend to be tired and irritable at that time of day. I used to call the hours between 5 p.m. and bedtime the "witching hour" at my house because my kids were cranky and unreasonable. It might be the golden hour for light, but there's nothing golden about most kids' behavior at this time of day; I'd rather photograph well-rested little ones in the morning in studio.

When you bring your light with you and know how to use it, the world becomes your studio. Regardless of where you're shooting, a solid foundation of location lighting techniques will give you the confidence that you can make it happen.

FIGURE 8.20 The two girls in their bedroom are engaged in a pillow fight with the photographer (opposite page).

ISO 200, 1/100 sec., f/5.6, 24–70mm lens

SECTION 3 THE SHOOT

Happiness is a place between
too little and too much. —Unknown

Styling and Props

PHOTOGRAPHERS WHO ARE HIRED TO SHOOT large ad campaigns or editorial spreads for major fashion magazines work with a creative team, which usually includes a professional stylist who selects clothing, a prop stylist who finds furniture or builds an entire set for the shoot, an art director who provides the concept and vision for the shoot, *and* professional models who know how to pose to bring the concept to life. As a children's portrait photographer, that creative "team" is you, your clients, and their kids.

In this chapter, you'll learn to approach each shoot as a collaboration with your clients. You'll find valuable tips for styling kids, discover the best basic props to invest in, and learn how to conceptualize a shoot for your clients to highlight the individuality of every child you photograph.

ISO 100, 1/200 sec., f/11, 70–200mm lens

Styling Kids

Styling kids isn't easy. In my experience, about one in ten moms have a way with clothing and styling their kids for a photo shoot. The rest of us need a little help. As a children's photographer, your clients look to you to provide guidance on the clothing selection for their shoot. Assisting them with their choices adds value to your services and gives you more control over every element that goes into the final photograph.

What Should They Wear?

The number one question I'm asked is, "What should they wear?" It is most moms' chief concern when having their child photographed. Not only is it part of my job to help my clients figure out how to dress their children for the photos, but also to help them see that clothing, actually, is *not* the main concern. Our main concern is that the kids are well rested, are excited to be there, and are having a good time so we can capture their unique personality. Everything else is secondary. That being said, a bad outfit can ruin a photo, so it's important to guide your clients in their clothing selections.

Getting beyond the "outfit" mentality is all part of the consultation process. Rather than just focusing on cute attire, I talk to my clients about our goal for the shoot. What are we trying to *portray* with this portrait? Of course, we want the kids to look their best, but first and foremost we want them to look like *themselves*.

Most moms have an idea of how they'd like to see their child photographed, and it's usually too formal (**FIGURE 9.1**) or not at all true to the kid. Mothers think in terms of what their child "should" wear in a photo rather than what shows their personality or speaks to the true nature of the child.

Every photographer has a slightly different take on the clothing selection process, which is actually a direct result of their own photographic style. Some photographers may prefer very stylized, themed portraits, whereas others favor stark simplicity. I tend toward clean and simple design, and place the emphasis on the children and their expressions (**FIGURE 9.2**).

FIGURE 9.1 This is how many moms feel they "should" dress their kids for photos (above).
ISO 100, 1/200 sec., f/9, 70–200mm lens

FIGURE 9.2 A simpler approach highlights a baby in a more interesting and unexpected way—slobber and all (opposite page).
ISO 100, 1/200 sec., f/9, 70–200mm lens

FIGURE 9.3 Looking for something beyond the typical ballerina portrait, this sassy girl was styled with her tutu, boots, and jewels but was captured in a stark setting, creating a more modern version of the ballerina.

ISO 100, 1/200 sec., f/5.6, 70–200mm lens

Get the kid's buy-in

Stuffing kids into an outfit they hate will not achieve the result you want, which is the kids having a good time, feeling confident, and as a result, being themselves. During the consult I advise my clients to get their kid's buy-in by allowing their children to participate in the selection of the clothes, props, or whatever we are including in the shoot. That way the kids will be invested in the process rather than having it forced on them. Even if what they want to bring is hideous and doesn't work at all, it doesn't matter. If the kids feel like they've had a say, they will act better, cooperate more, and be invested in the process with you. In cases where the kids' selections won't work, save that outfit until the end of the session and shoot a couple of frames of "their outfit." You might be surprised. Those images might be the best images of the shoot.

Exaggeration with a Twist

Because I don't use specific sets and backgrounds, I depend on the children's clothing, accessories, pose, and expression to tell their story. I often tell parents that we want to style their children "as a heightened version of who they already are."

This means that no matter what type of clothing we select for the child, there should be some slightly exaggerated element to emphasize the concept of the shoot.

If my subject is the sassy-diva type, I have mom bring as much of her daughter's girlie gear as possible. Then we style her in studio. For the girl in **FIGURE 9.3**, we selected some of her jewels, her metallic go-go boots, and her tutu. All that glam juxtaposed with her modern bob hairdo and the selection of the industrial simplicity of her surroundings kept the image from becoming too saccharine and girlie-girl. It's exaggeration with a twist.

This girlie-girl's brother is a fearless, super-hero-in-training, so we coupled a John Galliano designer suit over a yellow tee with two yellow squirt guns for a tongue-in-cheek, James Bond concept. It's exaggeration with a twist (**FIGURE 9.4**).

FIGURE 9.4 The designer suit could have made for a stuffy, formal portrait. Fortunately, this James Bond wannabe found the squirt guns in the prop bucket and was only too happy to show them off.

ISO 100, 1/200 sec., f/5.6, 70–200mm lens

Clothing Do's and Don'ts

Most rules are made to be broken, but there is usually reason behind the prevailing wisdom. Here are a few basic rules I've found helpful when it comes to styling kids for portraits:

- **Do consider going naked.** No clothes in this world are cuter than a bare baby's body. Moms may think they want to dress their babies in outfits for a shoot, but it's hard to compete with bare baby photos. You have only a short span of time to shoot babies naked: This window of opportunity expires somewhere around the one-year mark.

- **Do use layers.** Jackets, vests, layered t-shirts, cardigans, and leggings create texture and interest in an image, and each item's color and style is an opportunity to tell a story about the child wearing them.

- **Do use the dry cleaners.** Once the clothing has been selected, I suggest that the clients drop all the clothes at their favorite dry cleaner so everything is pressed and ready to go the day of the shoot. You don't want weird wrinkles in a shot that say "just purchased" detracting from the image.

- **Do bring the whole uniform.** If my clients want to include a sports uniform in our session, I ask them to bring the whole uniform (socks, cleats, pads, etc.). A soccer jersey over a pair of jeans and sneakers doesn't have the same impact as the full uniform, dirty cleats and all.

- **Do bring options.** I recommend that my clients bring more than one option if they feel unsure about their clothing selection.

- **Do seek help from the pros.** If selecting clothes isn't your thing, team up with a local children's clothing boutique for help. This reciprocal relationship can be beneficial to both businesses. The boutique owner can help you style the kids, you can provide images for marketing the boutique, and you both win.

- **Don't distract from the child.** This is the one rule that should be unbreakable. Just say *no* to huge hair accessories that completely engulf a baby's head or any outfit that ends up "wearing the kid."

- **Don't change.** Multiple clothing changes create a recipe for disaster, particularly with toddlers and babies. It's best to start with layers that you can peel away for a different look without having to completely change outfits.

- **Don't forget the shoes.** Nothing dates a photo faster than athletic shoes. My timeless shoe favorites are Converse sneakers, boots (like Hunter rain boots or cowboy boots), ballet flats, plain flip-flops, and bare feet.

- **Don't neglect the details.** Pay attention to how the clothing fits the kids. If the kids show up buttoned down and looking as though they are wearing a straightjacket, take a minute to roll up their sleeves, perhaps untuck a shirt, and finesse their outfits, making the style more appealing and individual.

- **Don't dress young kids ahead of time.** On photo shoot day, I suggest that my clients style their kids' hair and clean them up but bring the clothes with them instead of dressing the kids ahead of time. This makes for a comfortable, no-stress ride to the studio with no worries if junior finds a chocolate bar in the back seat (it's happened). The getting dressed part of the shoot becomes part of the experience, like playing dress-up.

- **Don't get haircuts right before the shoot.** I counsel my clients to schedule haircuts at least one to two weeks prior to the shoot to avoid that "just cut" look.

- **Don't break the bank.** There's no need to go over the top on clothing expenditures. My most stylish moms often mix one high-ticket item, like a jacket or dress, with less-expensive togs, such as a t-shirt or leggings from discount department stores for an affordable, layered look.

Tip: You may want to have a small clothing steamer on hand in case clients show up with wrinkled clothing. A quick steam makes everyone look their best and is much faster than ironing.

Styling a Group

Styling a group of kids requires a different approach than styling a single child. You should first consider whether you want the kids to coordinate or match one another. I find the best clothing looks are coordinated, and often layered versus matchy-matchy clothing that looks unnatural and forced. I suggest my clients select a palette to work from and then dress everyone in similar *tones* rather than all the same color. For example, if they find a great dress in mid-gray, they should make sure everyone is dressed in midtones, as in **FIGURE 9.5**. If they prefer a darker palette, such as jewel tones or black, everyone should be dressed in a variety of those dark or vivid tones.

Keep it simple

Conventional wisdom says that the more kids there are in the group, the simpler you'll want the clothes to be to avoid distracting from your subjects' faces. However, even in a group shot, I want the kids to shine as individuals.

FIGURE 9.5 This client chose a midtone palette based on gray and steel blue, dressing everyone in a similar tone, which highlighted the faces and expressions of the kids rather than their clothing.

ISO 100, 1/200 sec., f/11, 70–200mm lens

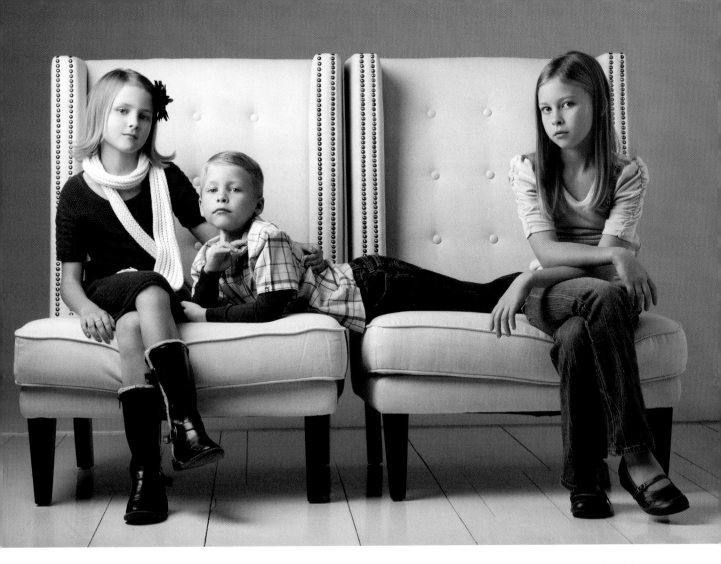

One kid might be the girlie-girl fashionista, but her sister may be more low-key and casual, as in **FIGURE 9.6**. The brother, as the only boy, can carry off a plaid pattern. Use clothing to accentuate the differences between the kids, and your client will love how each detail reinforces that child's personality in the final image.

A pop of color

Bend the "all-one-tone" rule by selecting a base color as the foundation for the clothing, and then introduce a pop of color, like the mustard yellow that repeats in different clothing pieces throughout the group in **FIGURE 9.7**. The addition of gray to the mix bridges the contrast between the bright yellow and dark blue.

FIGURE 9.6 The sister on the left is the fashion diva of the family, whereas her sister's clothing choice is simpler and sportier. The styling, with minimal accessories, tells the story in a subtle way.

ISO 100, 1/200 sec., f/11, 70–200mm lens

Even in a group shot, I want the
kids to shine as individuals.

One of a kind

A fun group to style is a gang of brothers with an only sister or vice versa. In **FIGURE 9.8**, the girl in the family is the only one in a dress, but we tied her in with her brothers by using black as the base color of their clothing and repeating the pattern on her socks with the pattern in their ties. The pop of purple in her faux-fur stole gives her center-stage attention as the only girl.

FIGURE 9.7 With navy blue as the foundation for the clothing, the client added pops of mustard yellow and gray to create interest and pull the look together (opposite page).

ISO 100, 1/200 sec., f/7, 70–200mm lens

FIGURE 9.8 The combination of a designer Dior dress and suits with a Gymboree hat and boots was perfect for this Gatsby-inspired shoot.

ISO 100, 1/200 sec., f/9, 70–200mm lens

FIGURE 9.9 Using an idea inspired by photographer Drake Busath, I've created clothing-palette guides like this one to help my clients visualize successful clothing pairings when they are shopping for clothes.

Note: No matter what type of seating you are using, be sure to have mom, dad, or an assistant close by as a spotter to avoid any unplanned Urgent Care visits.

Some Clothing Guidance

To help my clients with their clothing selections, I email them a link to a downloadable PDF file (**FIGURE 9.9**) that contains ideas for color palettes that other clients have used successfully in previous shoots. It gives them a starting point to visualize the clothing for their own photo session and is a helpful tool to use when they go shopping for clothes. I also encourage my clients to email or text me photos of outfits they are considering. It gives them confidence that they aren't alone in the daunting process of clothing selection.

Props or No Props?

Most furniture props fall into two distinct categories: secondary and primary. The secondary prop sort of blends in, giving the subject center stage. Although it can provide a bit of texture, a secondary prop doesn't call attention to itself. A primary prop, on the other hand, is very identifiable and memorable, but carelessly used can dominate the image.

Secondary Furniture Props

My favorite secondary props are the basics that I use time and again (**FIGURE 9.10**). They are a grouping of stools, pedestals, and platforms that complement my photographic style. Throughout this book you'll see them in use in several images. My secondary props have the following characteristics in common:

- **Neutral colors.** The reclaimed wooden cubes and concrete cylinders provide texture and don't conflict with the color in my subject's clothing.

- **Retro or industrial in style.** The vintage office stool, the rolling architectural file, or the retro kitchen table and chairs add subtle character. The rolling file also provides a low, wide platform and is especially helpful when I'm photographing toddlers who don't like to stay put. It gets them up off the floor just high enough that they pause before immediately climbing down, allowing me time to snap

a shot. It also allows me to shoot from a low angle without having to lie on the floor (more about shooting angles in Chapter 10).

- **Textured.** Organic wood grain, smooth concrete or crusty, or chipped paint all provide interest in an image without overpowering the subject. The distressed wooden set of "stairs" pictured is actually a side table I found damaged on clearance at a local furniture store. It is a great prop for positioning multiple kids at different heights.

- **Different heights.** Platforms, such as wooden apple boxes, can be purchased through B&H photo (www.bandhphotovideo.com) and are perfect for adding height to a child whether the child is standing or sitting. The white, wooden boxes were purchased at a flea market. They were painted a nauseous blue so I repainted them white.

- **Difficult to move.** Heavy pedestals or stools are best to use when you're photographing toddlers. The gray, concrete cylinders are hollow but heavy and cannot be easily moved—a perfect perch for toddlers who love to pick up and move little chairs rather than sit in them. A heavy chair or stool grounds little ones where you want them to stay. I found the concrete cylinders at a store specializing in outdoor patio furniture.

FIGURE 9.10 A curated collection of props selected for their texture, simplicity, and style.

Primary Furniture Props

Primary props are more specific and defined. They call attention to themselves and can take center stage. Primary props require careful use because they can overwhelm your subject. An example of a primary prop is the modern red chair in **FIGURE 9.11**. Brought in by the little girl's mother, the chair was the focal point of her daughter's room décor and the girl's favorite perch. In this case, the stark shape and bright color of the chair draw the viewer's eye straight to the subject and her sassy expression.

FIGURE 9.11 A modern red chair leads the viewer's eye to the little girl and her sassy expression and pose.

ISO 100, 1/200 sec., f/9, 70–200mm lens

Primary props are more specific and defined.

FIGURE 9.12 The princess chair is the most requested chair in my studio, but I have to ensure that it doesn't distract from the child I'm photographing.

ISO 100, 1/200 sec., f/9, 70–200mm lens

The most specific prop I own is affectionately referred to as the princess chair (**FIGURE 9.12**). Almost every little girl (and big girl) who walks in the door wants to be photographed in that chair. Although I have to be careful with it because it can overpower the child being photographed, as specific as it is, the chair is surprisingly versatile. I've photographed a range of subjects in that chair, from formal little girls to brides and even Santa Claus.

A mix of secondary and primary props was used to create a set for an Audrey Hepburn-inspired shoot for a 14-year-old client (**FIGURE 9.13**). Obsessed with Audrey Hepburn, the girl spent weeks looking at photos of Audrey and collecting jewelry and clothing for the shoot. During her consult we decided on several vintage Audrey images that we wanted to re-create for her. This image was my favorite from the shoot.

FIGURE 9.13 A careful combination of clothes, accessories, and props combine to support this conceptual shoot for a 14-year-old Audrey Hepburn fan.

ISO 100, 1/200 sec., f/9, 70–200mm lens

Buy or Borrow?

Usually, I purchase only secondary props and then borrow the primary props so that I'm not using the same distinct props over and over again. Fortunately, I share a building with two furniture and home décor stores that are full of one-of-a-kind furniture pieces. In exchange for providing images for the stores' blogs and social media, I struck a deal with the store owners to borrow props. This pact benefits all parties: The stores receive images for marketing, and I get a constantly rotating supply of interesting furniture pieces. Consider making a similar arrangement with a local antique dealer or home décor boutique in your area.

Costume Props

Rarely do I use costume props in my work unless we are shooting for holiday cards or a specific, conceptual shoot, but I've found that pulling out the costume props at the end of a regular family or kid session is a great way to wrap up a shoot and send the kids off on a high note. So when we're ready for some fun make-believe, out comes my ATJ prop cart (**FIGURE 9.14**) stocked with costume props that kids (and their parents) love to play with. My preferred props are open-ended enough to be used in many different ways. Here are just a few of my favorites:

- **Boxing gloves.** Two bright red pairs of Everlast boxing gloves in adult and kid sizes make for some amusing shots. You may question my latent violent tendencies, but these are everyone's favorite— boys and girls alike. They are perfect for highlighting sibling rivalry or a father and son smackdown.

FIGURE 9.14 The ATJ prop cart is made from old feed bins welded together to create a rolling cart of bins that are the perfect size to organize a collection of costume props.

ISO 100, 1/200 sec., f/9, 70–200mm lens

The most unique use of the boxing gloves was in a shoot I did with a boy recovering from brain surgery, which was necessitated by an accident at school. The boy (**FIGURE 9.15**) is the wild card of his family, and mom wanted to document this chapter in his life and celebrate his survival. The boxing gloves seemed like the perfect "you-should-have-seen-the-other-guy" prop. We used this image on the front of the family's holiday card with the caption, "Dear Santa, I can explain."

- **Sunglasses.** Several years ago I purchased four pairs of kid's-size, aviator-style sunglasses: three in neutral shades and the fourth in pink. These glasses make any kid look cool, and because the lenses are only slightly tinted you can still see the kid's eyes through the lenses (**FIGURE 9.16**). The biggest dilemma I face when using these glasses is getting them back from the kids before they leave.

- **Alphabet letters.** Using big, metal or wooden letters as a family's monogram or for a photo that will be used in an album, holiday card, or birthday invitation adds a strong, graphic element.

- **Superhero capes.** Many kids' favorite props are my collection of superhero capes. As Jerry Seinfeld said, "These aren't superhero fantasies; these are career options." The black Batman cape does double duty as a magician's cape when paired with a wand, a top hat, and an extra large mustache.

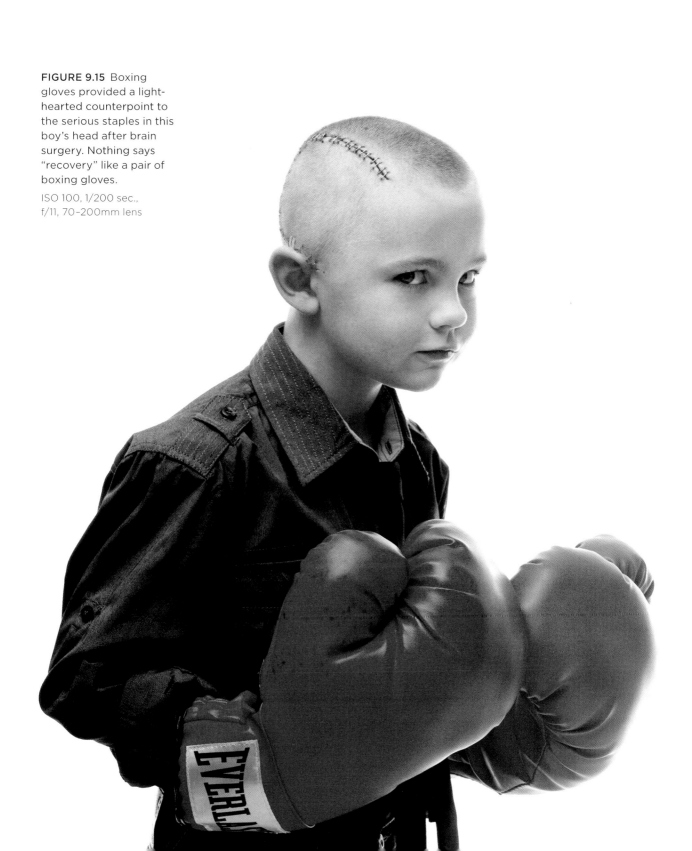

FIGURE 9.15 Boxing gloves provided a light-hearted counterpoint to the serious staples in this boy's head after brain surgery. Nothing says "recovery" like a pair of boxing gloves.

ISO 100, 1/200 sec., f/11, 70-200mm lens

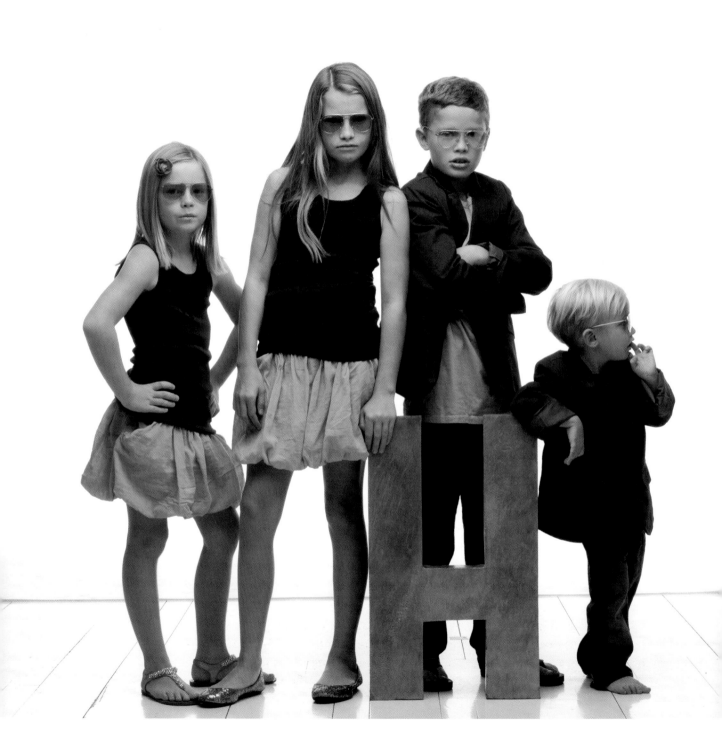

FIGURE 9.16 Aviator-style sunglasses look cool and still allow you to see the kids' eyes. Buy them in kid's sizes so they are the proper scale for a child's face (opposite page).
ISO 100, 1/200 sec., f/9, 70–200mm lens

FIGURE 9.17 Styled in a leopard-print-lined trench and perched on vintage luggage, this little girl is going places (left).
ISO 100, 1/200 sec., f/9, 70–200mm lens

- **Hats.** A stash of basic fedoras and panama hats in straw and black felt in varying sizes are also much loved among my subjects. Another of my favorites is a leather aviator cap with fur interior, as shown on the baby in Figure 9.2.

- **Luggage.** Trunks and suitcases are some of the best props to pair with either secondary or primary furniture props. They provide interest and context for a theme-ish shot, like the one in **FIGURE 9.17**, but can also act as platforms for kids to sit on without overwhelming the shot.

- **The rubber gun.** Inappropriate and politically incorrect on all levels, the rubber gun is a perennial favorite with boys. I use it as an incentive to get the other shots I want, because the rubber gun is rarely appropriate for a portrait. But sometimes that last shot that you do to "humor the kids" ends up being your favorite, even if it has a gun in it (**FIGURE 9.18**).

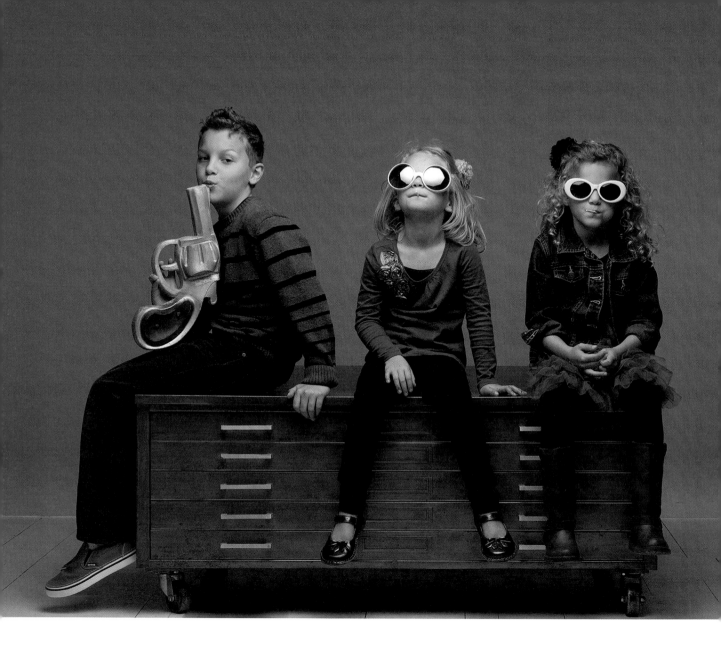

- **Candy.** At the end of a session I always offer kids a candy treat. Early on I began to notice that once they got the candy they exhibited a whole new range of expressions and lots of fun was going on. So, I've learned to keep my camera handy during the candy-giving phase of the shoot to make sure I don't miss capturing any of the fun. Candy necklaces and jewelry can also add an entertaining twist to regular jewelry in a more conceptual shoot.

Where to Find Great Props

You don't need tons of props; you just need a few of the *right* props—items that speak to your style and that you can use repeatedly. Sometimes you'll luck out and find certain props at bargain prices or free of charge. Other times you'll need to lay out some cash. But if an item will serve you for years, it's worth the expense. The following list contains places I return to frequently for successful prop hunting:

- **Texas antique markets.** Every year in the spring and fall in the fields of Round Top, Texas, a huge antique market takes place that lasts for two weeks (www.roundtop-marburger.com). This is where most of my secondary props (Figure 9.10) have come from. It is *the* place to get vintage trunks, industrial office furniture, reclaimed wood anything, retro furniture pieces, and unusual accessories of every kind. Get there early for the best deals.

- **Antique malls.** Almost every town has an antique mall where multiple vendors sell all kinds of vintage items. These are ideal places to find small props, like children's school chairs, vintage chalkboards, old frames, and rotary dial phones.

- **Home décor stores.** You might overlook home décor stores because you think they are too expensive for your budget. But almost every store will have some damaged or clearance items that it wants to get rid of. If you're looking for a specific item, ask the store owner to keep an eye out and give you a call if she finds something that meets your criteria. Check out www.onekingslane.com—an online source for unusual home décor items.

- **Garage and estate sales.** Don't underestimate your neighbor's junk as a resource for your prop needs. I bought a white retro chrome dinette set from a guy selling his grandma's old junk. But be choosy and buy only what fits your style and vision for your work.

Remember that the best time to buy an amazing prop is *when you find it*. Chances are good that you'll never see it again, and you'll beat yourself up over it for the rest of your life. Just buy it already.

FIGURE 9.18 This was the last shot of the session after candy had been dispensed and the kids were digging into the ATJ prop cart. With so many props it shouldn't have worked, but their attitude combined with the props made the shot (opposite page).

ISO 100, 1/200 sec., f/9, 70–200mm lens

B.Y.O.P.

You may find that the very best props belong to your client. That's the reason I ask my clients to bring props from their children's personal stash. Doing so can be part of getting the kids on board for the shoot, or the prop selection can have a more specific use, such as highlighting a developmental milestone or creating a distinctive image for the client's home.

Blankets and toys

The toys you play with as children hold a nostalgic appeal throughout your lives, so make the time to document these fleeting phases with your subjects in your next photo session. Other ideas for photogenic objects to bring to a shoot include:

- **The blankie (and thumb).** Don't wash it ahead of time (the blankie, that is).

- **The pacifier.** Most parents don't *think* they want a pacifier shot, but I always do one and they always love it. (I may convert these images to black and white if the pacifier is an obnoxious color.)

- **Legos or building blocks.** Use colorful or plain blocks and have the child build something for you, or spill the blocks around the kids and shoot down on them from above.

- **Toy trains or trucks.** Let the child line up the trucks the way he wants them displayed for you to photograph.

- **Favorite doll or stuffed animal.** No matter how worn and dirty, bring the baby or bear as-is. Think *The Velveteen Rabbit* rather than a brand-new version.

- **Dress-up clothes.** Once again, let the kids pick their favorite ratty princess dress or scuffed cowboy boots. The wear and tear just makes the image that much more authentic and memorable.

Parents may dismiss some of these items as unworthy of documentation, but the images created with a beloved item become more valuable with every year that passes.

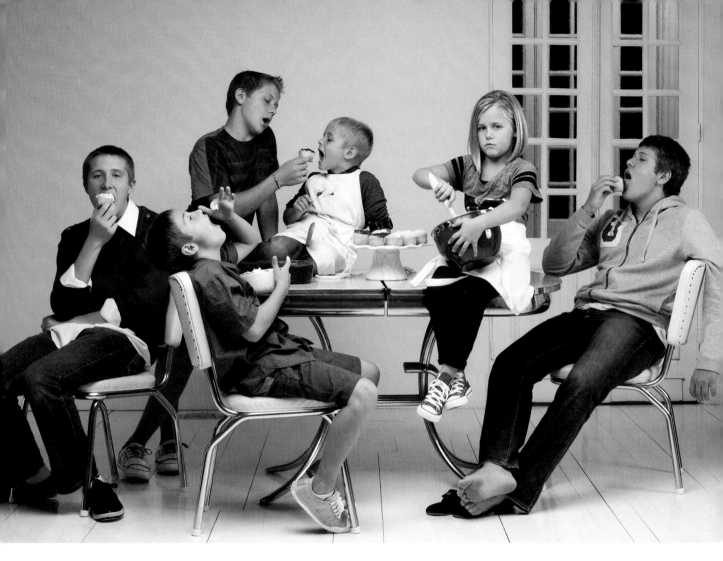

Food

Cake isn't only for the one-year-old birthday shoot. We shot the image in **FIGURE 9.19** specifically for display in the client's kitchen. With five boys and only one girl, we styled the girl with red sneakers and gave her a red bowl so she popped out in the monochromatic scheme. The boys didn't need much directing to chow down on the cupcakes they'd been eyeing for the entire shoot.

Other clients owned a chain of pizza restaurants in our area, so they arrived with hot pizza slices to use as props in their shoot.

FIGURE 9.19 As the only girl in a house full of boys, her expression clearly says, "I'm surrounded by idiots." This image was created to hang in the family's kitchen.

ISO 100, 1/200 sec., f/16, 70–200mm lens

FIGURE 9.20 This was a miracle shot. It's unusual to work with a dog well trained enough to stay on top of a platform, and even more unusual to get one-year-old twin boys to pose for the camera.

ISO 100, 1/200 sec., f/9, 70–200mm lens

Tip: For best results, advise your client to have the dog or cat groomed about five to seven days before the shoot.

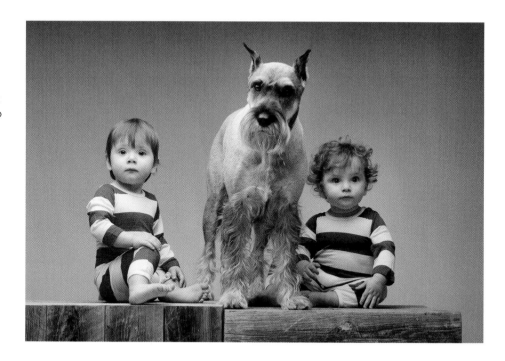

Pets as Props

Do you hear the circus sound track playing? The thought of photographing a bunch of crazy kids in addition to their animals never seemed like a good idea to me until I actually tried it. In that initial pet/kid shoot, the well-behaved pooch introduced an element of whimsy and meaning to the images, and the dog gave the kids something to do that wasn't directed by me.

Several shoots with pets later, I was hooked. It occurred to me that working with dogs and cats is the same as dealing with toddlers; the same tactics apply: Use lots of crazy noises (think meowing and barking) and distraction techniques (treats), and move quickly from one shot to the next. I approach an animal

shoot the same as a kid shoot: I get the quiet shots first (**FIGURE 9.20**) and then explore the fun stuff at the end in case the animal (or kids) aren't cooperative later.

Parents as Props

Parents can make the best props of all, especially when it comes to photographing babies. Have the parent turn away from the camera and place the baby on the parent's shoulder. You'll get eye contact with the baby and capture the love. You don't always need to have the entire parent in the shot. Sometimes I'll just shoot the legs of the parent with a toddler hanging on for dear life.

Props as Symbols

Client-owned props can provide an extra layer of meaning to an image. Some of my favorite sessions have focused on an item of special significance to the family.

In **FIGURE 9.21** we created an emotional image of a little girl with her father's combat boots. Her father was a soldier killed in the line of duty in Afghanistan when she was an infant. My client wanted to include the boots in an image with her daughter, but we didn't want her to be wearing them or have the image make light of the situation in any way. While struggling with how to portray this concept, I simply set the boots on the cart where the girl was seated and watched to see what would happen. She turned back to see what I had set behind her and reached out to examine the boots.

FIGURE 9.21 A little girl whose soldier father was killed in the line of duty takes a moment to touch and explore his combat boots.

ISO 100, 1/200 sec., f/9, 70–200mm lens

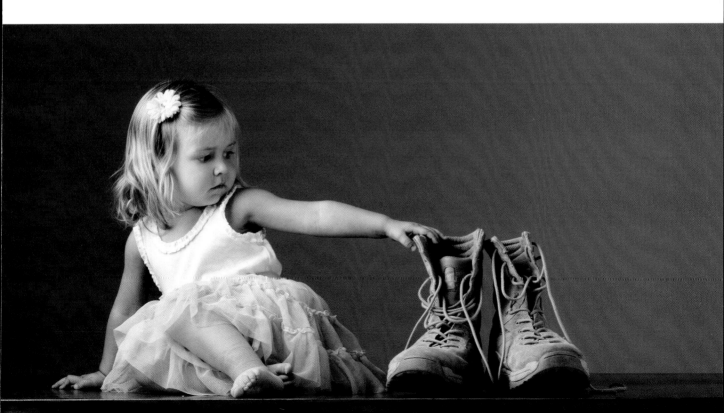

Over-the-Top Props

For most sessions, props play a small role or are brought in at the end of the shoot for fun. Sometimes, however, the props *are* the shoot. The boys in **FIGURE 9.22** and **9.23** are very creative brothers. Their graphic designer dad wanted to create superhero identities for them by highlighting their obsessions of the moment. Craft Kid (Figure 9.22) was surrounded by rolls of duct tape and wore a tool belt stuffed with his favorite art supplies. The low camera angle and flowing cape added a superhero vibe. Craft Kid's brother, aka The Human Wrecking

FIGURE 9.22 Craft Kid was created from this boy's obsession with crafts and his father's creative prop and styling skills.

ISO 100, 1/200 sec., f/8, 70–200mm lens

Ball, created his own "armor," which consisted of Tupperware knee and shoulder pads, a baseball hat with a bike helmet on top, and a duct-taped sword; Nerf ammo completed the ensemble.

Assemble your own creative team by consulting with your clients and collaborating with local boutique owners to help with styling and props. In no time you'll be creating unexpected and intriguing concepts for your own shoots.

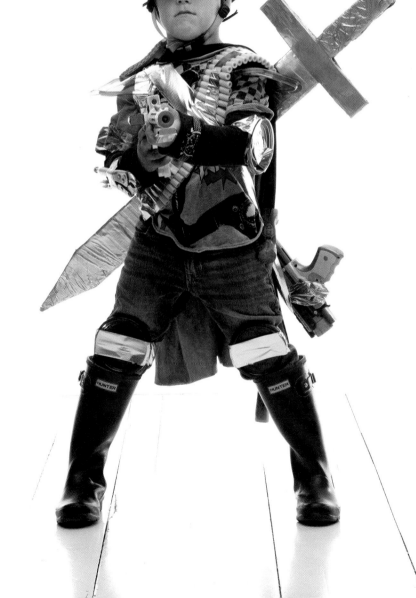

FIGURE 9.23 The Human Wrecking Ball used elements from the boy's own stash of homemade armor that he creates on a daily basis.

ISO 100, 1/200 sec., f/8, 70–200mm lens

In a still photograph you basically have two variables, where you stand and when you press the shutter. —Henry Wessel

Directing the Shoot

A PHOTO SHOOT IS SIMILAR to a Hollywood movie set, where the director is responsible for everything that happens on the set. A good director collaborates with actors and producers, but every decision she makes and every direction she gives is in an effort to maintain a strong, consistent vision for the picture. Your clients don't hire you for your photographic skills alone. They may not say it, but they are also hiring you as the director of the photo shoot. Your clients expect you to take control and provide clear instructions in addition to creating amazing images of their children.

In this chapter you'll learn how to do just that by assuming control of the shoot, establishing your point of view, posing your subjects, and then directing them in ways that bring out their unique personalities and expressions.

ISO 100, 1/200 sec., f/11, 70-200mm lens

It's All Your Fault

Tip: Remember that what happens on your set is your responsibility. Don't let anyone or anything detract from the energy and connection you have created with your subjects.

When clients hire you to photograph their children, they will hold you responsible for the end results. It doesn't matter that you advised them against horizontal stripes for their chubby tween. If the kid looks fat in the photos, the client will see it as *your* fault. It's the same with the photo session. Your client may try to take control and direct her kids during the shoot, but in the end you alone will take the credit or blame for how the images turn out. Therefore, make sure you establish a few ground rules ahead of time—for yourself and your clients. In a friendly yet firm way I explain my two unbreakable rules for any photo shoot:

- **Only one director on set.** As parents, we get so used to correcting our own children that it's almost impossible to turn it off. During the client consult, I warn clients against directing their kids during the shoot and giving commands such as, "Smile!" "Look over

here!" "Isabelle, don't sit like that," and so forth. I let them know that once they walk into the studio, I will handle the kids. They can take a break, watch the "show," or go shopping. Sometimes they'll forget my advice and begin directing their kids. I'll let them get out a couple of commands and then, in a joking way, remind them by saying, "OK, you're not allowed to talk to your kids for the next hour." Or I might address the kids with, "Guess what? You don't have to listen to anything your parents say for the next hour." The kids love it; it's light and funny but also reminds the parents that I'm taking charge of the session. The parents usually laugh, realize what they are doing, and go sit down. If the problem is more protracted, I'll suggest that mom go do some shopping at the store next door or that dad go read his iPad in my office.

- **Only one camera on set.** During the consult, I make sure my clients know that there will be no other cameras, including iPads or phones, on set. I'm not worried about them taking a photo that will compromise my portrait sales; it's the problem of two directors. If mom is calling out, "Look over here!" while snapping pics on her phone, that breaks the connection between my subjects and me. Once I explain that other cameras on set will distract the kids and take away from the success of the images, most clients get it. If clients want to Instagram a quick behind-the-scenes shot of their kids being photographed, I'll let them take one shot at the beginning of the shoot and then I expect them to put it away.

Be Prepared

Rules for good behavior should not only apply to your clients. It *should* go without saying that your lights, camera, and anything else you need are set up and ready to go before your clients arrive for the photo session. If you're photographing on location, arrive early and set up so you can spend time connecting with the kids, not worrying where you're going to position the light. Moms have enough on their minds while getting ready for the photo shoot; don't add waiting around for you to their list of concerns. At the shoot, have the client consult sheet on hand with the kids' names on it so you can commit their names to memory or at least use it as a reminder to call them by name during the shoot.

Tip: It's important to be prepared mentally and physically. If you need a shot of caffeine and some good music to pump you up before a shoot, do it.

Create an Atmosphere

Set the right atmosphere for your shoot using elements that are true to your style and personality. I make sure my studio is clean and smells good, and I always have music playing. I want my clients to feel as though they are arriving at a cool and interesting event. My first priority is to establish a connection with the kids within the first five minutes of their arrival.

As mentioned in Chapter 2, I have specifically instructed my clients before the shoot not to threaten their kids to be good while we're taking pictures. I've promised that we are going to have fun and that, although things might get a little crazy, it's all for a good final result. When the kids arrive for the shoot, I get down on their level, shake their hands, and introduce myself. A good icebreaker for younger kids is to act confused about their names and start calling the boys by the girl's names or vice versa. Little kids *love* to correct adults, and it starts the session off on an amusing note. For older kids, I ask them about school or their interests, which I've just reminded myself of by looking at the client consult sheet. I want my subjects to feel they are important and that this experience will be fun.

What's Your Angle?

Recall the quote at the beginning of this chapter, "In a still photograph you basically have two variables, *where you stand and when you press the shutter.*"

Give careful thought to where you are standing or sitting (or lying down for that matter) when photographing a child. Where you stand affects your angle of view and how your camera interprets your subject, making the child appear confident and important or submissive and demur. Like with every decision you make during a shoot, choose your camera angle with intention.

What's Your Director Profile?

As a photographer, your personality and how you interact and direct your clients are as much a part of your style as how you use light and composition in your images. Do you see yourself in some of the following descriptions?

- **The Techno-weenie.** This photographer is either so in love with her gear or so intimidated by it that she doesn't take time to engage the kids she's photographing. The techno-weenie spends too much time stressing out about technical details, "working the light," or performing death by posing; consequently, her images end up stiff and boring.

- **The doormat.** This photographer allows kids and/or parents to take control of the shoot and wonders why the client isn't happy with the final result. Wishy-washy in her approach and lacking the confidence needed to take control, the doormat is a magnet for the bossy, high-maintenance client.

- **The boss.** The flip side of the doormat, the photographer with the boss personality profile is not afraid to take control of whatever is happening on her set. Bring her your uncooperative, naughty, kids from hell, and she sees it as an interesting challenge. As the CEO of her shoot, the boss is happy to direct but also enjoys a collaborative relationship with her clients. She's savvy enough to keep her eye on the bottom-line equation, which is happy kids plus great images equals a satisfied client.

- **The flake.** As the name implies, this photographer is disorganized, late, and unprepared. The flake makes the shoot difficult for everyone. Interestingly, the flake tends to be the first person to complain about how difficult her clients and subjects are to deal with. She may be a talented photographer, but the flake won't go far without some structure to her business life.

- **The dictator.** The iron-fisted despot of photography, the dictator has her creative process on lockdown and her sets and poses reduced to a formula. There is no room for serendipity on the dictator's set. Maybe she's afraid of losing control or maybe she has her "go-to" technique dialed in and doesn't want to venture beyond it; either way, the dictator limits her creativity by not allowing for open-ended interaction with her subjects. Her lack of experimentation means that she misses out on happy accidents that could take her work in a new direction.

- **The pied piper.** Part comedian, part circus clown, the pied piper has many tricks up her sleeve to keep kids interested in what's going on. She never lets the energy lag and constantly keeps her subjects guessing. One minute she may be snorting like a pig; the next, she's whispering about the bird in the tree outside the window. The pied piper wants her subjects to have a great time, but she also wants to get the job done. All the tricks and cajoling have one purpose: Get the shot!

- **The queen of calm.** This photographer doesn't let anything ruffle her feathers. She's particularly good with newborns and shy children because her energy is low key and easy to be around. She has a vision for every shoot but prefers to let it unfold naturally rather than giving too much direction. She may get down on the floor and play with her subjects or be a fly on the wall, capturing them at play in a more photojournalistic style. Don't be fooled by her calm exterior. She may seem low key, but she always gets her shot.

Choose your camera angle with intention.

FIGURE 10.1 shows four camera positions, and FIGURE 10.2 shows the results of those camera angles. The differences may seem subtle, but compare the first and last shots by covering up the middle two and you'll get a clear idea of the difference a camera angle can make. Here are the four angles described in detail:

- **Worm's-eye view.** This is a very low camera angle, where the photographer is shooting up at the subject. It is achieved either by the photographer lying on the floor or by elevating the subject on a stool or platform. This angle works well for full-length shots and conveys respect for the subject in the image.

- **Neutral camera angle.** A neutral camera angle is achieved with the camera lens at waist height to the subject. The neutral angle is a safe choice and works well for full-length or close-up shots.

- **High camera angle.** The photographer at a standing position puts the camera at a high angle in relation to a child, essentially shooting down on the subject. This angle makes the child appear younger and more vulnerable—eyes looking up to the camera appear sweet and demure. This is a good angle for head shots.

- **Bird's-eye view.** A very high angle is achieved with the photographer standing on a stool or ladder. This view can create distortion in a standing subject, which can be used for effect (think big head and little feet). This angle can cause foreshortening in the image, making the subject appear stocky and heavy, but when used for effect can emphasize a chubby baby. Pay careful attention to the floor when you're shooting from a high angle because it will be your background.

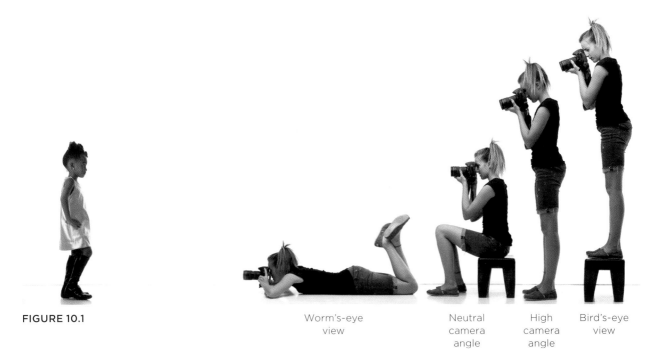

FIGURE 10.1

Worm's-eye
view

Neutral
camera
angle

High
camera
angle

Bird's-eye
view

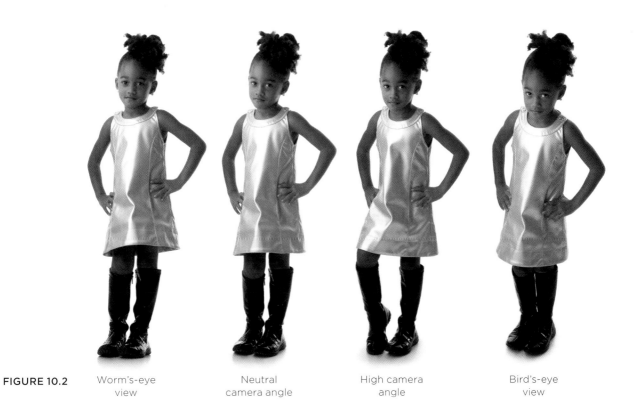

FIGURE 10.2

Worm's-eye
view

Neutral
camera angle

High camera
angle

Bird's-eye
view

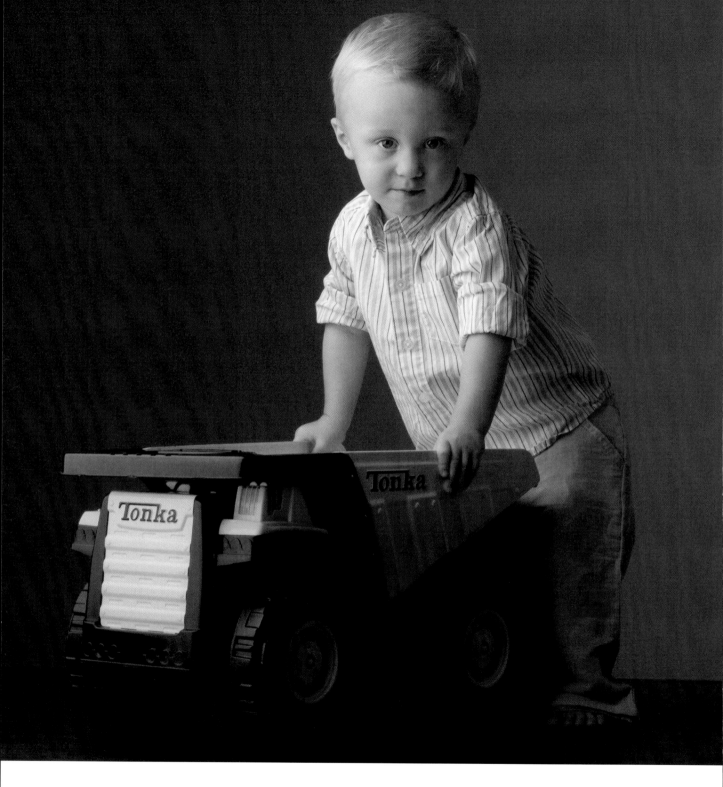

How Low Can You Go?

Because kids are small humans it makes sense to choose a lower camera angle than you may be used to using when photographing teens or adults. However, you may find it difficult to get a *low enough* camera angle without lying on your stomach or digging a pit to shoot from. A simple remedy is to use a platform, bench, trunk, or table of some kind to elevate the child, which will give you the low camera angle you are seeking. I prefer to photograph children from a low or very low camera angle for several reasons:

- **Enter their world.** A very low camera angle gives the viewer the feeling of entering the children's world at their level or seeing things from their point of view.

- **Large and in charge.** A low camera angle can make even the smallest child look commanding and important, like the shy but proud little boy in **FIGURE 10.3**.

- **Editorial feel.** Photographing kids from a worm's eye view is a departure from the typical portrait taken from a neutral or slightly high angle (**FIGURE 10.4**). Most high-fashion editorials are shot from a low camera angle. Shooting from a very low angle with a child as your subject creates an image that feels more edgy and fashion forward (**FIGURE 10.5**).

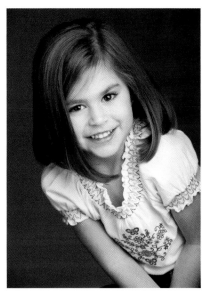

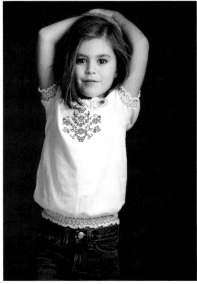

FIGURE 10.4 Shot from a high camera angle, this typical headshot is sweet and demure (top).

ISO 100, 1/200 sec., f/11, 70–200mm lens

FIGURE 10.3 Placing the boy on a 30-inch-high platform allowed for a very low camera angle, showing the truck detail and the boy's pride (opposite page).

ISO 100, 1/200 sec., f/8, 70–200mm lens

FIGURE 10.5 A low camera angle conveys a more editorial, grown-up feel for the same little girl (bottom).

ISO 100, 1/200 sec., f/11, 70–200mm lens

Begin with their natural movements and then refine their pose from there.

- **Natural stance.** Shooting from a low angle makes it easier to capture a child's natural stance and expression because the child isn't forced to look up to the camera.

- **More background.** A low camera angle means the floor or ground is less prominent than the background or sky. You can take advantage of this by playing with a sense of scale and create more negative space in your image.

- **Exaggerated action.** A low camera angle is particularly suited to action shots. It makes kids' jumps look higher than they really are and also highlights the pose and movement of your subjects.

If you've been photographing children from a standing position, experiment with new, more interesting angles and change up your point of view.

Posing

Posing is a very fluid term when it comes to photographing children. For babies, toddlers, and preschoolers, posing in the traditional sense won't happen unless you have a straightjacket on hand. The mere thought of trying to pose kids may seem like an exercise in futility, but there are several basic directions you can give that make sense to kids and that look good in a portrait.

To begin, I give my subjects an open-ended direction, such as, "Hop up on that stool for me." Then I watch to see what they naturally do. If the pose is good as is, I shoot it; if it needs adjustment, I can refine the pose from there. This is by far the easiest and most natural way to pose anyone regardless of age: Begin with their natural movements and then refine their pose from there.

Quick Basic Poses

Simple, explicit requests are best when you're posing children of any age. After you've been shooting for a while, you discover certain tricks that work with many different children. Just like your camera and gear, these little tricks will become one more tool you can use in the quest for a great shot. Here are a few basic poses that are quickly communicated using the right wording:

- **Criss-cross applesauce.** "Cross your legs" has different meanings to different kids. Somehow, the command "criss-cross applesauce" lets them know that you want them to sit like the boys in **FIGURE 10.6**.

FIGURE 10.6 These brothers are posed touching, but with one boy's back to the other, it keeps the pose from becoming too sweet.

ISO 100, 1/200 sec., f/8, 70–200mm lens

- **Elbows on knees.** I love the look of a subject leaning in toward the camera, and the quickest way to get this pose when your subjects are seated is to have them put their elbows on their knees, like the boy on the left in Figure 10.6.

- **Thumbs in pockets.** Deciding what to do with hands is always a concern in a portrait. Two helpful directions are to ask the kids to put just their thumbs in their pants pockets. Alternately, if they want to put their hands in their pockets, make sure their thumbs are showing (**FIGURE 10.7**). If they shove their entire hands in the pockets, the hands look strangely amputated without the thumbs showing.

- **Fold your arms.** This is a perfect pose for the sassy girl or for a boy who wants to look confident and tough (Figure 10.7). You'll find that just by folding their arms your subjects will usually shift their weight to one leg or the other, creating more interest in the pose.

- **Just a teeny-tiny bit.** It's the small, incremental movements that make the difference between a so-so pose and a great one, so it's important to have a method of directing kids to move in small increments. Asking a child to step forward can result in a huge leap toward the camera. Instead, I'll ask them to take a "teeny-tiny step" toward me and say it in a teeny-tiny voice. It's amazing how well this works with children of all ages (and adults).

- **Cross your knees/ankles.** Instead of asking your subjects to cross their legs (which can have multiple interpretations), be more specific and ask them to cross their knees or their ankles.

- **Perched vs. sitting.** When asked to sit in a chair, kids will usually put their bottom all the way to the back of the chair, which isn't the best look because the soles of their shoes are then facing the camera. Ask them instead to "perch" like a bird on the edge of the chair. This places them in a position where they are leaning toward the camera, which is a more engaging portrait angle.

- **Don't let me see the bottom of your shoes.** A common distraction in a portrait of a sitting child is that when they sit back too far, the bottoms of their shoes are visible. If the kids are barefoot, there's no problem. But if mom has carefully selected shoes, she'll want to

see them in the picture. Kids can "hide" the bottom of their shoes by pointing their toes, putting their feet on the floor, or scooting forward in a chair so their legs hang down.

- **The sticker trick.** Posing toddlers is like herding cats. The best you can do is to get them in the light and try to keep them there long enough to get a shot. The sticker trick is a great ploy for keeping young kids where you want them when you're shooting standing shots. Anchor them to the floor by placing a sticker or small piece of gaffer tape on the floor right where you want them to stand; then solemnly make them promise to "hide" that sticker from you with their foot. If they try to walk off, gasp and say, "Hurry! Cover that sticker up; don't let me see it." They will stay long enough for you to get a shot, and as a bonus, you'll get some great expressions from them as they try to cover up the sticker.

FIGURE 10.7 This brother and sister duo show off two basic poses—folded arms and thumbs out of the pocket— giving them attitude and something for their hands to do.

ISO 100, 1/200 sec., f/11, 70–200mm lens

Camera Aware or Not?

Depending on the portrait, you may prefer to pose your subject aware of and looking straight at the camera so viewers can see and feel the eye contact in the image. Another subject may be better captured when unaware of the camera or engaged in something other than being photographed, putting the viewer in the role of an observer.

I like to shoot camera aware and camera unaware images during a photo shoot depending on my subject and what we are trying to create for our final product. But one of my favorite poses when photographing more than one subject is a combination pose: Some subjects are camera aware and others are unaware in the same image, as in **FIGURE 10.8** of a young family with a new baby. Mom, dad, and baby are all wrapped up in each other (camera unaware) while the firstborn is looking directly at the camera. This combination camera aware/unaware pose creates a storytelling element in the portrait.

A more contrived yet energetic version of the camera aware/unaware concept is to shoot a family where mom and dad are laughing at each other as the kids steal center stage by jumping and looking directly at the camera. At your next shoot, change how you normally shoot by considering whether you want your subjects to look at the camera, each other, or something else entirely.

Show the Real Relationship

In recent years, portrait photography has moved away from formal, posed shots to a looser, more candid style, and much has been made of the importance of showing the relationship between subjects in a portrait. The most immediate way to show a connection between your subjects is by having them close to or touching each other. This is most natural with young families when they have babies in their arms. But what about when the children get a bit older? Or what if the family isn't very touchy-feely? It's important to document the relationship, but it's also important to document it accurately and with integrity. Most clients respond better to an image that is an authentic portrayal of their kids rather than a cute and cuddly yet inaccurate version.

FIGURE 10.8 The story of an oldest child told using eye contact with the camera.

ISO 100, 1/200 sec., f/22, 70–200mm lens

FIGURE 10.9 Be sensitive to the dynamics of blended sibling groups by taking a cue from their natural interactions.

ISO 100, 1/200 sec., f/18, 70–200mm lens

The group of kids in **FIGURE 10.9** is a blended family of step-siblings. They care for each other, but a saccharine-sweet shot of them hugging each other would not ring true for their ages or the family dynamics. In this photo session, we had club music playing in the studio so the girls were shaking it while the boys were wishing they were anywhere else. I simply emphasized what was already happening by positioning them in a line and reassuring the boys that if they cooperated, they probably would not be required to dance.

Highlight the differences in siblings with posing or just by paying attention.

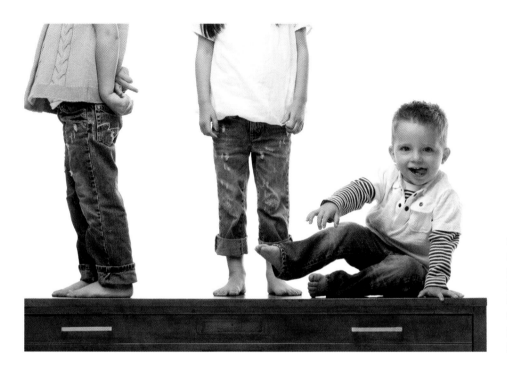

FIGURE 10.10 Even when no one wants to be posed, that can be a pose in and of itself. Don't lose heart; crop to the story and keep shooting.

ISO 100, 1/200 sec., f/11, 70–200mm lens

When boys get to the tween phase, they are eager to show their separation from their dad. You can still do the dad and son shot, but be sure to give junior a little respect. Pose him by putting his back against his dad (or brother). This stance gives him some visual separation from his dad but still keeps them connected.

You can also highlight the differences in siblings with posing or by just paying attention. The twin sisters in **FIGURE 10.10** are very different. The oldest twin is standing where she's supposed to be, front and center, ready for her photo to be taken. Her younger sister is easily distracted, so she's turned sidewise looking of at who knows what. Meanwhile, the naughty younger brother (and only boy) is determined to do things his way. This was mom's favorite image from the shoot because it showed their personalities and their relationship in a single image.

Same Pose, Different Year

I'm always surprised by how much my clients' kids have grown each year they come in to be photographed. Parents see their kids every day so they don't tend to see this dramatic growth. This is the reason it's fun to repeat a pose from an earlier session a few years later to highlight how much the kids have changed. The brothers in **FIGURE 10.11** and **FIGURE 10.12** were photographed almost five years apart in the same pose.

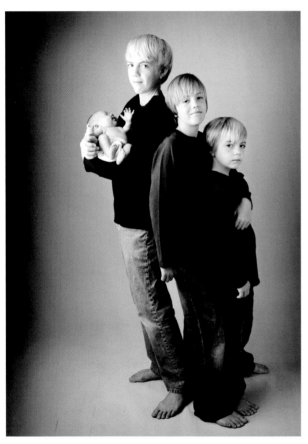

FIGURE 10.11 Four brothers were photographed together (from a high camera angle) to celebrate the birth of their baby brother.

ISO 200, 1/200 sec., f/8, 24–70mm lens

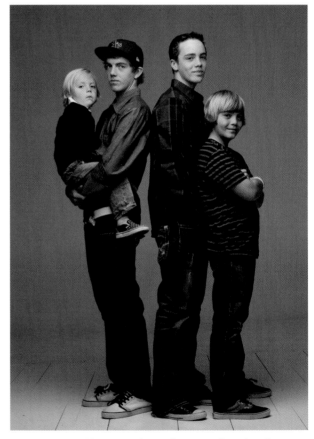

FIGURE 10.12 Five years later the same four brothers were shot in the same pose (from a low camera angle) to highlight how much they'd grown.

ISO 100, 1/200 sec., f/11, 70–200mm lens

Snort like a pig, speak in a whisper, or hit yourself in the head. Do whatever it takes to get the shot.

Directing for Expression

Kids usually love the shoot because they come into a scenario where a grown-up is dedicated to their entertainment, lets them run wild, and then sends them home with candy and a toy. What's not to love? My favorite part of photographing kids is the interaction between us during the shoot, and the better the interaction, the better the expressions.

The best compliment you could ever be paid by your clients is when they tell you that the images you created captured their child's real personality. These are the photos that capture authentic, natural expressions and the images your clients will love best. But how do you elicit those expressions on demand? It's all about prompted reality.

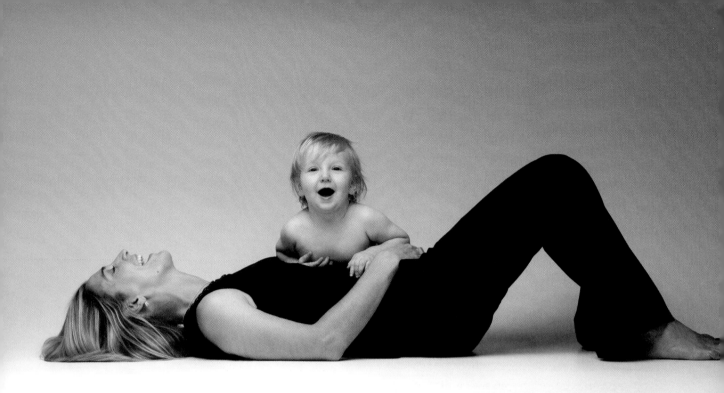

FIGURE 10.13 This confident mom was happy to sacrifice her body to the greater good of happy expressions for an authentic mother/son portrait.

ISO 100, 1/200 sec., f/8, 70–200mm lens

Prompted Reality

When you think about it, the entire portrait-making process is a false scenario. The very nature of planning clothing, location, lighting, and so on is contrived and artificial. The only "real" elements in the mix are the children you are photographing and their actions, reactions, and expressions. It's your job as the director to set something in motion that your subjects can respond to. It might be something you say, something you direct your subjects to do, or a scenario that you devise to elicit an authentic reaction. Photographer and mentor Julia Woods calls it *prompted reality.* Prompted reality is an authentic expression by your subjects that is elicited by your direction.

For example, the mom in **FIGURE 10.13** had a clear vision of what she wanted—a natural, fun portrait of her and her only son. The foreign surroundings intimidated the little boy at first until I asked mom to get on the floor and roll around with him, allowing her boy to use her as his personal jungle gym. The background, lighting, and setting are all artificial, but the moment between this baby and his mom is 100 percent authentic.

The better the interaction, the better the expressions.

Prompted reality is directing your subjects to do *something*. The actual direction may not be what you really want them to do, but their reaction to your request is the expression you're looking for. In essence, you are directing for the results, not the actual direction. It's my job as the photographer and director to create an environment where true-to-life expression can happen, and the reality or personality of the child can emerge.

It's easy to over-pose your subjects, making them appear stiff and bored. The following techniques will help you keep kids' expressions fresh by giving them something to do or react to:

- **Shh, do you hear something?** Say this in a whisper, and the child will pause and listen. In general, whispering will make a child lean forward and listen for what you are about to say. It's a good trick that results in an authentic position, wide eyes, and a sober face.

- **Eyes only to the floor, then back to me**. This is a great direction to use to maintain engagement in your subjects' eyes. Direct them to move only their eyes and look at the floor. Then, when you give the signal, ask them to look right back at you.

- **Keep it moving.** The key to avoiding static, overly posed images is to keep your subjects moving. That doesn't necessarily mean big movements; even shifting from one foot to the other or one bum cheek to the other will keep the pose from becoming stilted.

- **Flashdance.** Ask your subject to do something a little bit different after every flash of the light. Kids love this because it makes them feel like supermodels.

- **Keeping their attention.** Babies and toddlers are constantly in motion anyway, so the trick to directing them becomes maintaining their attention. Refer to Chapter 2 for good tricks on retaining a little one's attention.

- **The fan.** I love using the fan, especially when I'm shooting little girls with long hair in dresses. The fan doesn't have to be turned on high; just a little wind adds movement and interest in an image.

- **Subtle sabotage.** One of my favorite tricks of all time is a sabotage game, which can be used in many forms. For example, I might say, "I bet I can guess your middle name, so don't tell me what it is." Then I'll guess crazy names like Henrietta or Bertha. Anything that will get a rise out of the kids. It cracks them up and makes

them feel superior because they know the right answer and you don't.

- **Make the noise**. If you want to capture an image where kids are yelling or laughing and you direct them to yell or laugh, they'll usually just open their mouths and pretend to yell. The shot never looks right. Direct them to actually make the noise—to actually yell, laugh, scream, or as was the case in **FIGURE 10.14** growl.

- **Mine!** Part of the reverse psychology discussed in Chapter 2, this is the ultimate technique to use with three- to five-year-olds. If a child refuses to do what I want him to do, I'll say something like, "Don't you hug *my* dad/baby/toy!" This usually makes them do exactly what I told them not to. The whole "it's mine" concept starts in earnest at approximately age two, but for some very young kids, this trick can backfire and make them cry, so proceed with caution. However, at age three, kids pretty much know you're kidding, so they'll get into it with you and sass you back, declaring that it is in fact *their* dad/baby/toy, *not* yours. So there.

- **Don't tickle/hit me!** This trick requires an accomplice, an assistant, or a parent. If the child is not paying attention to me, I'll create a show for him by telling him, "Your mom is trying to tickle me, don't let her do it!" in a very fearful, pleading voice. All the while mom is perched over me with "tickling hands" at the ready, slowly acting as though she's going to tickle me and then she *does*. I then scream dramatically,

FIGURE 10.14 If you want a tough guy growl, have the kid actually make the growling noise. A fake growl just doesn't cut it.

ISO 100, 1/200 sec., f/8, 70–200mm lens

which results in hilarity all around. This stunt also works with some-one hitting me with a toy rubber mallet I have on hand or bonking me on the head with a ball—whatever it takes to get a reaction.

- **Get dad!** Make a big deal of calling the kids over to you and tell dad, "Don't you listen to us; it's a secret!" Then direct the kids that on your cue they should run over and tackle dad. I say this in a stage whisper loud enough for dad to hear so he knows what's coming. If you're lucky, you'll work with a dad who knows how to ham it up for the camera (**FIGURE 10.15**).

- **Give dad a spank/time out.** Kids love it when I threaten to give their mom or dad a time out. The idea of their parents being disciplined is a delicious concept to most kids, and their reactions show their approval.

- **Biggest fake laugh ever.** This technique shouldn't work, but it does. When older kids are stuck in the cheesy smile or tight-lipped look, I'll direct them to do the "biggest fake laugh ever." They usually don't get it right the first time, but just like smiling makes you feel better, even a fake laugh can result in natural, happy expressions.

- **Bored supermodels/ mean girls/tough guys.** I love to create images with sober faces and a little attitude, so for a shot or two I'll direct older kids to act like bored supermodels or to think like a mean girl (or tough guy). It's amazing how this affects not only their facial expression, but how they stand and sit.

FIGURE 10.15 Direct kid's to jump on dad and try to knock him over. This antic makes for great expressions, especially if dad's on board.

ISO 100, 1/200 sec., f/8, 70–200mm lens

- **Give him a big kiss.** This direction can elicit a multitude of responses depending on who it is asked of. For tween brothers, you can imagine the "Eww, gross!" expression, but for the toddler cousins in **FIGURE 10.16**, the request was taken at face value.

FIGURE 10.16 Usually the "give-him-a-big-kiss" direction is meant to make kids crack up. This pair of cousins took me seriously, and you can see that one boy is more committed than the other.

ISO 100, 1/200 sec., f/8, 70–200mm lens

- **Who's the brat?** This trick is a perennial favorite of mine. When siblings are in a shot together and they've been photographed before, they'll instantly strike the expected, cheesy pose. To shake up the composition, I'll ask them, "Who's the biggest brat in the family?" They usually start pointing at each other and cracking up, which makes for a great interaction shot.

- **Muscles.** No boy shoot would be complete without the requisite "gun show." It's especially fun to get the muscle shots when the boys are very small, and regardless of how small and skinny they are, you can see that they think of themselves as the Hulk.

- **Look in my lens.** If you're having trouble getting the child's attention, tell him, "There's something in my lens; can you see it? What is it?" You'll get a more intense expression aimed right where you want it.

- **Everyone look at _____.** This is a good way to break up monotony in a shot. After you've captured the normal, go-to poses, try the direction, "OK, everyone look at Jack (or whomever you want them to look at)! " Then when they look at him, follow up with something like, "Awww, he's sooo cute!" I'll repeat this several times calling out a different kid each time. I don't know why, but for some reason this always makes kids giggle, and it loosens everyone up.

- **The big finish.** From the beginning and throughout the shoot, I've promised the kids they'll get to do some crazy stuff at the end. The big finish might be a dance party where we crank up the music and have them

dance for the camera or it could be a muscle posedown, or perhaps a karate kick contest. The kids may want to pull out some props and go nuts. This is their big reward for doing what I asked of them. They can do whatever they want (within reason), and I'll shoot it. This is where the outfits that didn't make the cut make an appearance as well. Or, if the kid has big ideas and wants to try something you know won't work, you can let her try it at this time. You may get nothing from this part of the shoot, or you just might be surprised (**FIGURE 10.17**).

FIGURE 10.17 Wrap your next shoot with a dance party, and let everyone get in on the action. Music, props, and dancing combine for an energetic shot.

ISO 100, 1/200 sec., f/8, 70–200mm lens

Managing Energy on Set

My kid photo sessions are relatively short—usually 40 to 60 minutes. My shoots are a cycle of warm-up, engagement, craziness, and exit. Whatever your style, you are responsible for managing the energy on set during your shoot. Here are some tips for doing just that:

Tip: Psych yourself up before a shoot with your favorite music or a kick of caffeine. Your mood will set the tone for the shoot so make sure you are upbeat and ready to go.

- **Your energy.** If you're not happy and energetic, no one else will be. You owe it to your clients to be physically and mentally prepared, and excited to take on the lunacy that is a kid shoot.

- **It's what you say *and* how you say it.** If you want the kids to calm or slow down, talk in a soft, calm voice or whisper so they have to strain to hear you. If you need to amp up the energy, talk louder, make silly noises, laugh, or even scream in delight over their antics. You will set the tone for the shoot, so do it intentionally.

- **Time of day.** Mornings are usually the best time to photograph kids. Make sure you ask mom about the nap schedule for little ones and plan accordingly. If kids are tired or just home from a hard day at school, you'll be fighting an uphill battle. If the shoot is scheduled for after school, advise mom to give the kids a snack and allow them time to get ready and change gears.

- **Emergency candy.** I've had shoots where a shot of sugar for the kids was the only boost that would make the energy happen. Remember that you aren't establishing lifetime nutritional habits; it's your job to get the shot. Ask mom, of course, but don't be afraid to suggest a little sugar if the energy is dwindling.

- **Encouragement.** Keep the energy up and the flow moving with positive encouragement. If you've posed the kids and the shot's just not working, shoot it fast and say, "Great!" and then move on. Don't let the kids know the shots are not working; they'll lock up and get worried (especially the oldest child) or get bored and want to be done.

- **Music.** A good playlist can lift the mood of everyone on set. If the child has a favorite artist, download a few of the singer's songs and play them during the shoot. I find that dance/club music (download the clean version) fits the bill for almost every shoot. Even very young kids like music with a beat.

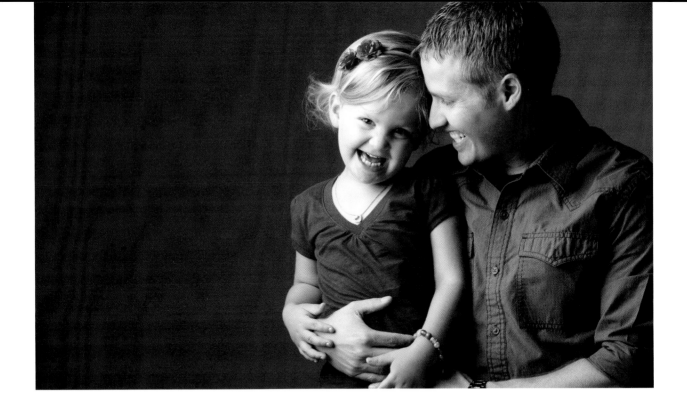

Common Problems

When you're directing for expression, you'll inevitably run into some common problems. From the cheesy smile to the blinker, any number of problems can derail your shot. Knowing how to quickly correct and overcome these issues will keep your shoot on track and lead to more natural expressions from your subject. Here are some remedies to overcome some inevitable obstacles:

- **The cheesy smile.** I don't know why, but at age five kids suddenly plaster on a stretched-lip cheesy smile anytime a camera is near. A couple of tricks to conquer the cheesy smile are to have the child blow a raspberry or stick out his tongue at the camera. The fact that the child got permission to stick out his tongue at you is usually enough to break the cheesy cycle and prompt some new expressions.

- **Shyness**. If your subjects are painfully shy and unsure, you'll have a difficult time getting good expressions from them. Give them a home base from which to operate by allowing them to hang with mom or dad. You'll be surprised at how expressive shy kids can be once they know they are safe in dad's arms (**FIGURE 10.18**).

FIGURE 10.18 Some children may need mom or dad as their "prop" to feel comfortable turning on the charm for the camera.
ISO 100, 1/200 sec., f/11, 70–200mm lens

- **Squinty eyes or blinking.** Sometimes a child might squint her eyes or blink in anticipation of my flash. You can overcome this problem by asking the child to close her eyes and on the count of three open them and look at the camera. It usually takes two or three times to get the expression right.

- **Tight mouth.** The tight mouth is the close-lipped cousin of the cheesy smile and is most commonly seen in kids ages seven and up. They know they shouldn't do the cheesy smile, but all their nervousness is manifested in the tight smirk on their face. Try the same solutions suggested for the cheesy smile. You can also try asking the child to breathe through her mouth. Her lips will part and her mouth will instantly relax. This also works well for kids with braces.

FIGURE 10.19 Instead of over-directing, keep shooting and don't miss any of the action.

ISO 200, 1/200 sec., f/11, 70–200mm lens

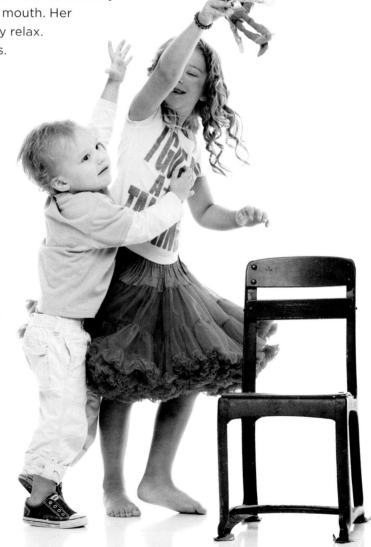

Shoot First, Discipline Later

When parents tell me that they have very well-behaved kids and that I won't have any trouble photographing them, my first thought is "borrr-ing." I see it as a good sign during a consult when my clients try to prepare me for their "challenging child." That's how I know we'll have a good time. The challenging kid with a spark in her eye is the unexpected element that will make for an entertaining shoot and attention-grabbing images. Perhaps that's why I end up photographing my fair share of rambunctious kids with an attitude. I warn parents ahead of

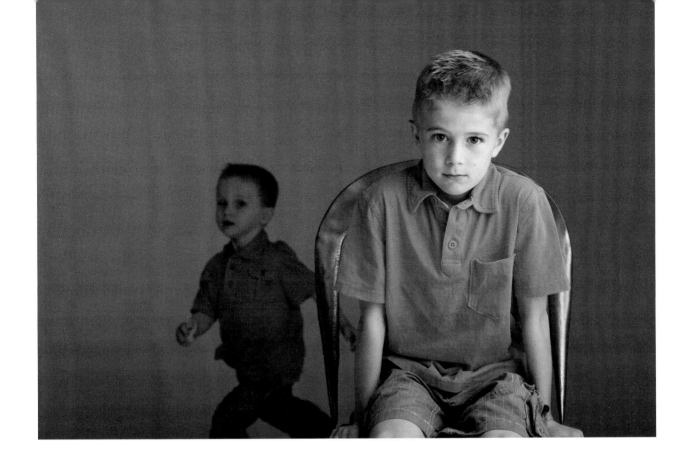

time that I may allow behavior that they would not and to prepare them-selves for things to get a little chaotic by the end of the shoot.

Although I love the wild card elements, it doesn't mean they are easy to deal with. I have to use all my tricks and patience to deal with the naughty kids, but my mantra is always, "Shoot first. Discipline later."

When an older sister is torturing her younger brother by holding his favorite toy above his head, as in **FIGURE 10.19**, you might think to inter-vene, but remember that you're not the parent; you're the photographer. Shoot first. Discipline later.

The naughty younger brother in **FIGURE 10.20** was not interested in being photographed until his older brother sat down for a shot. Little brother then began running in and out of the background, showing off for me. I almost shooed him off the set until I realized this was an opportunity for a more dynamic shot—one that tells the story of a long-suffering boy and his pesky younger brother. Shoot first. Discipline later.

FIGURE 10.20 Big brother regards the cam-era while his little brother tries to disrupt the shoot by running in circles.

ISO 200, 1/200 sec., f/8, 70–200mm lens

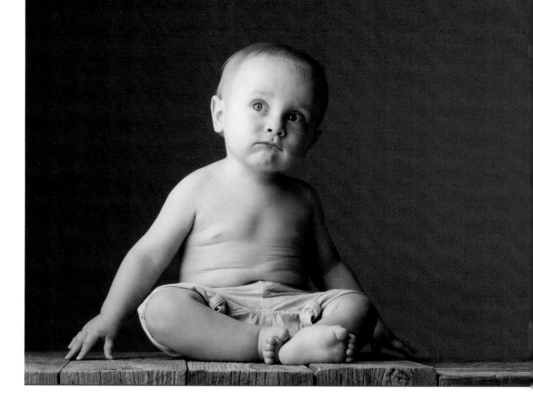

FIGURE 10.21 This toddler boy is tellingly expressive, from his quivering chin to the tips of his fingers and toes.
ISO 100, 1/200 sec., f/8, 70-200mm lens

Rather than trying to micromanage your subjects' every action, go with the flow of what's happening at the moment and make it work for you. Can you convert misbehavior into a storytelling shot? Take a step back and see if there's an image to be made out of the anarchy.

Tip: If you don't already, be sure to dress comfortably on shoot day. You may end up on the floor or jumping around like a lunatic, so dress accordingly.

The mark of a successful shoot is when the parents leave my studio apologizing for their wild children and confess that they're sure we didn't get a shot worth using. When you press the shutter is a matter of anticipation and timing. By directing the craziness, you can anticipate that *something* will be happening. Wait for it, watch for it, and capture it. Shoot first. Discipline later.

The Unexpected Element

I'm always on the lookout for something unexpected in an image—a fleeting look or distinctive gesture—something that is unique to that child. The beauty of children is that their social veneer hasn't fully developed, so they are more open and transparent than adults, giving you lots of material to work with.

When you're editing your next shoot, look for the unexpected element in the following areas:

- **Toes and feet.** It's amazing how expressive feet and toes can be. Does she point her toes like a ballerina? Is he standing flat-footed except for that one toe?

- **Hands.** Hands can be as expressive as a child's face. Watch for how kids hold onto a favorite toy or how they cling to a parent. The little boy in **FIGURE 10.21** has expressive hands *and* feet.

- **Eyes and eyebrows.** Do the kids have a certain look they give their mom? Perhaps they raise an eyebrow or maybe exhibit what I call the "crusty" look when they think you're a little bit crazy (**FIGURE 10.22**).

- **Mouths.** Some kids bite their lips when they're nervous; others might hang their tongue out of their mouth when they concentrate. Read their lips; you might see an intriguing quality.

- **Shoulders.** Shrugged or slumped shoulders can tell two different stories. Children's posture is a clue to how they are feeling. Pay attention.

Usually, it's not one obvious gesture but a combination of tiny movements that tell a larger story about a child. Develop your eye for detail by watching for these small gestures when you're shooting and especially when you're editing. Notice and highlight these nuances in every shoot. Your clients will love that you've paid attention to and captured what they love about their children—a reminder of what they see every day.

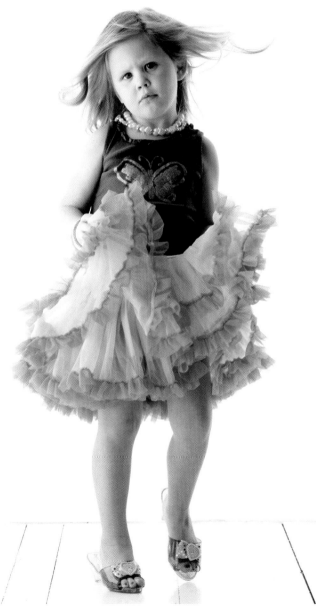

FIGURE 10.22 A little girl's "crusty" expression is an unexpected counterpoint to her girlie-girl outfit and sassy dancing.
ISO 100, 1/200 sec., f/11, 70–200mm lens

Which of my photographs is my favorite? The one I'm going to take tomorrow. —Imogen Cunningham

Putting It All Together

AT THIS POINT WE'VE COVERED a lot of information, and there's so much to think about and remember. You've learned about kids at different stages and how to light, style, and direct them. But how does it all come together in an actual shoot?

In this chapter you'll follow the process of two studio shoots from beginning to end. The girls in both shoots are ballerinas and were photographed just a couple of months apart. One is a chubby toddler, and the other is a leggy teenager. Both were photographed at a transition stage in their lives—a stage that their mothers wanted to freeze in time.

ISO 100, 1/200 sec., f/11, 24–70 mm lens

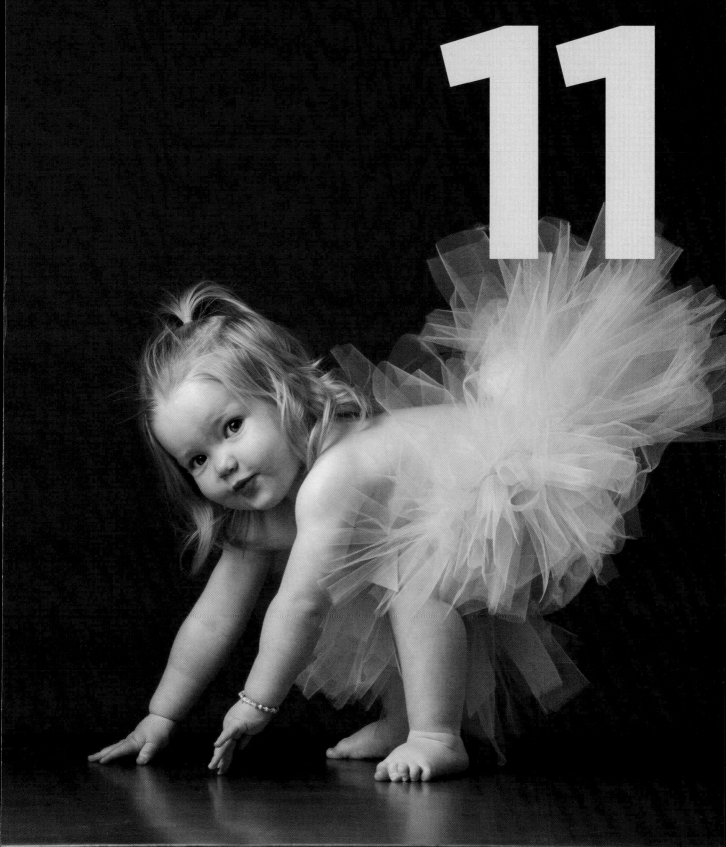

Studio Shoot: Lucy

Long before I even picked up the camera, the shoot with Lucy began like any other—with the client consultation. Lucy is the youngest of five in a very busy family. Her mother had been conscientious about having the children photographed often but suddenly realized that she had no photos of Lucy alone. Because Lucy was at that deliciously chubby toddler stage, Mom knew the shoot needed to happen soon before she grew lean and began to look more like a little girl than a baby. I suggested a studio shoot so we could create a study of Lucy's features. Here are a few more details about Lucy:

SUBJECT: **LUCY**

☐	AGE	18 months
☐	DEFINITIVE FEATURES	Fair-skinned, chubby body, big eyes, tiny mouth
☐	PERSONALITY	The youngest of five, sweet and even-tempered
☐	LOVES	Mom and candy
☐	MOM WANTS	To capture the "chub" before it disappears
☐	I WANT	To show off her skin texture and all the rolls on her wrists, cheeks, and ankles
☐	CONCEPTS	Babyhood, innocence

Styling Lucy

We agreed on a 9:30 a.m. shoot time when Lucy would be fresh and ready to take on the day. When we discussed clothing options, I discouraged Mom from bringing too many outfits because we wanted Lucy to have fun and be herself, not be changing into different outfits, which would only stress her out. Mothers of large families are famously

We wanted Lucy to have fun and be herself.

unflappable, and Lucy's mom was no exception. She showed up with one outfit and one pink tutu, which was perfect because Lucy was not in the mood to be photographed that day. She seemed nervous and clung to Mom like a barnacle. We warmed her up by shooting some photos of her in the clothes she came in. It took a few minutes, but Lucy began to loosen up a little as long as Mom wasn't out of sight.

Recognizing that our window of good will might be short-lived, we quickly stripped her down and popped on the tutu. With the tutu on and nothing else but a diaper, I could see that from top to toe this little girl was *pink*. From her strawberry blonde hair to her rosebud lips to her pale pink skin, she was a chubby, pink darling and the tutu was the perfect pink "frame" to show her off.

Lighting Lucy

Because Lucy is very fair-skinned, I planned to light her so she'd appear luminous on a darkish background. I didn't want the background to be black because it would be too harsh, so I lit it to be a darker gray than I usually use by setting up my main light and a platform for her to sit on about 14 feet in front of my white, unlit cyc wall. Positioning Lucy that far away from my background created a dark gray background with just enough light to keep it from becoming completely black.

For the main light I used a Profoto studio strobe inside a Chimera 3 x 4-foot softbox with a recessed front panel. This light modifier is smaller than my typical 60-inch Octabank, so it controls the light better. Its recessed front panel keeps the light off my background, making it appear a darker gray. Even though the light modifier was smaller than I normally use, by placing it very close to Lucy it was still a very large light source in relation to my subject, so it produced a soft light.

Tip: If you aren't yet confident in your lighting skills, keep it simple by using just one light and a reflector so you don't compromise your interaction with your subject.

Because I wanted to capture every crease and curve of her body, I positioned the main light at approximately 90 degrees to the platform and then pulled it toward the camera until the platform where she would be sitting was barely on the back side of the light. Anticipating that Lucy would be moving around, I added a white V-flat opposite the main light to add in a little fill and keep the shadows from becoming too dark.

Directing Lucy

While we were making the lighting changes, Lucy had been frolicking around the studio and was now ready to climb up on the platform and be photographed. Because Lucy was feeling a bit fragile that day, I didn't want to overwhelm her with my usual crazy antics; instead, I enlisted Mom's directing help. By having her prompt Lucy through all her "tricks" while standing right by me, Lucy could respond to Mom and still regard the camera. It wasn't long before we were rewarded with a show of Lucy's famous "O" expression.

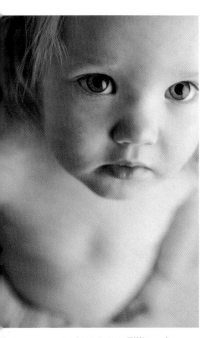

FIGURE 11.1 Filling the frame with creamy pink skin highlighted her blue eyes and rosy mouth.

ISO 100, 1/200 sec., f/2.8, 70–200mm lens

Next, I moved in close for a tight shot of Lucy's face and skin (**FIGURE 11.1**). The high camera angle emphasized how little she is, and the short depth of field highlighted her eyes.

Getting Your Shot

Although I knew we had enough shots to show Mom, I still hadn't captured the image that I wanted. While Lucy took another quick break, I brought in a platform of reclaimed wood to juxtapose against Lucy's smooth skin. Then we perched her on top with her chubby legs hanging off the edge. At this point she discovered the silk ribbon on her tutu and was fascinated by it. With her arms forward and her chin down, she was in the perfect position to show off the rolls and creases I had been dying to capture. I cropped in close, focusing on her body for the final shot in **FIGURE 11.2**. This image hangs in my office. I call it the *Shar-Pei Ballerina* because she has so many creases she reminds me of a shar-pei puppy.

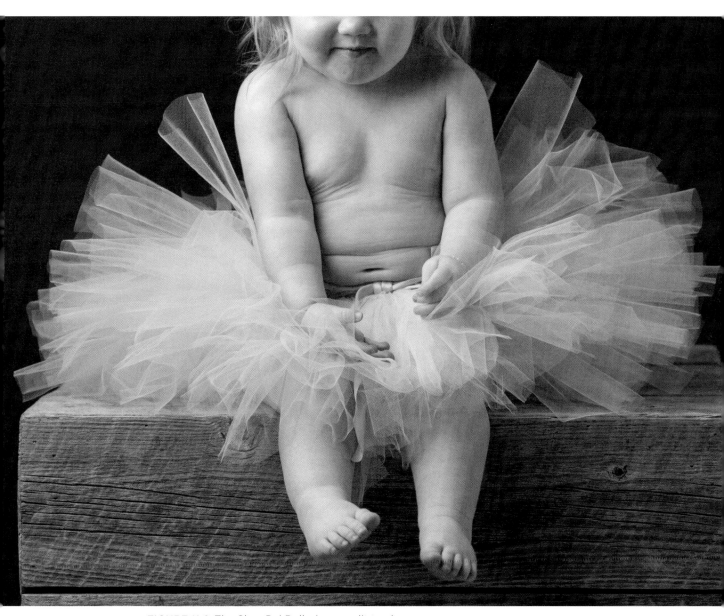

FIGURE 11.2 The Shar-Pei Ballerina was lit to show off every roll and crease in her toddler body.

ISO 100, 1/200 sec., f/13, 70–200mm lens

Studio Shoot: Samantha

Samantha was an only child who hadn't been photographed in a while. Her mom emailed me a specific request: "My daughter is turning 13 and about to get braces. We were thinking of getting some photos before she looks all grown up." Samantha had just recently upgraded from glasses to contacts so her mom wanted some photos of her before the braces went on. Here are a few more details about Samantha:

SUBJECT: **SAMANTHA**

☐	AGE	Just turned 13
☐	DEFINITIVE FEATURES	Expressive hands, long legs, and freckles
☐	PERSONALITY	Only child, funny and silly, a giggler, reserved but not shy
☐	ACTIVITIES	Ballet
☐	MOM WANTS	To capture her before she "looks all grown up"; incorporate the color purple
☐	I WANT	To capture the in-between phase between girl and young woman
☐	CONCEPTS	Grace, youth, and metamorphosis

Styling Samantha

During the consult, Samantha's mom gave me great direction about what she wanted highlighted in her daughter's images. Mom's favorite color was purple, so she wanted purple to represent a symbol of her love for her daughter in the photos. Samantha is an accomplished ballet dancer, and we discussed incorporating her ballet costume into the shoot. Samantha started lessons when she was little and had been dancing en pointe for some time. For this reason, I asked Mom to bring a bunch of old, outgrown, or worn toe shoes to the shoot. Because Samantha is an

only child, Mom knew she would have definite opinions about how she was portrayed. When we discussed clothes, I suggested she let Samantha select her own outfits with minimal guidance. I advised her to bring more clothing and "stuff" than she thought we'd need to give us options to choose from.

We decided to photograph Samantha in the studio because we wanted to highlight all of her features: hands, freckles, long legs, and other characteristics. And, I wanted to explore some different lighting techniques to highlight this transformative stage in Samantha's life. The beauty of photographing 13-year-old girls is that they are as into the photo shoot as you are. They are only too happy to change their clothes multiple times; they stay where you put them; and they are collaborators in the process of creating the images.

The shoot was scheduled three days after Samantha's thirteenth birthday. Mom and Samantha arrived excited about the shoot and carrying lots of outfit options. Samantha also toted in a box full of her old toe shoes. We started by photographing Samantha in a T-shirt and jeans, and worked into a dressier, more mature look that she had selected. Samantha was easy to photograph due to her sunny personality, and she had confidence to burn. Next, she dressed in a formal, flowing black dress, adding black tights and her toe shoes.

Tip: Redheads usually prefer color images instead of black and white because they show off their distinctive red hair.

Lighting Samantha

For the first shots, I set up my main light up and over Samantha with a single strobe head in a 60-inch Octabank. The gray background and black dress made the image (**FIGURE 11.3**) seem monochromatic, but her red hair and pink toe shoes added a bit of subtle color to the image. I wanted some movement in the image, so I brought in the fan to move her hair slightly. This was Mom's favorite image, and it hangs in a large canvas in their home.

Samantha's form and bearing were so beautiful I wanted to try a sort-of silhouette with her en pointe (**FIGURE 11.4**). I turned off the main light and turned on the background lights to light the white cyc wall, throwing

I wanted some movement in the image, so I brought in the fan to move her hair.

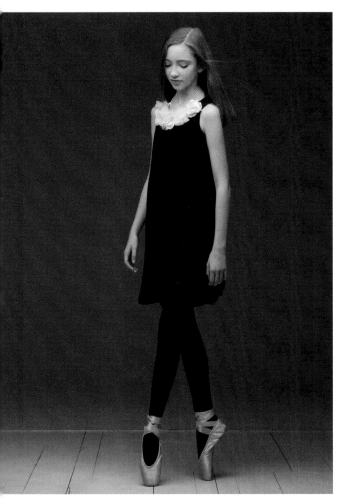

FIGURE 11.3 The formal attire and traditional toe shoes are juxtaposed against the plain, modern background.

ISO 100, 1/200 sec., f/11, 70–200mm lens

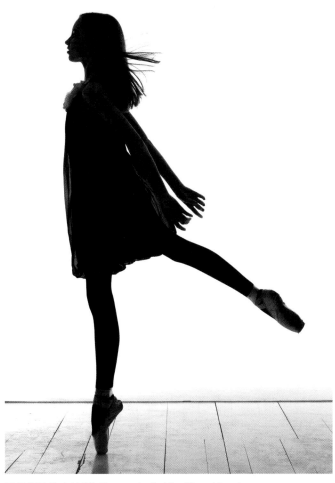

FIGURE 11.4 With the main light off and background lights on, the result is a sort-of silhouette.

ISO 100, 1/200 sec., f/11, 70–200mm lens

Samantha into silhouette. Samantha is in the same place as she was in Figure 11.3, only the lighting has changed. I had her turn so her profile was more toward the camera, and my assistant held the fan to move her hair and dress.

Ever since the consult with Samantha's mom, I had been envisioning the next shot in my mind. I wanted her to appear in a spotlight and to be holding a bouquet of her old toe shoes, symbolizing how far she'd come in her dancing. While Samantha put her hair up and changed, my assistant, Jeff, and I tested the next lighting setup. We positioned a single beauty dish up and over with a 20-degree grid on the front, which created a pool of light on the floor (**FIGURE 11.5**). Samantha came on set in a camel leotard with a black tutu and tights.

The first test shots showed that her black tutu and legs were disappearing into the dark background. To fix that issue, I aimed a background light (shown on the right side in Figure 11.5) with a 20-degree grid spot attached at the background just behind her to create a soft spot of light. It was just enough to see her tutu and keep the background from going completely black.

Tip: If possible, test your lighting with an assistant (or parent) so that you have everything ready when your subjects walk on set.

FIGURE 11.5 Setting up a spot light with a beauty dish before we put the grid on the front of the dish.

ISO 100, 1/200 sec., f/11, 70–200mm lens

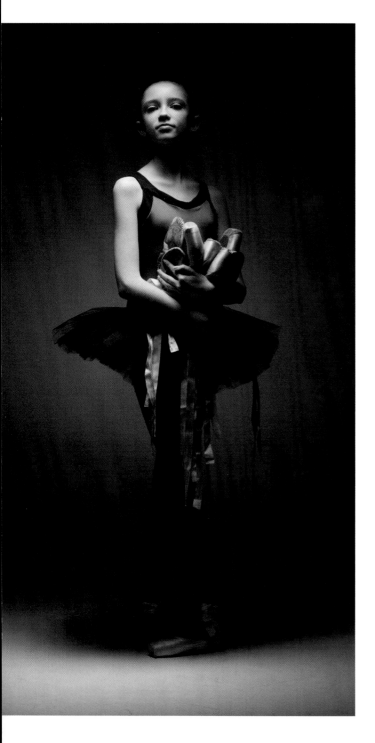

Directing Samantha

We presented Samantha with her bouquet of toe shoes with ribbons draping down. To exaggerate her long legs and regal bearing, I got down on the floor for a very low camera angle. I then directed her to inch forward very slightly into the light and look down at me while keeping her chin up (**FIGURE 11.6**). Like Figure 11.3, at first glance this image appears to be monochromatic, but the color in her leotard and tights causes the viewer to take a second look. You can see that she is very young, but her stance and expression show the maturity that lies behind her youth.

Getting Your Shot

I felt like I'd gotten the shot I wanted in Figure 11.6, but then Samantha started fixing her tutu and I saw something intriguing. I directed her to do it again but this time while en pointe. She had moved forward a bit and was looking down, so her face fell in shadow as she fixed the tutu (**FIGURE 11.7**). The combination of both pools of light, one on the background and one beneath her feet, provided just enough light to show her silhouette. The beauty dish overhead skimmed the light across her upper body, illuminating the angles on her shoulders and arms.

FIGURE 11.6 Emerging into the spotlight with her bouquet of toe shoes.
ISO 100, 1/200 sec., f/13, 70–200mm lens

This image stayed with me for days after I shot it. I kept coming back to it because, in a way, it's a portrait that represents girls and women of all ages. We all perform a balancing act on our toes, trying to be perfect and look good while we are doing it. Sometimes we are so busy attempting to do it all that we get in our own way and block our light. This image is a good reminder to be in the moment and enjoy what is happening right in front of us.

Keep Shooting

A spotlight idea kept calling to me, so when Samantha went to change into a different leotard combination, I pulled the beauty dish off the strobe head and positioned the bare bulb light to face the camera, creating a stage effect on the cyc wall. When she reemerged, I asked Samantha to assume center stage on the set (**FIGURE 11.8**). The bare bulb light was very hard, but it provided great rim light for Samantha. In addition, there was enough reflection from the white wall camera right to throw light into her face and the front of her body. Her tentative step forward and sideways glance back are a poignant reminder of this phase in her life—not a little girl, not yet a woman; I love her unsure expression in this image. From the low camera

FIGURE 11.7 My favorite shot was lit with a beauty dish and shot from a low angle.

ISO 100, 1/200 sec., f/11, 70–200mm lens

FIGURE 11.8 Shooting straight into the light can be tricky, but it's worth it when it comes out right (below).

ISO 100, 1/200 sec., f/16, 70-200mm lens

FIGURE 11.9 Hard, harsh light isn't always a bad thing (opposite page).

ISO 100, 1/200 sec., f/16, 70-200mm lens

angle you can see how long and thin her legs are. She reminded me of the little ballerina inside a jewelry box I had when I was a kid.

Turning Samantha toward the same background light used in Figure 11.8 resulted in light that was too hard on her face, but because she was prancing around and trying different ballet moves, I didn't interrupt the flow. I shot a few frames that I knew would be useless, just to keep her moving. Then she looked down, and in that position what had been harsh, unflattering light turned out to be the perfect light to illuminate the non-camera aware moment in **FIGURE 11.9**. In this image, you can't tell how old she is. She could be 13 or 19. Her expressive hands are highlighted, and the purple in her leotard—the symbol of her mother's love—combined with the light to produce a favorite shot. We finished up the session with some close-up shots of her face and cute freckles, and a quick image of her and Mom together. By the end of the shoot we were all exhausted but exhilarated by the collaboration and creative energy.

SECTION 4 THE FINAL PRODUCT

You don't take a photograph,
you make it. —Ansel Adams

Finish the Job

IF YOU ARE PASSIONATE ABOUT PHOTOGRAPHY, you'll refine
your craft by reading books and blogs, attending workshops, and
practicing new techniques. You'll spend time with your clients
learning about their children, conceptualizing and styling a shoot, and
then photographing their kids. You'll do whatever it takes to get the
shot. After the shoot, you'll spend yet more time editing the shoot
and making sure the best images are ready to show your client.

Most photographers average seven to nine hours per shoot. And
that's just the time aspect of the shoot. That doesn't take into account
the money you've spent on your gear, computer, and software. After
investing all this time and money, what happens to those carefully
crafted images that you've put your heart and soul into creating?

ISO 100, 1/200 sec., f/16, 70–200 mm lens

This final chapter has nothing to do with photographic technique or children. Instead, it is an appeal to finish the job you've started by valuing your time and your work, refining your product, and seeing it through to the end. I'll provide a brief look at how I've chosen to work in my business and explain why I've made these choices. Describing how I work is not meant as a prescription for everyone. But it might help you develop your own way of working that can evolve with you over time.

A Real Photographer

A few months ago I received a call from Lindsey, a no-nonsense mother of four who was interested in having me photograph her family and children. Her first statement to me was, "I want a *real* photographer." I laughed and asked her if the photographers she had used previously were *pretend* photographers.

During our conversation, Lindsey's concerns centered on five compelling reasons for calling me—reasons that highlight problems she has experienced before when having her family photographed. In the interest of helping you avoid some of the mistakes that I and many other photographers have made, I'm sharing these reasons with you. The following five "wants" are, in Lindsey's words, what she was hoping for and why she was looking for a *real* photographer:

- **A professional.** Lindsey wanted someone whose job it was to make portraits and who could and would handle the process from beginning to end, not a friend "with a nice camera." She wanted someone who would return her calls, show up on time, and create a beautiful end product for her.

- **Not overwhelmed.** Lindsey confessed that she had discs full of unedited photos of her kids taken by other photographers. And because there were so many images on the discs, she couldn't decide which shots she wanted to print; consequently, she had become overwhelmed and had done nothing with the images, so they live on her computer rather than on the walls of her home.

- **Some direction.** Lindsey expressed hope that during the shoot I would direct her family and tell each member either how to stand or what to do. "We're not models; we don't know how to pose to look good in a photo." She talked about frustrating past shoots where her kids ran wild while the photographer seemed reluctant to take control.

- **Your opinion.** Like every client, Lindsey had questions about the clothing selection for the photo shoot, but she was actually more concerned about getting guidance when it came time to selecting the actual photos. "Will you tell me which ones you like best, or do I have to pick them all?" She was worried that I would show her 100 photos and that she'd be overwhelmed again.

- **Images on my walls.** "I'm bad with decorating," Lindsey confessed. Her family had recently moved to a new home, so she was excited about the prospect of finally having photos of her kids on her walls but didn't know where to start when it came to framing and finding a place for the portraits to hang.

Over the years, I think I've made almost all of the mistakes Lindsey complained about. But when I saw that what I was doing didn't properly serve my clients, I changed how I worked. Lindsey's list of requests validated some of the toughest decisions I've made in my business, decisions such as not selling digital files, insisting on a consultation before the shoot, and viewing the images with my clients rather than posting them in an online gallery. Choosing these practices has served my clients well.

The rest of this chapter addresses each of Lindsey's comments and how you might handle similar requests from your own clients.

Be Professional

Photography, as a profession, is no joke. It's hard work and takes more than just being good with a camera. The definition of being professional can be reduced to one sentence: *Do what you say you're going to do*. Sadly, photographers have a reputation for being flaky. I know this because of how often clients comment on the fact that I was the only

It is your business; you can make it what you want it to be.

photographer to return their calls or emails. It's too bad, too, because there are some very talented photographers who could be more successful than they are if they'd take the business side as seriously as they take their art.

Edit Your Work

Dumping a bunch of images in an online gallery for your clients to pick from isn't doing your job as a professional photographer; neither is burning a disc full of unedited images and handing it off to your clients. Your clients shouldn't see unedited images. By edit, I mean weed through the images and reduce them to the best of the best, which is also known as creating a tight edit of your work. As a photographer, it is your job to edit your own work ruthlessly. Don't expect your clients to do your job for you. You are the best judge of which images have the best lighting and composition, and convey the message you want to portray. *Show only the best of the best and cut the rest.*

Print Your Work

A few years ago I decided to stop selling digital files of my work for portrait clients. I did worry that I might never work again, but realized my clients were taking discs of digital files I had sold them to the local drugstore to be printed. I was so tired of seeing bad purple- or green-tinged prints of my work on my clients' walls!

My work wasn't being presented in the way that I knew it should be, and I hated that. At least those clients were printing their photos. I was more concerned about clients who weren't printing their photos at all. What was happening to those images (**FIGURE 12.1**)?

It occurred to me that Ansel Adams didn't turn over his negatives of Yosemite to the National Park Service and let them print the photos. In his opinion the print was as much a part of the art as the capture. Adams's famous quote, "The negative is comparable to the composer's score and the print to its performance" is still valid for digital photography. With digital photography, the capture is only one-third of the job.

FIGURE 12.1 How do you want your work to be portrayed?

ISO 400, 1/200 sec., f/5.6, 24–70mm lens

The other two-thirds are postproduction and the final print. Having come a from a film and darkroom background, I knew just how magical a good print could be. From that point on I was determined to settle for nothing less for my clients.

Is there something about your service that is bugging you or that you don't like? If so, change it. It is your business; you can make it what you want it to be. Set your standards high, because clients who value those standards will find you and appreciate your attention to quality.

Provide Direction

You learned in Chapter 2 that the client consult sets you up for success by allowing you to meet the client prior to the pressure-cooker environment of the photo shoot. The consult reduces stress for your clients and for you by setting expectations ahead of time so there are no surprises. You act as a consultant, helping your clients with clothing selection and helping them to envision the possibilities for the images you'll create. Part

of the consult I do with my clients includes discussing the end product. I ask them what it is they envision hanging in their home, and where will it hang. Having this information before I even pick up the camera means that I am shooting for what the end product will be rather than shooting a bunch of images and hoping my client will buy them.

In Chapter 10 you learned about taking control and directing the photo shoot. Although it might put you out of your comfort zone to direct and pose your clients, it is part of your job as a professional photographer. To help you learn to direct and pose better, pay attention to and collect poses that appeal to you in magazines and online. Start a Pinterest board for poses you find and refer to it before your next shoot. Trying to re-create or use those poses as a starting point will go a long way toward giving you the confidence to direct and pose your clients.

Have an Opinion

Because I want to be in the room when my clients see their images for the first time, I don't have them proof the images online. It's a pleasure watching their reactions when they realize that time has indeed flown by and their babies are growing up. I want to be a part of that feeling parents have at pivotal times in their children's lives, like graduations and baptisms. It is those times when they pull back and get an objective view of how truly beautiful and amazing these creatures are that they helped create. That is what I call *the crack*. The crack is the payoff—the reward for all the hard work up to this point. There is no way I'm going to just load the images online and say, "Call me and let me know what you want." That would be the ultimate disservice to my clients. They need help selecting the best images for their home and visualizing how they can all hang together with the décor they already have. They want my opinion on which images I like best and how I think they should be displayed.

Your clients want your opinion, so have one. You are the artist, even if you feel weird seeing yourself that way. Your clients see you that way. So, how do *you* think the images should be printed and displayed? Do you

see them as a series of images hung together or one large image hung alone? Should they be framed and matted or printed on gallery-wrapped canvases? The options for printing and the presentation of digital images is overwhelming, even for photographers who deal with these decisions every day. Imagine then how your clients feel.

If you are having a difficult time helping your clients decide what to do with their images, think about what you would do if these were photos of your kids and you were going to put them up in your home. Begin there. Your clients don't need to know about every possible variation of luster coating and substrate board. They just need to know how *you* think it should be done.

What Would MOMA Do?

When it comes to presenting images on my walls, I believe in timeless, archival presentation and display. If I'm paying for expensive custom framing, I want to know that I'll like it as much in ten years as I do now.

While visiting the Museum of Modern Art in New York several years ago, I had an epiphany about presentation. As I toured the exhibits, I realized that the curators used a consistent treatment for displaying photography and fine art—a white, archival, 8-ply matting and black frames or stretched canvas that was timeless.

Matted and framed or wrapped canvases are how I present my work in my photography studio and in my home. It is also the method I recommend to my clients for the portraits I've created for them (**FIGURE 12.2**). This presentation style has worked with the many different décor styles I've had in my home over the years.

What type of presentation rings true for you? Which method do you love best when it comes to printing your work? Don't select a frame or presentation method based on what's on sale at the lab this week. Select your presentation based on what gives your work integrity and how, in your professional opinion, your work should be displayed.

Select your presentation based on what gives your work integrity.

Delivered and Installed

Recently, we delivered and installed the framed portraits in Lindsey's home. For most of the collections I sell, delivery and installation are included in the cost because I want to make sure the portraits are presented and hung appropriately for their size and for the room where they are displayed. It also reduces marital discord when the husband hangs them incorrectly and the wife tries to tell him what to do.

Installations are the closest most moms get to that Christmas morning feeling. Having us show up at her house with photos of her children and hang the photos on the wall for her is a rare treat.

As I was writing this chapter I called Lindsey to check in to see how she was enjoying her photos and also to make sure I remembered our initial conversation accurately. I asked her how her experience with our studio was different than the other photographic adventures she had had. Lindsey shared several compelling last thoughts:

- **Sitting down ahead of time.** Lindsey commented on how comforting it was to sit down and plan ahead of time during the consult. She knew what to expect and was less stressed about every aspect as a result.

- **Not going to be cheap.** Lindsey talked about saving up for the portraits and how she knew when she called that it was going to cost more than she had previously paid but that it was worth it to her if she could reach her end goal of having portraits on her walls. She said that the whole process was "quicker and easier than other shoots, and we got exactly what we wanted and more."

- **Love the results**. "I didn't know I'd love it this much," she said. She knew she would love having her family on her walls (**FIGURE 12.3**), but she didn't know how much she would love seeing them every day and how they made her new house seem so much more like home.

This is the successful beginning of what I hope will be a lifelong relationship with this client. I may see her only every other year or every three years, but if she knows that I care and can get the job done for her, we've established a foundation of trust and have formed a mutually beneficial relationship.

FIGURE 12.2 My studio specializes in creating timeless portraits for display in my clients' homes (opposite page).

ISO 400, 1/125 sec., f/5.6, 14–24mm lens

FIGURE 12.3 Lindsey and her family. This
client knew exactly what she wanted.

ISO 100, 1/200 sec., f/11, 70–200mm lens

Value Your Work

Value your time and your work; if you don't, no one else will. This is especially pertinent to photographers of the female persuasion. Many of my female colleagues underestimate the value of what they do and the time it takes to do it. Be real about how much time it takes you to photograph, edit, and retouch your work; then price your work accordingly. The aspects of pricing and running a business could be another book entirely, but it's vital to place a value on your services. If you don't, you may end up bitter and resentful of your clients rather than thriving and enjoying your time with them.

Much like the art of photography, the business of photography is a process of trial and error. The best decisions I've made have usually been made after I've done something the wrong way, realized it wasn't working, and then tried something new. Don't be afraid of evolution and change. Both are essential to your growth as an artist and a human being. How do you like to work? Why do you do what you do? The answers to these questions will differ from one photographer to another. Considering your responses will enable you to communicate clearly and confidently with your clients.

Because you've chosen to be a children's photographer, you are in a unique business in that what you create becomes more valuable over time. The images you create are priceless enough to be the first items your clients would grab on the way out of their burning home (after their kids and dog, of course). The images you create are all that will be left when the children in those images are no longer on this earth. The images you create today are tomorrow's heirlooms. They have value. My hope for you is that you'll pursue your art with integrity and passion. Trust your instincts, and don't be afraid to make mistakes—a lot of them, and some of them more than once. You'll learn from every experience. My favorite quote of all time, which happens to be by Erma Bombeck, sums up my philosophy: "When I stand before God at the end of my life, I would hope that I would not have a single bit of talent left, and could say, 'I used everything you gave me.'"

Use yourself up in the pursuit of your dreams. You'll never regret it.

> Pursue your art with integrity and passion.

Index

A

accent light, 92, 93
action shots, 25, 41, 152–154, 226
alphabet letters, 204, 206
ambient light, 107, 160, 164–168, 177
antique markets/malls, 209
aperture, 105, 107, 160, 163–165. *See also* f-stops
ATJ prop cart, 202, 204, 209, 215
atmosphere, 220
authenticity, 10, 11–13, 236–241
available light. *See* ambient light

B

babies. *See also* newborns
 clothing changes, 193
 keeping attention of, 237
 lighting, 89
 naked, 33, 89, 192
 posing, 226
 in studio, 183
 working with, 29–31, 212
background stands, 138–140
backgrounds
 black, 149–152
 considerations, 134
 gray, 149
 lighting, 93, 143–145, 147
 white seamless, 136–157

base exposure, 163, 164–165, 176
Beauty Dishes
 examples, 132–133
 overview, 100–102
 using, 106, 110, 147
bird's-eye view, 222, 223
black and white photos, 91, 210
blankets, 27, 34, 210
boom arm, 114
boxing gloves, 202–204, 205
boys, 39, 41, 207, 233
building blocks, 210
Bumbo, 29, 30
"Butterfly" lighting, 123–126, 152–153

C

camera angles, 220–226
camera shots. *See also* photos
 action shots, 25, 41, 152–154, 226
 groups. *See* group shots
 portraits. *See* portraits
 test shots, 163, 164
cameras
 client cameras on set, 219
 recommendations, 79–80
 renting, 79
 sync speed, 79
candy, 17, 34, 208, 242
capes, superhero, 204
catchlights, 123

child photography
 authenticity and, 10, 11–13, 236–241
 common mistakes, 50–51
 considerations, 4
 developing your style. *See* style
 props, 198–215
children
 babies. *See* babies
 boys, 39, 41, 207, 233
 clothing, 27, 33, 188–198, 246
 communicating with, 17
 developmental stages, 27–48
 difficult, 20–24, 244–246
 gathering information on, 16–17
 girls, 38, 39, 42, 43, 191
 interaction with parents, 48
 middle child, 45–46
 as muses, 63–65
 newborns, 27–28, 173–175
 oldest child, 43–45
 personality traits, 18–26
 "the poser," 24, 25
 posing. *See* posing
 preschoolers, 34–35, 180–182, 226
 sassy, 20
 school-age, 35–38, 180–182
 shyness, 17, 18, 243
 siblings, 43–48, 232–233
 slow to warm up, 18–19

mouths, 244, 247
Museum of Modern Art (MOMA), 271–272
music, 220, 240–241, 242

N

natural light, 72, 94, 105, 181
ND (neutral density) filters, 111, 176
neutral camera angle, 222, 223
neutral density (ND) filters, 111, 176
newborns. *See also* babies
 at home, 173–175
 working with, 27–28
notebooks, 62

O

Octabanks
 overview, 97
 seamless, 106
 Up and Over setup, 123–126
 working with, 94, 95, 97, 106, 110
one-light silhouettes, 129–131

P

pacifiers, 210
Panda Eye Effect, 123–124
paper, white seamless, 138–139
parents
 assistance from, 33
 bringing own camera to set, 219
 consulting with, 16–17
 interaction with children, 48
 as props, 212
PC cords, 80, 81
pets, 212

Photek Softlighter, 98
photo shoots
 directing. *See* directing photo shoots
 laying groundwork for, 16–17
 music during, 220, 240–241, 242
photographers
 clarifying intention, 8–9
 common mistakes/solutions, 266–275
 delivering/installation, 273
 editing/printing work, 268–269
 imitation, 55
 professionalism, 266, 267–268, 275
 providing direction/opinions, 267, 269–271
photography, 62, 63. *See also* child photography
photos. *See also* camera shots
 black and white, 91, 210
 Day in the Life series, 180–182
 delivering/installing, 273
 editing. *See* editing photos
 groups. *See* group shots
 portraits. *See* portraits
 postproduction, 78, 80, 155–157, 163
 printing, 268–269
 test shots, 163, 164
Pinterest, 62
PocketWizards, 80, 81
portraits
 authenticity and, 10, 11–13, 236–241
 capturing "the real kid," 11–13
 evoking emotion, 6, 8
 groups. *See* group shots
 overview, 6–11
 same pose, different year, 234

vs. snapshots, 6–7, 11
white seamless, 136–157
window-light, 111–113
posing, 226–235
 basic poses, 227–229
 camera awareness, 230
 cheesy smile, 243
 overview, 226
 relationships, 230–233
 same pose, different year, 234
postproduction, 78, 80, 155–157, 163
preschoolers, 34–35, 180–182, 226
printing photos, 268–269
professionalism, 266, 267–268, 275
prompted reality, 236–241
props, 198–215
 blankets, 27, 34, 210
 food as, 210–212
 over-the-top, 214–215
 parents as, 212
 pets as, 212
 as symbols, 213
 toys, 34, 210
 where to find, 209

R

reality, prompted, 236–241
reflections, 123
reflectors, 98–100
relationships, 63–65
Rembrandt lighting pattern, 127–129
respect, 17
rubber gun, 207